SELF-HELP NATION

*The Long Overdue,
Entirely Justified,
Delightfully Hostile Guide
to the Snake-Oil Peddlers
Who Are Sapping Our Nation's Soul*

TOM TIEDE

Atlantic Monthly Press
New York

2023872262
ACE-9790
23.00

Published simultaneously in Canada
Printed in the United States of America

FIRST EDITION

Library of Congress Cataloging-in-Publication Data

Tiede, Tom
 Self-help nation : the long overdue, entirely justified, delightfully hostile guide to the snake-oil peddlers who are sapping our nation's soul / Tom Tiede.
 p. cm.
 ISBN 0-87113-777-1
 1. Self-help techniques—Miscellanea. I. Title.
 BF632.T56 2001
 646.7'00973—dc21 00-046904

DESIGN BY LAURA HAMMOND HOUGH

Atlantic Monthly Press
841 Broadway
New York, NY 10003

01 02 03 04 10 9 8 7 6 5 4 3 2 1

To the ideas, writing, and poetry

that are superior to my own,

two of the three easy to find in this world.

CONTENTS

SELF-HELP NATION

Magic Bullets

🦋 🦋

When the wind blows,
On a hot day,
It dries the skin,
And indicates,
Either,
That things aren't so bad,
Or,
If the wind stops,
The heat will be worse than before.

What's wrong?

Among other endeavors, none of which I can recommend, I have in my several lives been the proprietor of a bookstore, where little of very much interest takes place, save the irregular observation of disparate men and women, also a few children, engaged in the exaggerated belief that, as it's been said, there is power and profit in losing oneself in other people's minds.

By way of an exorbitant example, I remember a marvelous, not to say utterly terrifying illustration that occurred on a summer afternoon when I was called to a mostly empty house in the foothills of the Blue Ridge Mountains, and engaged there to purchase a thousand used books that were piled directly in the way of a floor-to-ceiling refurbishing project.

The books were in fine condition, most of them were recently published; many of them, indeed, were hardly opened and essentially virginal. I went about the count with little enthusiasm at first, distracted as I was by the dust and disorder, and by the earlier glance of a neighborhood woman in a T-shirt that advertised "38-Inch Hooters." But one hundred volumes into the collection, I became intrigued, I might say amazed, and just this side of drop-dead stunned.

Most of the books were what are optimistically known as self-help publications, each with an obligatory painting of front-cover razzmatazz, each with a whiz-bang title designed to further lure Visa card attention: *Life Is Too Short to Be Ordinary; Don't Shoot Yourself in the Foot; Goddess Power; Smart Cookies Don't Crumble; Life Would Be Easy If It Weren't for Other People; Chicken Soup for the Soul; The Goodness Guerillas; It Only Takes a Minute to Change Your Life; No Place to Hide; When Bad Things Happen to Good People; Life and How to Survive It; Bus 9 to Paradise;* and, groan, the truly ditsy: *Everything I Know I Learned in Kindergarten.*

As to the last book: indeed.

As to the rest of them: sigh.

In the overall there were in excess of six hundred self-improvement entreatments scattered about; so three-quarters of the considerable library was given over to writings about do-it-yourself betterment. Most of the books were hardcover, rush-out-and-buy first editions, and they carried a cumulative cover price of more than $12,000. To hell with the hooters, when casual anthropology can unearth a modern epiphany in a stack of print. I calculated that the boob who bought the books (all of which had been published in a three-year period) had spent an average of $4,000 per annum to learn how to fix everything from his sex life to his eating disorders to his water-closet peculiarities.

I turned slowly to the seller, and said: "Good gum, man."

He replied: "Don't look at me—they're not mine."

He said the person who bought the books had moved away from the home and left them behind. He said the man had a computer business, was married, and had a mortgage on the house. Then he added, not smiling, in pain for a fallen fellow, that in one swoop the poor dumb son of a bitch had lost his business, separated from his wife, and, Jesus jumps into the Jordan, was also forced from his occupation of the house by way of a contract repossession.

The seller, a man who had held the paper on the contract, was now picking up the pieces.

We rolled our eyes in the unison reserved for merged thoughts.

The seller poked at the books. "Here's one on family success. Here's one on happiness."

I said, "Repossessed?"

He said, in words of the kind: "It can ruin your whole lunch hour. This boy paid me $50,000 down and made most of the payments for five years, plus taxes and insurance, all of it now into the pit. Look at this—he's got fifty–sixty self-help financial books here. For what? Do you believe that? For what? If he'd spent the book money on the mortgage, uh, who knows?"

I know. If the man had paid the rent and ignored the silly books, the man would at least have been less of a loser. He would also have been more of a man. Self-improvement books are narcotics in ink. They obtund with false promise. Someone has said that all of the wisdom in all of the self-help books can be reduced to the Sermon on the Mount, and even that assessment may be charitable. The jails, divorce courts, and bankrupt records are stuffed with misguided if not demented folks who squander time, money, and hope on the sidewalk psychology and desert wind contained in these depressing tomes.

I looked further through the pile of books in the home. There were thirty cookbooks (mostly pastry) and half that many others regarding dieting. There were more than a hundred volumes about personal organization in a house so dirty I was tempted to put socks over my shoes. There were books on sex ("pull a pillowcase over their head

3

and kiss them with a very wet mouth"); books on stress ("soak your hands in water when anger threatens, in a toilet bowl if nothing else is available"); books on motivation ("if you fail, wear your watch on the other wrist, as a reminder of things gone wrong"); and books on the woman who thought her husband was a hat ("pull a pillowcase over their head and kiss them with a very wet mouth").

And on each dustcover there was a photograph of a tickled-pink author, smug, smiling, and sweet with success, which must have driven the desperate buyer off the bridge, since a great many of the man's miscarried collection concerned themes of grim mental illness, real or otherwise ("I'm Okay, You're Okay. You aren't? Naughty. Read chapter 17 on the happy child within you, and watch for my next book, due soon from my smug, smiling publishing house").

I boxed the books, put them in my Jeep, and drove them to my store. Once at the shop, I discovered another sad truth about the publications, perhaps the mother of sad truths. All of the books had the dust jackets folded as bookmarks within the first twenty or thirty pages; presumably, the man who bought them never looked much further than the periodical introductions.

He was on the hunt for a rapidly fired magic bullet.

It cost him $12,000 to find out there are none.

Repeat: none.

Life is troubling. Get used to it. Hair falls out, marriage is a necessary cachexia, business smells, there's never enough money to do what one wants to do, and God isn't listening.

Sorry.

This isn't to suggest surrender. Or that the fatalists are right.[1] Eating Dr. Nutrition's egg yoke laced with bird pollen *may* prevent

1. Fatalists claim that all events occur along an inevitable course. Fatalism was first a Hebrew doctrine; today it's prevalent among Muslims; inevitably, they hate each other.

shingles, for all I know, and surely a regular couple of hours of lower-bunk snuggling *does* help the medicine go down. A good book *is* a year of schooling, and a faithful friend *can* be, as what's-his-name, Jesus, found out from his disciples, more fulfilling than one's self. No doubt there are wonderful moments, terrific rushes, and temporary relief for most of our dilemmas save that of end-game expiration.

But magic bullets? No.

Try coping. If that fails, try the priesthood, walking to Belmopan, or Jack Kevorkian. You'd do better selling crack than leafing through massifs of fix-up advice; and the pay is steady.

The novelist Kurt Vonnegut was recently said to have written a few self-help suggestions for graduating students at MIT. He was credited incorrectly, it turned out; the list was manufactured by a Chicago journalist named Mary Schmich. The advice can therefore be applied to people of all ages, some of whom may not know what MIT means, and includes:

- Wear sunscreen.
- Don't worry about the future. Or worry.
- Sing.
- Don't be reckless with other people's hearts.
- Get plenty of calcium (or you'll miss your knees when they are gone).
- Dance.
- Travel.
- Don't mess too much with your hair.
- Trust me on the sunscreen.

Get the point? There is no point. The list reminds us that there are fewer solutions than there are problems—how can it be otherwise? So while it may be healthy to exercise over this discrepancy, the exercise cannot change the discrepancy, the figures never add up. Science is precise, and terrible. Existence is random, and terrible. But

rejoice: sing, dance, travel, and if you are still in the dark about personal illumination, here are some additional thoughts to perpend while applying the sunscreen:

- Don't give way on the sidewalk to those who are less than amicable.
- Speak up.
- Get off your butt.
- Don't visit your doctor so often that you remember his name.
- Those who habitually watch television are less likely to deserve valentines.
- Sleep is the sister of death. Go to bed late.
- Make many acquaintances, some friends, and know the former are of more service.
- Don't waste time or tempt disappointment believing in fairies.
- Never let Kurt Vonnegut get credit for your work.

Christopher Isherwood said that living is not so bad if you have good luck and a good body; William Osler wrote that we are here to add what we can to, not get what we can from, the surroundings; Voltaire said the remedy to a field of thorns is to pass through it quickly, for delay and contemplation make it worse; Kathleen Norris observed that all that's necessary in our community is to accept the impossible, do without the indispensable, and bear the intolerable; and Mary Rinehard said, finally, "A little work, a little sleep, a little love— and it's all over."

And yet most people insist on taking it all most seriously. Enter the rogues, such as personal development consultants, who pledge satisfactions. Christopher Morley took it for granted that by lunchtime the average chap has been so beaten down he will believe anything. And it's always been thus. The self-help consultants have taken the search for answers to new and unblushing lows, but the search for Homo sapiens perfectibility is as timeless as it is illusory.

One early advocate of the search was a runt named Yoritomo Tashi, who vended life-building advice around the turn of the twentieth century. In 1916, he wrote *Timidity: How to Overcome It,* a book that research might yet find to have transformed the once retiring people of Japan into the rats who bombed Pearl Harbor. Tashi said that traditional timidity was "a mistaken virtue . . . a weakness that leads to the mistrust of self and that causes the fear of ridicule."

He continued: "The movements of the timid are always gauche, indicating a lack of sincerity . . . for it is rarely that his words correspond to his thoughts. The timid also feign gentleness, and they are obsequiously polite. Their very countenance indicates embarrassment and artifice." The timid, he said, "are audacious, pessimistic," and should better well be shot.

Tora, tora.

And long before even Tashi, there was Sir Thomas More, a medieval aesthetic. More was decapitated in the fun-loving England of the sixteenth century, for his wish to separate the church from the state and the king from his sexual conquests; but he might more fairly have been executed for burnishing the opinion that humankind can solve its problems by cowering together in perfect harmony. He lived at a moment when the printing process was coming into its own, and he presaged and established the model for, say, *Everything I Know I Learned in Kindergarten* by writing a self-improvement book for all seasons, *Utopia.*

Historians still debate the reasons Sir Thomas took time from his devotions to publish *Utopia.* It's noted that the name of the place itself, Utopia, was derived from a Greek word meaning "no place," that the Ademus people of the place can be translated as "not people," and that the river mentioned in the descriptions, Anydrus, means "not water." This play-around hints that More wrote the documents as high-hill intellectual fancy, for recreational purposes, and perchance believed that the fable would serve no purpose other than Renaissance amusement.

Others disagree. They say More was nothing if not a reformist, a gentilesse with an impulse of noblesse oblige, and he wrote in the spirit of revolution. The opinion is that More was an early socialist who hoped that committed people with fair motives could make everything right.

In any event, the nobleman wrote of harmony, the absence of suffering, brotherhood, and rigorous idealism. That is, solutions for everything over the height of the zoysia. Sir Thomas More found the answers in planned—call it communistic—living. Everyone is educated. Everyone is sheltered. Everyone is happy, strong, pleasure-seeking, robust, in demand, free of want, and kind of heart. There is no crime in Utopia, nor oppression, nor failure.

Sound good?

Also, expensive.

The cost is personal choice. With a progressive tax.

Not that More was a totalitarian. If it was possible not to be a totalitarian in Tudor England. But decades later, in the early eighteenth century, William Godwin wrote of a utopia where the happiness of people "is the most desirable for science to promote," and said the promotion would lead to the elimination of drudgery, including sexual intercourse. And at the same time, Jeremy Bentham envisioned utopian living arrangements where people would give up liberty for security—"states of wardship"—where life would be tranquil and industrious. We need not mention the philosopher who brought all of these seeds to fruit, in the eastern Europe of the first half of the twentieth century: hello, Joe Stalin, murderer, bad egg, utopian.

The costs aside, though, the novelties of Sir Thomas More continue to intrigue into the third millennium. Few believe any longer that people can be herded into jurisdictional purification, but the longing for perfectibility, at least in the American ranks, has become damn near a democratic demand. We have developed an insatiable hunger to believe that anything is possible, that everyone should have everything, that the Twenty-eighth Amendment to the Constitution is

hinged to the guarantee that "If it's broke or bent, or even if it isn't, it must be repaired."

Therefore, as one consequence, we witness the annual printing of a mountain of self-help publications. Most of them are as substantial as cobra hair, but many of them are also riotously successful. *Chicken Soup for the Soul* is an illustration of both ends of the last sentence. The original manuscript was at first rejected by thirty-three publishers—one wishes there had been a finally frustrating thirty-fourth—yet the writers went on to sell almost thirty million copies (a 1998 figure) of a series that includes *Chicken Soup for the Mother's Soul, Chicken Soup for the Teenage Soul, Chicken Soup for the Pet Lover's Soul,* and *Chicken Soup for the Soul at Work.*

It tempts legal retaliation to mention the gop in these spineless publications. There are 101 inspirationals in each book; the writers say the number has a spiritual connection, and the stories go "to the heart, to the core being of a person." The Brothers Grimm would heave on this sentimental bilge.

And yet the books are only a part of today's self-help Godzilla. There are also thousands of self-improvement computer sites (yesyoucan@ feelswell.com); the government spends billions each year promoting self-help admonitions (eat five servings of vegetables daily, lay off the Butterfinger bars); the broadcasting industry disseminates self-help public service announcements (recycle Christmas trees, use condoms); and there is now a satellite television station called the Success Channel that is given over to "positive, life-enhancing programming, twenty-four hours a day."

The television channel's "success coaches" are the same people who brought us *Life Is Too Short to be Ordinary* and other Caldecott Medal nonfiction. The same people who write the books about creating wealth, losing weight, shopping shrewdly, making friends. That is to say: Bill Bailey, won't you please go away; Rudy Ruettiger, a football never-was who markets his embarrassing mediocrity as persistence; Nido Qubein, one of the "sleeping giant" awakeners; Dr. John

Gray, Men Are from Mars, Women Are from Venus, Where Are the People from Earth?; John Bradshaw, who, after years of making money from fools, should be able to afford a shave; and Grandmaster Tae Yun Kim, who peers from her martial arts dust jackets with a look that says: Don't get funny, buster, with my myofibril development.

Some of these thuds are doctors and lawyers. Others are housewives self-taught at Starbucks. Actually, the housewives are the more lusory; they dance on the tips of their toes. The doctors and lawyers are no fun, and use no footwork; minding their liability premiums, they also punt a lot, telling the befuddled that, in the end, it's ever best to "seek professional help."

Yet the pros and the ams come together regarding human behavior. They say it's bad and it's getting worse. They say there are a good many serious social disorders today, and that there will be a good many more tomorrow, and the next day, and the day after that, God willing.

Yo, as they say, normalcy is a thing of the past. Anything that we do in the present is curious. People used to get angry when they were cut off in vehicular traffic; now they are displaying "road rage." Pepsi addicts used to worry only about tooth decay; now they may have caffeine-induced anxiety problems. John Leo, the columnist for *U.S. News & World Report,* has listed other new worries as: Internet addiction, inhalant abuse, telephone scatology (heavy breathing), and "attention deficit hyperactivity disorder," a name given to what Leo says is the perfectly normal behavior displayed by kids who toss paper wads in grade-school classrooms.

Oh, citizen, thy name is dysfunction. It's also stress, guilt, and road rage.

Ask your parents what *dysfunction* means. If you are under forty, ask your grandparents. They will tell you to wash your face. Great numbers of Americans before the 1960s were not fixated by what was wrong, but by what was right. They were individualists in a common struggle. They were taught self-responsibility rather than self-help. Disorder? Stress? Depression? Real men and women say work it out,

and don't linger; life is brief enough without wasting any of it on, like: wither road rage?

Dysfunction?

Get down.

Stop eating if you're fat, and stop rogering Jinny if you don't get anything from it.

Miracles do not happen outside the imagination.

Or, lacking this, read the Sermon on the Mount. I do not stand in Christ's circle. But the Bible (and other religious works of the kind) keeps children from strangling their parents in the kitchen, and notwithstanding the purpose of its authors, the wisdom in many of the pages, cleansed of interpretative politics and pollution, was, is, and will be permanently excellent.

Jesus, as Oscar Wilde might have had it, did not pay much attention to learning, only to teaching. And his chief contribution in this respect was the day in Matthew's narrative when he "went up into a mountain, and when he was set, his disciples came unto him, and he opened his mouth, and taught them, saying" (such things as):

Blessed are the poor in spirit.
Blessed are they that mourn.
Blessed are the meek.
Blessed are they which do hunger and thirst after righteousness.
Blessed are the merciful.
Blessed are the pure in heart.
Blessed are the peacemakers.
Blessed are they which are persecuted for righteousness' sake.
Ye are the salt of the earth, the light of the world.

Read it again: there's not a word about dysfunction or telephone scatology.

Nor is there anything about fix-everything advisers. But the self-improvement salespeople have been fruitful and multiplied. As a

consequence, I feel the want to invoke the wrath of regret upon some of them, who represent all of them, and by way of an introduction we'll start with three who have written books that are emblematic of the malefic categories of the self-help ideology.

You're Dumb, I'm Smart

Dr. Laura Schlessinger is a witling who gives know-all advice by radio, as well as through books, which means she is a menace twice again. She shouts at and denigrates her listeners and readers, which means she should have neither. She's a moralist, a stiff spine, a hanging judge, a smell fungus, a censor, a hall monitor, and, naturally, in a society where so many will pay people to beat them with straps, she is also largely popular and wealthy. I'll get to hypocritical in a jiffy.

In one of her books, *Ten Stupid Things Women Do to Mess Up Their Lives,* which she dedicates to her husband, poor man, and to her son, who she hopes will grow up to be as perfect as herself, Schlessinger recites an itemization remarkable for its evasion of ken or originality:

One. *Women have stupid attachments to men they need for identity.*
Two. *Women beg for stupid courtships.*
Three. *Women tie themselves down in stupid devotion.*
Four. *Women allow themselves to be stupidly passionate.*
Five. *Women permit stupid cohabitation, thinking men will eventually want them.*
Six. *Women have stupid expectations, using marriage for self-esteem.*
Seven. *Women use stupid conception to get to love and commitment.*
Eight. *Women allow themselves and their conceived to be stupidly subjugated.*
Nine. *Women let themselves be stupid wimps.*
Ten. *Women stupidly forgive, in attempts to maintain relationships.*

This list makes one happy that men are running things. But only if the author knows her stuff. She doesn't. She knows how to parrot, how to shriek, how to twist her worry beads, but in her concern for the problems of women, she has been educated by romance novels. Sure, women can hook into poor fish. Sure, they can attend the wrong fellows. And? And? What's the interpretation for the gals? It says merely that they are human beings. The list could as fairly be applied to guys, common as it is; and if it were, *everyone* would be Schlessingeristically stupid.

But being human is not being dumb. Dr. Laura's roll curses people for being people. There may be three or four women who have met and married Phillip B. Perfect on the first try. Everyone else has had to conduct chancy experiments. This is how it must be. Birds do not fly the first time they try their wings. There is nothing to lose, and everything to gain, from "stupid" attachments and courtships. Even an unworthy subjugation in the winter can bear a promising bud in the spring; try it—even if you don't like it, you'll be better for it.

Laura Schlessinger is herein typical in the fix-it-up field. She sees clouds and calls it rain. She thus exposes the business for what it is: opportunism. She tells people what's the matter with them so that she can then tell them how to repair the faults. The one strategy follows the other, and it does not matter if either is valid, not when people are gullible, not when the enterprising preach fear rather than fact, not when there is self-help money to be made from the madness.

In her particular, Schlessinger also exposes its hypocrisy. Beware of those who go too often to communion. This catechist has broken many of the rules she tells others to keep. In 1998, pictures of Schlessinger were posted on the Internet. She was in the altogether. The photos had been taken some years before by a man other than her husband. She was to be caught with her panties down in a stupid attachment with, in a stupid courtship with, and in stupid sub-

jugation to a pigmy so small he would reveal his private life to the universe and in that passion shame both himself and his courtesan.[2] One of the things to be said about this is that Mrs. S. used to have different color hair.

Another thing is that she looks better in clothes.

It occurs to me that I have had pictures of myself taken by women other than my wives. My hair is the same color, but I believe the circumstances qualify me, à la Laura, to publish items of my own about the problems of women. I will also print a list of men's problems in the last chapter of this book, but for now, "Ten Excusable Things Women Do to Mess Up Their Lives":

One. *They are born with better temperaments than men, and overreact when the outlook does not pair with reality.*

Two. *They are soft and furry, in spite of feminist protestations to the contrary, and spend too much mistaken time in the attempt to compensate.*

Three. *They believe in things like magic, dreams, and silver linings, and have difficulty coping when none of them work.*

Four. *They also believe in justice, a certain ticket to harsh disappointment on this planet.*

Five. *In their ceaseless endeavor to emulate men (a rare low aim for the ladies) they have a genius for adopting the worst of the male traits, such as arrogance and competitiveness, and why do women now scar themselves with ab enhancement?*

Six. *They think too much without using their imaginations, thus are easily trapped in cages of their own creation, cages that do not otherwise exist.*

2. In explanation, Schlessinger attempted the Bill Clinton Yaw: "I've undergone profound changes over the course of my life, the most important of which is my journey from basic atheism to an observant Jew." Not only is this sentence without grammatical consistency, it fails as explanation. Better to have said: "I'm not perfect. I will try to remember that from here on."

Seven. *They underwrite, and so contribute to, the false notion that (good) men care very much about locker-room ideas of glamour, and butt bounce, and fail in this regard to appreciate their own (usually special) physical qualities.*

Eight. *Unskilled optimists, they fly high when the sun shines, and crash in the storms.*

Nine. *They begin relations as affectionate companions, then become mothers, then become grandmothers, leaving affection and companionship to others.*

Ten. *They spend too much paralyzing time worrying about items one through eight.*

You're Dumb, I'm Smart, Because I'm Educated

M. Scott Peck is one of these suspects who use an initial for a first name. That notwithstanding, he has published one of the most successful self-help books of the modern period. Since 1978, *The Road Less Traveled* has sold more than five million copies, according to the publisher's accounting. And it's easy to see why. Not only does the book purport to show readers "how to embrace reality and achieve serenity" in their lives, it has the thumbprint of a man "educated at Harvard (B.A.) and Case Western Reserve (M.D.), [who is] currently Medical Director of the New Mitford Hospital Mental Health Clinic, and a psychiatrist in private practice."

Harvard.

The kind of thing that keeps them reading by evening lamp oil in Mayberry.

Peck uses his credentials to take believers on "the journey of spiritual growth." Did I say he also believes in "God's love"? In my paperback copy of his book the author takes up 311 pages to point out that: "Life is difficult" (page 1); "Life is a series of problems" (page 1),

"Discipline is the basic set of tools we require to solve life's problems" (page 1). Page 2 is all the more seismic, not to mention pages 3 through 310, and when he gets to page 311, he brings everything home, puts a lid on the corn bin, and gets down to his knees in the parlor:

"I sometimes tell [my patients] that the human race is in the midst of making an evolutionary leap. 'Whether or not we succeed in that leap,' I say to them, 'is your personal responsibility.' And mine. The universe, this stepping-stone, has been laid down to prepare a way for us. But we ourselves must step across it, one by one. Through grace we are helped not to stumble and through grace we know that we are being welcomed. What more can we ask?"

Amazing how it's all so simple. Everything is going to be okay. Everything's been fixed. If you can't see that, your psychiatrist can. And, glory: the world is an airport, we need only do those things necessary to purchase the tickets, and the destination is The Kingdom of Forever.

A skeptic would say this is spider spit.

But then M. Scott Peck went to Harvard. What do I know? If one has an M.D., a nice home, a fine job, and club memberships, one can be expected to assume that everything is great.

This does not mean M. Scott has had nothing but free throws. He speaks of the time he was playing a game of chess (what else?) with his daughter. He says he was trying to develop a closer relationship with her. But she wanted to go to bed, and so she asked him to hurry his moves, at which time he said, "No, goddammit"; then, realizing his goof, he burst into tears after his daughter conceded the game, and to make a long story short he was in agony a whole lot.

He also writes of the moment, as a mere child himself, that his parents packed him off to Phillips Exeter Academy, a place he describes as "a boy's preparatory school of the very highest reputation, to which my brother had gone before me. I knew that I was fortunate to be going there, because attendance at Exeter was part of a well-defined pattern that would lead to one of the best Ivy League colleges

and from there into the highest echelons of the Establishment, whose doors would be wide open to me on account of my education background. I felt extremely lucky to have been born the child of well-to-do parents who could afford 'the best education that money could buy,' and I had a great sense of security which came from being a part [of it]."

The trouble was, young M. Scott Peck did not like the academy. No. Not at all.

And he told his well-to-do mater and pater.

"But you can't quit," his pater said, "it's the best education money can buy."

"I know it's a good school," the sad lad replied, "but I'm not going back."

So, Peck continues, as if this happens to every troubled child, including those in the barrios: "My parents were understandably alarmed and took me forthwith to a psychiatrist, who stated that I was depressed and recommended a month's hospitalization, giving me a day to decide whether or not this was what I wanted. That night was the only time I ever considered suicide. Entering a psychiatric hospital seemed quite appropriate to me. I was, as the psychiatrist said, depressed. My brother had adjusted to Exeter; why couldn't I?"

The reader who by this time is not weakened by grief for the author might wonder about a kid who contemplated suicide for being a kid, about parents who would send a kid to a psychiatrist for being a kid, and about a psychiatrist who would give a kid a day to rid himself of depression by falling in line; but the author draws it to a conclusion before there is time for clear thinking. Peck writes that he decided to stay clear of the academy, notwithstanding the rub for himself, his parents, and the psychiatrist; instead, he took, he says, "my destiny into my own hands."

This is the kind of raw human penetration that has sold more than five million copies.

Book buyers, do what you wish. As for myself, I do not care to be advised by snobs. And not particularly by one so lacking in irony as author Peck. He was sent to a psychiatrist because he didn't like a school? The psychiatrist then determined that he had a mental problem that could be cured by liking school? And in the end he takes destiny into his own hands by becoming a psychiatrist himself? This professional swell fails to understand that a tense chess game with his daughter does not qualify as insight, that the destiny he took into his own hands was in fact the same elitist destiny offered by his parents, and that if he really had anything to say today, he would be a stevedore rather than a nutcracker who sentences children and others to "hospitalization."

You're Dumb, I'm Smart, Because I'm Successful

Og Mandino has a name that sounds of the days of Alley Oop. Alley made points by beating people over the head with a club. Og has done the same thing, all these years after, with repair-yourself publications such as *Og Mandino's University of Success,* subtitled: "The Greatest Self-Help Author in the World Presents the Ultimate Success Book," with an extremity to the subtitle that reads: "This Amazing Volume Contains a Complete Course on How to Succeed—Taught by Fifty World-Renowned Experts—And Will Advance You, Lesson by Lesson, into the World of Exceptional Achievement."

Reading the 520-page paperback requires a skull snaffle. The "exceptional achievement" would seem to be persuading fifty people of this sort—the likes of Lord Beaverbrook, J. Paul Getty, and W. Clement Stone—to contribute to the first self-improvement manual written by men (and a few women) who by and large could buy and sell the publisher. Getty was so rich his picture was on some of his currency. Stone could afford to acquire even presidents. Beaverbrook

might have repurchased America for Britain but didn't because it includes Georgia.

And what do these Bigstuffs tell the Littlestuffs about the pursuit of success? The time to get started on it is between the years eight and eighty, or else.

Getty, oil baron: "Anyone aspiring to succeed in the personal and vocational spheres of existence must constantly weigh, measure, gauge, and evaluate what can—and cannot—be accomplished under the circumstances that prevail and the resources that are available. In brief, it is essential to separate the wheat of the possible from the chaff of the impossible in both spheres."

Stone, insurance tycoon: "Whoever you may be: executive, lawyer, doctor, teacher, sales manager, superintendent, foreman, athletic coach, priest, or rabbi, you will have many struggles and battles of importance in influencing others . . . achieving your desirable goals and . . . eliminating your undesirable habits. You will win or lose depending upon your willingness to pay the price to engage in thinking and planning time and . . . to use your mind power [for positive purpose]."

Beaverbrook, publisher and industrialist: "There is one attitude against which I warn the person who would do well in life. It is summed up in the phrase: 'Trust to luck.' No attitude is more hostile to success, and no phrase more foolish . . . because in a universe governed by the law of cause and effect, strictly speaking, there can be no such thing as luck. . . . Most 'good luck' can be explained by industry and judgment, most 'bad luck' by a lack of these qualities."

That's it, course completed. Where do you want us to send the diploma?

But wait, Og Mandino himself provides commencement. Go forth from his university, he says in the book; you should not "crawl into [a] little corner of self pity and just let the world pass you by."

This is crumb-bum stuff, certainly. It cannot be otherwise. The rules of success do not exist, outside common sense, which does not always work; great men can tell us little more.

Except W.C. Fields: "Start off every day with a smile, and get it over with."

Readers, I've already lied to you. I said I would illustrate three authors who write of subjects that enjoy major self-help constituencies. Make it four. The fourth is for the minors.

You're Dumb, I'm Smart, You're Also a Slob

If M. Scott Peck was a cosmic force, he would be classified as a constellation. Ronni Eisenberg would be a red dwarf. Eisenberg is the author of *Organize Yourself;* she may be too disorganized to do the book alone, so she has a coauthor, Kate Kelly. Even together they are faint objects in the book-publishing skies. Millions of people are aching to achieve personal growth; fewer care much about folding the socks in the drawer; this is the self-help pecking order that proves that even a dropout from Phillips Exeter Academy can count royalties.

Eisenberg did not go to Harvard either. So rather than philosophy, she believes in practicality. She can be tough. She says procrastination is no darn good; she sniffs at ovens left mucked with the pie burnings; and she does not believe you will ever receive a Kennedy Center Honor if you cannot get to work on time. And yet, what? Her book was quickly remaindered.

It's unfair. Plus, she is so right. Consider those among us who are tardy on the job. Say it's a bad securities day. You have 100,000 shares in Phillips Academy, and it's fallen below sell. Where is your broker? Late as usual. Your equity ratio is on the line, not to mention your index plan, and he's still stumbling around in his oven trying to pry a muffin loose from the pie burnings.

Eisenberg spells it out. If you want to get to the office at nine, for example, you must get out of the house before nine. Don't wait too

long to get ready, she goes on, and clinches the suggestion with an enormous hint: Lay Out Your Clothes the Night Before! See? You don't have to be a psychiatrist to be helpful. Wait until you see how to hang stuff in your closets.

Afterword: The New Testament does not mention it, but Norman Vincent Peale may have been in attendance at Calgary. He was the one wearing bells on his cap, telling everyone to be happy.

Peale did not invent optimism, nor was he ever tried and convicted of selling elixir lineament, but he was the founding father of the modern self-help hippodrome. He may have never read Thomas More—indeed, his writings suggest he never read anyone—yet he became famous and wealthy for fingering the twentieth-century social dysfunction that prevented a better habitat: gloom. Peale said pessimism was no good, my friends. He suggested instead: positive thinking.

It was as if the dawn broke at midnight. Peale said a smile and shoe leather would get Willie Loman farther than shoe leather alone. He started a motivational organization, he wrote a syndicated newspaper column, he had regular radio and television shows, and several of the books he wrote, including *The Power of Positive Thinking,* are still in print, still selling briskly.

And it is difficult to argue with his premise. Good thoughts *are* more healthy than bad. Peace *is* easier than war. And it's better to be employed than it is to be out of work. It could be said in passing that when you expect the worst, it doesn't hurt so much when it happens; and that you can't know the difference between up and down if you stay on only one of the levels; but, okay, these are evasive arguments, and, realistically, there is only a wee little power in negative thinking.

Still, Peale's pronouncements can be faulted, if only because they resemble in content the poop of all popular self-help inspirations.

They are prodigiously ordinary. Peale did what most repair writers do. He told us what we already knew. He would tell his constituents to "give life all you've got"; the constituents would reply, "that's absolutely right." Peale would deliver page after page of other well-known homilies, the constituents would be amazed at how much they had in common with the author, and bonds of support and admiration would be forged.

Take a look:[3]

- "It's always too soon to quit."
- "All the resources you need are in your head."
- "What are you afraid of? Forget it."
- "Use upbeat words. Never talk down."
- "Plugging away will save the day."
- "Keep on keeping on."
- "Only alive people have problems. The more you have the more alive you are."

All of this dates back to the wall drawings of the cavemen. What child exists who does not understand the advantages of taking as many swings as allowed at the ball? I think there is always a time to give up, for example, if only strategically. And I avoid people who are cavalier about eventualities, as if they were always something merely to be removed, like soiled shirts; one can't "forget" the fear of hunger, disease, war, ruin, or the dying of a comrade, unless one would counsel being chipper in Pilate's Jerusalem.

3. From *You Can If You Think You Can*, published first in the 1970s. It's worth mention that Peale was at one time criticized by organized religion for his views, and he was also criticized for some of his political pronunciation (he said John Kennedy, as a Catholic president, would owe his allegiance to Rome). If you think about it positively, you can't please everyone.

Likewise, we question the tiresome, timeworn, and cuddly coupling of life and problems. Peale, like most lowbrow Ciceros, waded in shallow water, writing for readers whose problems revolved around finding success, being liked, having influence. He skipped the big bricks. Most commercially motivated self-betterment ringmasters skip the big bricks. A man who has, say, lost his family in a fire cannot be exhilarated, much less comforted, by his continued existence, by the temerity of the argument that he would not be privileged to feel so bad if he'd been killed as well.

Other than this, right, a pom-pom shake for Pealean optimism.

But tell us something we've not been told, Norman; you too, Rudy and Nido.

Like: Rhetoric has not once turned a stumbling block into a stepping-stone.

Afterword number two: Regarding whatever benefits there are in pessimism, I believe it can at least be cleansing. When you hit bottom, it can be salubrious to dwell there for a time, look at it, get afraid of it, so that you are reminded of what it is that you want to avoid.

I do this with genius born of repetition. When I fall, which is often, I get back up, but not until I've felt thoroughly sorry for myself, and beat the horse that dropped me. Misery has some short-term merit. And though it is sometimes difficult to be a son of a bitch, or shift blame, I maintain a strong will. So I walk in the wilds of my (modest) tree farm, I curse the circumstances of my disposition, I blame everyone but myself, which is iconoclastic therapy, and I invent melancholic, cathartic poetry, the lines of which will appear at milestones throughout this critique.

> *I write from Bleak Street,*
> *Under the lamp post,*
> *Where hideous truth is illuminated.*

Where the garbage is not collected,
And the air is sick with the odor
Of people who are worried
Of being consumed.

Where the pushcarts sell poison,
And the structures are collapsing,
And traffic moves through intersections
To scatter prayers.

Where the day is full of fighting,
And there is tension over the night,
And money will buy anything,
Except escape.

I write of the human mind,
And its untidy home,
And of my inability to assign respect
To urban renewal.

Afterword number three: This being written at my tree farm, close by Charlottesville, Virginia, passing reference should be made to Thomas Jefferson, one of the founding fathers of self-helpism.

TJ was the first person in the nation to be this-and-that-and-everything. He was likewise the most knowable and unknowable of the revolutionary illuminaries. He was a reluctant yet lifelong politico, he was a modest man who delegated no credit for constructing the Declaration of Independence (he said others who worked on the document ruined it with editing),[4] and his remarkable presidency was

4. One change. The Continental Congress deleted Jefferson's condemnatory reference to King George's support of slavery. Tom was, all his life, a slaver of droll humor.

in substantial respects unsuccessful. He was rightly considered an "Apostle of Americanism" and wrongly thought of as a "howling atheist"; he put forward individual liberty from the Atlantic to the Pacific and shackled his own black people; he preached small government and doubled the size of the nation with the Louisiana Purchase. What a fellow. What energy, what brilliance, what production, what history, what—in selected events—evilness.

And what balls. Tom, as others of his rank, had an urging in his character that referred to a superiority over others regarding comportment. He knew everything. He suspected others did not. He was like Dr. Laura in this respect. He was employed in the pursuit of moralistic fix-it-up:

- "Love your neighbor as yourself, and your country more than yourself."
- "Never buy what you do not want because it is cheap; it will be dear to you."
- "Pride costs us more than hunger, thirst and cold."
- "We never repent of having eaten too little."
- "Nothing is troublesome that we do willingly."
- "When angry count ten; if very angry, an hundred."

And like Schlessinger, he could be hypocritical. He would advise A and perform B. He was not frugal, but wasteful, not modest but egotistic; in some respects, he was also immoral.

The slavery was most immoral. Jefferson knew that buying people was a savage ritual, but he participated anyway. In this regard he was a much more contemptible brute than the plantation oafs who had no intellectual grounding. Friendly historians have tried to explain away this cruelty in TJ's nature. The true explanation is as cruel as the cruelty itself. He was, as were all those who took part in the human auction, interested more in self-interest than in self-assessment. He used one bond servant, Sally Hemings, for bedtime calisthenics; he

used all of the others to build his monuments. Without slaves, Jefferson would have had to get regular work, to do for himself, to sweat; without slaves, he could not have been Tom Jefferson.

The piquant Jefferson legacy, in this recall, is the result of one liberated mind and hundreds of chained men and women. Said in a more wickedly ironic way, slavery made it possible for Jefferson to leave this nation a better soul than his own, a soul that is more moral than moralizing.

Afterword number four: Way down here, I should make the first of what will be several cowardly disclaimers in association with this critique. I recognize that there are sound advisories and good intentions in many—at least two or three—self-improvement works. Likewise, I concede that some few fuzzies might profit from reading, or listening to, or taking rubbings from the likes of John Bradshaw, or, hup-one, hup-two, Rudy Ruettiger. Clearly, many people are hungry for "answers" they are not receiving elsewhere (in the churches and in the temples), and thus perhaps John and Rudy are at least as credible as our reverends and rabbis.

Then why am I complaining? My purpose is not denial, but perspicacity. I wish people to think for themselves, not as they are instructed by others, so they can bed the flowers of their efforts in the soil of understanding rather than propaganda. If you tell me that you are going to start collecting white stones, I will tell you that white stones are of no value, and you will tell me that white stones are beautiful and are of value to you. Both of us are correct. That's understanding. That's individuality. That's self-reliance instead of self-help. Keep it in mind as you leaf through this inadequate if full-blooded offertory.

CHAPTER TWO

Relationships

🦢 🦢

I know a hummock
Where the ibis gather
To exchange news,
And sleep.
They have one another

I watch them,
At night,
Fragile white notes in a dark tune,
With envy.
I am alone.

Sonya Friedman looks out from the dust jackets of her books, too cute by half, which is appropriate under the circumstances, because the books are similarly ornamented. This is a woman with no floor to her depths, who writes material with titles such as *Men Are Just Desserts* and *A Hero Is More Than a Sandwich* and—ye gods and little fishes—*Smart Cookies Don't Crumble.* With the human mind capable of this kind of mimicry, it's no wonder we have droughts.

Friedman is listed in the jacket apologies as a psychologist, a person who makes a living, as lawyers make a living, from human imperfection; besides this, she is a talk program host, which puts her down there with the likes of Homely Don Imus, and other klaxons, skin rashes, and public toothaches. The subtitle for *Just Desserts* is

"How to Give Up Junk Food Love and Find a Naturally Sweet Man."
To now, I have always been against book burning.

Friedman's specialty is relationships. She thinks they are all right,
providing they are conducted according to the rules she compiles on
page after page of gullibly orthodox advice. "I've discovered some-
thing true," she writes at the end of the introduction to *Smart Cook-
ies*. "You have control over three things—what you think, what you
say and how you behave." This is the stuff of doctorates in psychol-
ogy, and talk shows, also the first day at the day-care center.

Here's more:

- "Let go of the need to tend others to the exclusion of your own
 development."
- "If we expect too much, we encourage limitations, not expan-
 siveness."
- "Start now to free yourself from dissatisfactions."
- "Not every put down need [*sic*] to be taken seriously."
- "Every good lover isn't necessarily a good person to love."

The insight is underwhelming. And yet Dr. Friedman knows. She
knows that real psychologists spend years writing brilliant academic
books that fetch $5,000 advances from university publishers, who sell
four thousand copies (when the stars align correctly), while backyard
brainmeisters can market fuzzy-wuzzy self-improvement treatises on
television or in bookstores for the equivalent of the Mexican GNP.
Further, Friedman also understands the fundamental reason for the
difference; real psychologists do not offer promise in their books, only
insight; they do not provide sutras for behavioral perfectibility, for
there are none. Sonya knows that Americans will not spend money
on the truth, for cob's sake, when platitudes are easier to digest, and
when the television and publishing marketeers share their sentiment.

She has therefore mastered the necessary distinction: simplifica-
tion. She crams her books with black and white, in this way yielding

to yellow. *Smart Cookies,* for one, has some two hundred pages, all of them cowardly. There are the requisite ticketing of "myths," in this case called "traps," that women should avoid ("I'm too old, it's too late anyway."); there are the lamebrain promises of new life for old ("The best is yet to be. You can be reborn every day."); and there are the artful "case studies" that make the point the author is making before she makes it.

Take Jane and Ben as a case study of a Friedman case study. "Consider Jane," as she puts it, frankly, "who tells me of her disappointments in life." The author says Jane, who is married to Ben, a medical-school dropout, is debating whether she will become a doctor herself, and swiftly encounters stonewall jealousy from Ben, who has become merely a high school teacher and wants to know who is going to do the cooking and care for the twins. Writes Friedman: "Jane swallows Ben's reminders of her wifely duties. His scornful response is nothing compared to the emotional tempest boiling inside her. . . . Jane is conducting serious debates within herself."

Why is it that the case studies in self-improvement books always involve highly educated people? Where are the Stanleys and Stellas? In any event, the scholarship to learn from all of this is, drum roll: Be Yourself. You heard it right. If you want to be a brain surgeon, honey, grab hold. As for Ben, he should rot in hell, or in high school curriculum, for trying to manipulate the missus.

Needless to say, "Be yourself" is information contained from birth in the cells of all animals including Atlantic sprat. Still, the penetrating Dr. Sonya Friedman is a princess of the personal development industry. To validate her standing, there are three testimonials to her singular wisdom on the *Cookie* dust jacket alone. Says Mary Ellen Pinkham: "If you're a smart cookie, you'll buy this book." Says Dr. Dan Kiley: "Sonya has cooked up some four-star survival recipes for today's woman." And says Dr. Spencer Johnson: "[She] shows women how they can have a better life."

And who are Pinkham, Kiley, and Johnson?

They are the writers, respectively, of *Mary Ellen's Best of Helpful Hints, The Peter Pan Syndrome,* and *The One-Minute Manager.*
Yup, fellow self-helpers. You praise my book, I'll praise yours. Isn't publishing great?
Ah, Sonya, cute person. We've said some unkind things. We don't regret them, but we concede that you are merely a small nuisance in a business that manufactures giants of your species. The late Leo Buscaglia springs revoltingly to mind.[1] Loving Leo, who, one might say, wanted fame and fortune in the worst way and got it.
Sonya Friedman at least adheres to the self-help writing principle of making people feel guilty of something. Leo Buscaglia was never so indecorous. He became popular in the way that Art Linkletter became popular, by revealing nothing except butterfly kisses. Recall Linkletter's wildly funny and interplanetarily famous feature, "Kids Say the Darndest Things." The kids in his television program, and in his subsequent books, were of course prompted to say whatever Linkletter believed his constituency wanted to hear (or so it seemed to me and everyone else I know), and it went down like jelly in summer.
Buscaglia authored such things as *Love; Love Cookbook; Bus 9 to Paradise;* and *The Fall of Freddy the Leaf.* If Friedman is cute, Buscaglia

1. Buscaglia died in 1998, at seventy-four years of age. The Associated Press obituary noted that "the bearded, teddy-bear apostle of love who customarily ended motivational speeches by giving everyone in the audience a hug," wrote more than a dozen books that sold more than thirteen million copies in twenty languages. Among them were *Loving Each Other* and *Living, Loving and Learning.* At one time, five of his books were on the *New York Times* best-seller list. Buscaglia died of a heart attack, ironically, and no doubt is now hugging Moses, who also has a beard but reads no books except his own ("And Enos lived after he begat Cainan eight hundred and fifteen years, and begat sons and daughters: And all the days of Enos were nine hundred and five years: and he died. And Cainan lived seventy years, and begat Mahalaleel: And Cainan lived after he begat Mahalaleel eight hundred and forty years, and begat . . ." Great stuff).

was preparing for sainthood. He was a Jiminy Dickens break-no-bones. He believed in God, good deeds, warm rain, Boy Scouts, hot cross buns, the Great Pumpkin, and Tinker Bell. Everything is straight arrow and birdsong in Leo's books. He never encountered a pessimism. Life for him was pecan pie on Thanksgiving.

When he got mad, if only slightly, at things such as the propensity of human beings to hate one another for the skimpiest of reasons, he passed it over gently; then he would talk of love as an alternative, as if nobody had thought of it before, saying something powerful, like: "I believe that we are all searching for something that will make existence more meaningful." What a guy.

In *Bus 9*, Buscaglia, a professor of education, wrote about such beatifications as Joy and Giving and A Better World in takes of two pages apiece, sometimes three when he really got involved. He addressed questions that have confounded the largest and smallest minds in history; questions of the purpose of existence; questions of the duties to self and others; questions to which there have never been any answers except many answers, almost all of which are so contradictory as to evidence an absence of meaning.

And each of Mr. B's sage reflection is to formula. Start with a timeworn example, add a couple of dance-a-jig paragraphs, and finish with an inoffensive message lifted from the Dick and Jane standard of literature.

To illustrate. In two pages concerned with life's passions (*two* pages, maybe six hundred words; this is as much as self-fix-it readers can absorb at a sitting), Buscaglia started with this: "There are those many very scholarly people who say that the unicorn is a mythical animal and never existed." From that badly worded revelation he skipped to painfully brief notations on the idea that belief in the spirit of the unicorn is on the same street as belief in the spirit of man. He ended his ten-paragraph dissertation with: "I am still finding unicorns. I know they are not extinct. They are to be found anywhere. By the way, if you know of any, would you please let me know?"

This is the straight stuff. This is Buscaglia on a roll. This is "Babblitive and Scribblitive," as Robert Southy might say again. More people have purchased Leo's books than live in Texas; the numbers must be bracing to producers who rerun the Ernest movies for rugrats on Saturday A.M. Self-help books and television have much in common: emptiness, and audiences.

"Sometimes I stretch out on the floor of my office (for a nap)," wrote Leo.

"If we make time for play, it can change our lives," wrote Leo.

"If we must begin at square one, then so be it," wrote Leo.

Rejoice! Happiness is easy, as is love, and everything else; better, they are each simple.

Why do people purchase and read this oatmeal? Only Moses knows, and he's not saying nothing. My guess is that human beings do not want to think of life, or its components, as nasty, fattening, and short; therefore, they opt for philosophic veneering. We cannot bear to cope with the hearsay that this is it, there's nothing else, and that living is dominated by hard labor and wretched disappointments; therefore, we listen to the contrary, authoritative voices that are hopeful and soothing, and we set apart the grave rumor that it matters not in the end.

So, getting old? Leo Buscaglia said the numbers are "meaningless." Helpless? Cute Sonya says without equivocation that "you have the *right* to personal power." Lonely in the morning? Read Loving Leo: "To conquer loneliness we shall each have to assume the sacred responsibility of becoming a complete person. And most of all, to define ourselves without always including someone else in the definition."

Let me say, softly, that if you are aging, helpless, and lonely, these cited couplets are not solutions, they are emotional peculations, and, from where I stand—with feet always in danger of turning to clay— if you read them, and believe in them, you will still be aging, helpless, and lonely.

Old age is not meaningless, Buscaglia, wherever you are—it's immensely difficult.

No one has a right to personal power, Friedman; opportunities, maybe.

And loneliness has little to do with belief in ourselves; strong men and women die without pity because they do not have a hand to hold, a face to kiss, or a call on the answering machine.

Now I suppose I am approaching the personal. I'm reluctant to do so, but it's a requirement in this sort of scholarly endeavor, that of wanting to peddle a book. I think I know as much about relationships as Sonya and Leo, and more than Sonya about aging, helplessness, and being alone. I have turned sixty, I have had failed relationships all over the globe, and I have been so lonely on occasion, often helpless to do much more than object to it, that I've developed survival habits that include conversations with myself. I can be erudite when I talk to me, and of course I have to listen, though I can interject arguments—that is, if slumber does not get me first.

> *There is a glow on the eventide*
> *That promises an end to the rain,*
> *The mariners say.*

> *But it does not end,*
> *Where there is no one,*
> *To share the change*

When I take over the world, soon now, I will counsel one and all to check the urge to beg advice from someone like Leo Buscaglia. If one cannot intellectualize his own restructuring, if one cannot rise up from his own personal foundation, the construction will continue to be weak. Leo's views offer secondhand paste for the materials of living that in fact require the nails we forge from our own experience, from our own journey, from our own definitions of possibility.

33

Self-reliance, self-knowledge, and self-control are the best building blocks of sovereign success.

On the other hand, here follow two more examples of paste posing as nail architecture.

Negative Men

It is scarlet how men have treated women for the last ten thousand years. It is alabaster how the women have been able to keep going, and the reason they have is self-betterment books.

One of the books is *Nasty Men*. It is subtitled, "How to Stop Being Hurt by Them Without Stooping to Their Level." It makes one want to stand up and wave one's bandanna.

But wait, it ain't that all men are bad. The author of *Nasty Men* is a man. Jay Carter is a writer who lives somewhere in Wyomissing, Pennsylvania, far from where most nasty men reside, and besides being a man, he loves his wife, a woman who has been saved from the history of men, and he says of her in his publication: "I wish to thank my lovely wife, Sheila, for her support of my writing and in my life. A dozen red roses, and dinner." A man like Jay Carter takes some of the sting out of the scarlet way women have been treated for ten thousand years.

And then there is his dedication:

"To the butterflies who still hang out with the caterpillars."

It makes you want to stand up and wave your whip.

Jay says it's not just women who've been hurt by nasty men. It's "women *and* men." But, even though it's alabaster how some men have been able to keep going too, let's drop them. This book is chiefly about women as victims—those buttercups who have been beaten by a drunk, attacked with insinuations by a loudmouth, and reduced to depression by dysfunctional depressives. "What we are really talking about here," the author from Wyomissing writes, "is *invalidation*

34

[his italics]. An invalidator treats you a certain way for the express purpose of making you feel less capable or less important than you are. If someone invalidates you at the right time, and in the right way, it can make you a psychological cripple."

Author Carter does not wear gloves in the ring. He says some men are "Hitlers," which stands to reason in view of the fact that one was. He says their purpose is to "extract from you all your strength." He says the motivation of these people "is power or control or both." Both!

He says, moreover, that there are three different types of Hitlers. He says 20 percent of the male population are emotional Ribbentrops, pee-heads with no malicious intent; 10 percent have the habits of Rudolf Hess, with scant inherent criminality; and 1 percent is "evil," "selfish," and "has no conscience." Ladies, watch out especially for the last one; if you see a man walking a dog named Wolf, patting kids on the head, don't you goddamn believe him.

Still, one of the rats may sweep you off your feet. They've been doing it for ten thousand years. And in that case, Jay Carter says you should do what they do in Wyomissing: practice psychology, because it's better than stooping to a man's level—poisoning the Mellow Yellow—and it's legal.

- When he shouts, "What the hell are you doing?" don't cringe, say "shut up," or apologize; the better response is to say, "Are you angry about something? I am picking up the papers that you have left strewn across the floor." (That is, if he understands the word *strewn*.)
- If he criticizes your driving, don't turn the wheel over to him. The better response is: "If you have a problem with my driving, please don't joke about it. We can talk about it rationally later. It makes me nervous when you watch my driving. . . . Please be quiet so I can drive well."
- If he groans, "Is it that time of the month?" don't say, "Screw you," which, in the circumstance, is not applicable. The better response

is: "If you are truly concerned with how I feel, I appreciate it. I feel fine. Now, what were we saying?" (We were talking about orgies.)

And yet, author Carter does not want you merely to be so rational in all this that you will be strewn around the floor by the fellow's retorts. He wants you to be tough; don't settle.

Here, writes Carter, is how a woman might confront her husband about lying:

> SHE: I want to talk with you about something serious.
>
> HE: What?
>
> SHE: Last Friday you told me you had to work overtime, and you came home with beer on your breath.
>
> HE: I was working with some of the guys, and we stopped for a beer after.
>
> SHE: I know what you did. You went to a go-go dancer club.
>
> HE: (Sheepishly) I didn't want to tell you, and hurt your feelings.
>
> SHE: (Angrily) I want you to know that lying to me is a very serious matter. If I can't believe you, I can't trust you.
>
> HE: I'm sorry. It won't happen again.
>
> SHE: You are going to have to convince me it won't happen again. I want to know what you are going to do about it. I really need to know what you are going to do about it.

Jay Carter does not tell us what the man with the beer on his breath can "do about it." It seems fair that an apology should be sufficient for a crime not subject to a stretch at Attica. We know that Adolf, if met in this way by an angry spouse, would at least have withheld Wolf's Kibbles & Bits, but there are other men who would just go out and get drunk again at the go-go.

Carter, the traitor, is right: There are nasty men.

And?

If 31 percent of the male tribe is really so bad (which it isn't), and women deal with those men with psychology (they are not that dumb), things will soon not even be safe in Wyomissing.

Negative Women

Celibate Wives is a book written by two gals who may have edited Jay Carter's *Nasty Men*. Joan Avna and Diana Waltz say they have not slept with their husbands for years and are the better for it. They do not necessarily recommend it, but they believe they are in solidarity with millions of others who are frigid, or cannot get it on, in chaste marriages. No doubt.

Listen to one woman the authors interviewed during research: "When he was picked up for being a Peeping Tom, I felt disgusted, humiliated, and betrayed. I stifled my rage and didn't let him touch me for a year."

The guy looks in one wrong window, and pop.

Yet we know no more about him. The authors are mum. When his wife threw him out of the bedroom, we assume, the only thing he could do was to go back to the windows.

But let's be serious. Celibacy is not a laughing matter anywhere but St. Peter's Cathedral. "The last time we made love," says Joan Rivers, "he used chalk to make an outline of my body."

The authors say half of the people involved in celibate marriages are men, and half are women. This is like: Fifty percent of the men cheat on their wives in America; the rest do it in Europe.

The authors say some people stop screwing because they want to make a commitment to God. God may not then let them in heaven, of course, for ruining the lives of their spouses.

But let's be serious. Avna and Waltz say essentially that if we can accept Brian Cook, we can accept anything. A lot of marriages have driven people to sex.

The authors say that if your husband or wife has done something to make you turn it off ("Whenever we get close, he pulls away"), all is not necessarily tout fini. They do not actually counsel selling yourself into the sex slave trade, but, on page 56, they provide a realistic alternative, which, when all the fancy correlations are removed, they call Pillow Pounding:

"Look around your house for a small throw pillow, or buy an inexpensive one. In your mind give this pillow your husband's name. When you are expressing your anger at your husband, you will talk to 'him,' the pillow. One woman we know splashed her husband's aftershave on the pillow to make the effect more realistic. . . . As you feel the anger energy building within you, give yourself permission to let it come out. Feel free to hit or slap the pillow, beat it against something, stomp on it, or throw it at a wall across the room. Curse the pillow and use any vile or filthy words that come to your mind— they are helpful in expressing anger."

And they talk about nasty *men*?

But let's be serious. The authors say if you don't want to have any fun, you don't have to. That's what United States democracy is all about. Well, it's not in the Constitution, exactly.

With relation to the foregoing, a P.S. If ten billion dogs chew on ten billion bones, one of them will carve a statue with its teeth. When one million counselors write one million self-help publications, some of the advice will have meaning. I'm referring now to the general theme in *Divorce Busting,* a work by a relationshipper named Michele Weiner-Davis who promotes what she labels "solution-oriented therapy." She writes: "Couples [should] learn to identify what they do differently when they are getting along, so they can do more of it." Voilà, she goes on: if there is bliss in holding hands at the movies, or walks in the hills, or reading together in front of the fire, do it often, and set aside the negatives until mutual sentiments have softened.

All right, the advice provides no nuclear detonation. Nor is the argument something brand-new (accentuating the positive is one of the best and the oldest diplomacies). Yet the author's thesis leads to pondering. If couples can focus on agreeable matters, some fat in their union might be turned into muscle, and better health could follow. Weiner-Davis says it works even when practiced by one side of a relationship, without the knowledge of the other side, because the magic is to get back on the same side of the road, where everyone travels in the same direction.

One wishes Weiner-Davis would have retired her word processor after presenting this fine advice. But self-improvement writers have a lump-of-coal gift for stumbling off into the swamps. She goes on in her book to say flatly that "divorce is not the answer," which is a misstatement of the same kind as "divorce is always the answer." She also writes that students of solution-oriented therapy can expect results within a month, a promise almost certain to cause disappointment, anxiety, and relapse among the couples she wants to repair.

So it is in so much of the self-help literature. The inspiration is usually overestimated, the promise is usually broken. The writers divide all interaction into neat pots, then direct readers on how to recognize the one at the end of the rainbow. They insist there is a Mr. Right or a Miss Right for everyone, if only everyone has the eyes to read the fix-everything manuals, which manuals, as best I can make out, conclude that there are something like eight right women and six right men in this latitude.

Here, as further illustration of inspiration that jumps the track, I have a paperback entitled *How to Marry the Rich*. It has been published in part for people who have knowledge of the beheading punishments of divorce settlements. The book is written by Ginie Polo Sayles, cited as "America's foremost 'Marry Rich' consultant, as seen by millions on Oprah." Millions of whom? Ginie Polo Sayles neglects to reveal that anyone who turns on a television before dark does not have a chance in Amarillo of marrying anyone but Bubba Bonner.

At any rate, Ginie Polo Sayles has one of the most self-serving professional names since Cardinal Sin, the Catholic prelate of the Philippines. Yet if she knows enough not to appear in public as, say, Margie Swiggle, she lets us down regarding the snagging of wealth. Here is an author with her finger on nothing more revealing than what the British know as carfuffle.

She calls the prey "sugar daddies and sugar mommas." Veddy stylish. She suggests moving to where the rich live (if you can buy your own $800,000 condo in West Palm Beach). She says money hunters should walk quickly, or "revved-up," to belay the image of a commoner. She writes that flirting includes arching one's back to its highest point ("My god, my dear, I have never seen better posture; would you come with me on my sloop to the Cayman Islands?").

Best of all, Madam Sayles tells us where to find the *most vulnerable* rich. In newspaper obituaries, naturally. She explains that the dead have no further value in these matters, but they leave their gains to their *widows and widowers.* She says the obits may not note the financial condition of the widows and widowers, but there are "code words" that can be just as helpful. If the obituary says that the late Mrs. Jackson was married to Jack Jackson III, the roman numerals are suggestive. If the Jackson homes are listed in New York and Aspen, loosen your underwear. If one of the Jacksons founded Acme Enterprises, later sold to GMC, or graduated from Yale, or was a member of the Redwild Hunt & Country Club, take notes, devise a wedding-bells strategy, and think about butlers and briskets at Rio Rancho.

Ginie Polo Sayles. Remember the name. When she dies, someone will get her loot.

Then again, ladies, suppose you don't care if your next man is wealthy. All you want is someone with a gasoline credit card who can program the VCR. In this case you should not only avoid *How to Marry the Rich,* you should avoid *The Rules,* another self-help paint job. *The Rules* is a paperback authored by Ellen Fein and Sherrie

Schneider; the cover identifies the text as consisting of "Time-Tested Secrets for Capturing the Heart of Mr. Right"; there is nothing to identify Ms. Fein and Ms. Schneider, possibly because they are from another galaxy, a place far away that has formulated plans to weaken Earth by separating all of its men from its women.

The authors say there are thirty-five rules.

Below are seven of them, if the print ink has not faded in regret:

- Don't talk to a man first, or ask him to dance.
- Don't go Dutch on a date.
- Don't call him, and rarely return his calls.
- Don't accept Saturday night dates after Wednesdays.
- Stop dating if he doesn't buy you a romantic gift for your birthday.
- Don't live with a man (unmarried).
- Don't see him more than once or twice a week.

Not surprisingly, two of Fein and Schneider's rules have to do with absolutism. They warn the reader not to discuss *The Rules* with an analyst, and they add: "Do the rules even if your friends think they are crazy." In sum: "Trust No One But Us; But If You Remain Stuck on the Bus Without a Seat Partner, We Already Have Your Fare (the Book Purchase), Sucker."

Best to forget the names of Fein and Schneider. Neither writer can hit the potty.

Bear with me. I'm almost finished with this chapter. First, I must mention a weathered, well-thumbed book entitled *How to Read a Person Like a Book*. I forget, if I ever knew, who wrote the work, and I'm too "revved-up" at this point to care. But I remember that the thin volume represents the low-water level of the self-improvement industry, that of intellectual fraud. The writers say that if something walks like a duck, it's a duck. Groucho Marx put that theory to rest years ago. Nonetheless, fix-it readers will believe anything if it lacks complexity.

Hence, *How to Read a Person* insists that human beings can be understood by body language. If a man has folded arms, he is saying: keep away from me. If he sits with a leg over the arm of a chair, he is indicating indifference to his companion. If a woman crosses one leg with the other, and lets her foot bounce, she is bored. If she is rubbing an eye with a finger, she "can't see" your point. If someone tugs his ear, he wants to interrupt the conversation; when people hold their lapels, they think they are grand stuff; and if you rub the back of your neck, the authors here say that you are frustrated.

The authors, whoever they are, have apparently not seen Humphrey Bogart and Company trash all of these conclusions in *To Have and Have Not.* When Bogey tugs his ear, he's already butted in, and too bad for any creep with a beret. When Lauren Bacall lets her foot dangle, baby, it's something other than boredom. If the authors ever write a sequel (*How to Read a Book Like a Person*), they should admit that people cannot be effortlessly categorized; we are all disgustingly different; when I rub the back of my neck, for example, it's because it aches for the world in which self-improvement is so precious a desire that it can be invented by windbags.

Did I say I was almost finished with the chapter? I'm sorry, another digression. A man who goes by the name of Peter Trachtenberg has written a self-help book called *Casanova Complex,* which has to do with, quote, sex addiction. Trachtenberg believes that many men and women have relationships for the same emotional reason that winos drink Thunderbird from the bottle. He says he knows, because he himself was a, quote, sex addict. He hints that he had an exhausting time between the covers, and he is now a recovering, quote, crotch junkie.

Do not ask me if recovering sex addicts, like recovering winos, are destined never to taste the nectar again. In this consideration, though, it would serve Trachtenberg right. The self-help industry to which he is addicted prospers on human weakness. Therefore, the more weaknesses, the better, and it follows that if authors can be found to

tell us that we are communicating when we cross our legs, they can be found to insist that we may be, quote, sex addicts when we don't. I don't fully know about sexual codependency, of course. I'm not competent or well read regarding psychology. And I make a distinction in this circumstance from something like nymphomania. But I think sex addiction is, as a popular matter, something like chocolate addiction. It exists only and conveniently as a term. Some people like to dinkle. Some people like to dinkle a lot. Should we shake our fingers at either camp? Alternatively, should we shun the celibate? I put it to you that if we are going to sharpen these points into needles, then everyone who fucks, or does not fuck, can be said to be *addicted* to one behavior or the other.

Herewith a plea for reason. We should not demonize needs and preferences simply for reasons of shorthand. We are guilty enough of errors and woes unlimited, without forever updating the list. If one likes something, like sex, or Dove Bars, and if it satisfies, even if it may be personally harmful (divorce, high cholesterol), one will probably do it as often as one can. That's not addiction, necessarily, that's the craving for a little atom of relievo in a temporary world that is being made increasingly unsettling by those who find darkness in everything.

So, the end of the chapter. Let's give the wrap-up to Buscaglia: "We might learn a lesson from Snow White. She dreamed that someday her Prince would come. But in the meantime, in place of moping around, she had a good life with the Seven Dwarfs."

And: "So have you hugged your wife, husband, father, mother, child, grandmother, grandfather, mother-in-law, father-in-law, neighbor, coworker, priest, minister, psychologist, boss lately?"

What is this guy, a sex addict?

Afterword: Leo Buscaglia's jollity is, let's assume, genuine. Let's say too that he was in balance with a universe that many of the rest of us find cheerless. I admire him for that, if with a suspicion born

of experience. The second law of cynicism is that people, even the best of people, are never what they seem to be (the first law of cynicism is that all laws are squishy). Mohandas Gandhi, the great soul, said that he used to test his commitment to self-will by sleeping chaste with the young girls of his Indian commune, and though I think Gandhi was one of the five most attractive beings of the twentieth century (along with Roosevelt, Edison, Ray Charles, Churchill, George Burns, and Mother Teresa—I can't count), I don't for a wink in time think he refrained from a little rubby during this research project.[2]

I'm reminded too of Karl Menninger, another fine spirit, perhaps the most renowned psychologist of our period, and a brief, casual acquaintance of yours truly. Years ago, he read something he enjoyed in one of my newspaper columns; he wrote me, and we arranged to meet for dinner in Kansas City. We went to his private club there, a place of oiled oak and worn pedigrees, where a dropped spoon was cacophonic, and where we chatted very quietly about matters of Menninger's specialty, criminal conduct and cultures.

It was, I remember, quite boring, until the dessert arrived. I had cake, Dr. Karl had cherries, and suddenly he stopped talking, stopped any animation at all, and sat looking freeze-frame at his bowl of cherries. I asked him if anything was wrong. He said, "There's juice in the cherries." I said, what of it? —and he replied, now sternly, "I didn't order juice in my cherries."

Whereupon, Dr. Karl Menninger, a famed student of human behavior, a seasoned *galantuomo* who was venerated for his compassion and reason, stood up at the table, called the waiter, said loudly, "I will not eat wet cherries!"—and continued to stand there, almost blue in

2. Burns once said: "Retirement at sixty-five is ridiculous; when I was sixty-five, I still had pimples."

color, with every eye in the sanctum on him, until the damn things were towel dried, exchanged, or what have you.

We are merely tissue and blood, you must understand. Everything else is show.

And I don't think Buscaglia believed in unicorns at all; literary income, sure.

CHAPTER THREE

Sex

❦ ❦

Education,
Ignorance.
Growth,
Stagnation.
Fellowship,
Bigotry.
Love,
Hate.
Charity,
Parsimony.
Persistence,
Surrender.
Sex,
Sex.

I have learned the meaning of life.
It is never knowing it.

The most treasured of my meager possessions are those given to me
by the complement of friends I have known. I have on a shelf, for
example, a book written by Sanford Teller, a New York public re-
lations *zamorin,* a wit, and an out-from-the-closet correlative mu-
tualist, whom I've known if not well enough for more than thirty
years. The book is entitled *This Was Sex.* It's a first edition, and there

was never a second. Pity that, because the text reveals an education that should be taught as a university major. The discipline is that, as Dwight Eisenhower once observed, things are more like they are now than they ever were before, which may or may not be another way of saying: history is the father and laughter is the mother of enlightenment.

Teller wrote in the late 1970s, when the sexual revolution emerged into folly. He mentioned the proliferation of cinema attractions such as *High Rise;* the lucrative publication of books such as *Happy Hooker;* the street-corner marketing of plastic love partners with pulsating vaginas; the scientific interest in technology that increased the size of love muscles (peter pumps); and the growth of sexology, the Dr. Ruthian idea that talking about douching helps.

Helps, hell. Teller decided that, with all of this, fair dinkum ragging in America was on the decline. He said the orgasms were not keeping pace with the divorce rate. He suggested that the stiff price for novelty is not necessarily physical. He concluded that the hormonally challenged were trying too hard, that they had become uptight and troubled by the pressure to perform like Long Dong Silver, and that it was time to remember what our parents and grandparents taught us about things like fellatio and piss masks: go back to it to get on with it.

Teller advised that the manuals on sex had already been written. He said our forebears "laid down simple, easy-to-follow directions," because they lived in "a time when sex was what it should be"—that is: for right-thinking males and their vessels. Ergo, his book is a compilation of the patty-butt self-help stuff of the early century and the not-so-early century, advice from those who had an idea that men and women were different from each other.

Some samples:

Love in the man—Undoubtedly man has a much more intense sexual appetite than woman. He loves sensually and is influenced

47

in his choice by physical beauty. In accordance with the nature of this powerful impulse, he is aggressive and violent in his wooing.

Love in the woman—With a woman it is quite otherwise. If she is normally developed mentally, and well-bred, her sexual desire is small. If this were not so, the whole world would become a brothel and marriage and a family impossible.

It is certain that the man that avoids women and the woman that seeks men are abnormal.

—Joseph G. Richardson, M.D., Professor of Hygiene, University of Pennsylvania (assisted by seventeen other authorities), *Health and Longevity* (1909)

. . . Before my marriage I lived a perfectly continent life. During my university career my passions were very strong, sometimes almost uncontrollable, but I have the satisfaction of thinking I mastered them. It was, however, by great efforts. I obliged myself to take violent physical exertion. I was the best oar of my year, and when I felt [a] particularly strong sexual desire I sallied out to take my exercise. I was victorious always, and I never committed fornication. You see in what vigorous health I am: it was exercise that saved me.

—Professor Thomas Shannon, A.M., international lecturer, prolific author of books and articles on eugenics, 1914

We cannot find language sufficiently emphatic to express proper condemnation of one of the most popular forms of amusement indulged in at the present day in this country, under the guise of innocent association of the sexes. We have not the slightest hesitation in pronouncing flirtation pernicious in the extreme. It may be true, and undoubtedly is the case, that by far the greater share of the guilt of flirtation lies at the door of the female sex, but there do exist such detestable creatures as male flirts. In nine cases out of ten, he is a rake as well. The male flirt is a monster. Every man

ought to despise him; and every woman ought to spurn him as a loathsome social leper.

—J. H. Kellog, M.D., *Plain Facts for Old and Young* (1888)

As age advances, new laws gain the ascendency in the married life. In well regulated lives, the sexual passions become less and less imperious, diminishing gradually, until at an average age of 45 in the woman, and 55 in the man, they are but rarely awakened and seldom solicited. After the "change of life" with women, sexual congress while permissible, should be infrequent, no less for her sake than that of the husband, whose advancing years should warn him of the medical maxim: "Each time that he delivers himself to his indulgence, he casts a shovelful of earth upon his coffin."

—A physician (Nicholas Francis Conkel), *Satan in Society* (1876)

The physical effects of onanism:

1. The victim is subject to loss of spirit, weakness of memory, despondency and apathy.
2. Anaemia and facial acne are common.
3. There is a loss of manly bearing and proneness to blush.
4. The path leads to imbecility and premature senility.
5. The continence and demeanor stamp the onanist as an object of reasonable suspicion.
6. His genitals bear the marks of his degrading practice.
7. His digestion and heart action are disturbed, and he becomes a moody, apprehensive, hypochondriacal invalid, if not a gross pervert.

—James Foster Scott, M.D., former obstetrician to
Columbia Hospital for Women and Lying-in Asylum,
Washington, D.C., *The Sexual Instinct; Its Use and
Dangers as Affecting Heredity and Morals* (1898)

This perversion of a natural instinct [sexual dreams], and these sudden lapses from virtue which startle a small portion of the community, and afford a filthy kind of pleasure to the other part, are but the outgrowths of mental unchastity.

Filthy dreamers, before they are aware, become filthy in action. The thoughts mold the brain, as certainly as the brain molds the thoughts. Rapidly down the current of sensuality is swept the individual who yields his imagination to the contemplation of lascivious behavior himself. Before he knows his danger, he finds himself deep in the mire of concupiscence. He may preserve a fair exterior; but the deception cannot cleanse the slime from his putrid soul.

How many a church member carries under a garb of piety a soul filled with abominations, no human scrutiny can tell.

How many pulpits are filled by "whited sepulchers," only the Judgement will disclose.

—Kellog, *Plain Facts*

Okay, enough. Sandy Teller's book's instruction is that truth is often aligned only with time. Facts are fleeting, as everyone knows who was ordered by their mother to get plenty of sun and milk. When I was a boy we were told that one could determine if a girl had a social disease by putting earwax in her vagina; and that if one became too violent in coitus the dick would be trapped by (1) a defensive muscle, or (2) angry parent; and that the difference between Asian and American women did not have as much to do with vaginal obliques as with patriotism.

Without firm beliefs, it's said, man is helpless against the dragons.

And yet, what changes? André Maurois observed years ago that the well bred should keep absolute convictions out of their conversations, yet the outrage continues. We can grin at Paul, in Corinth, for saying that the only excuse for refusing sex in marriage is "devoting yourself to prayer," or at the later-learned conviction that orgasm

originates in the liver; but similar bile is promoted today in the self-improvement business, and, if history is prognostic, a Sanford Teller a hundred years hence will write a book of the crank sexual instructions of our era.

For one, catch this from *ESO, The New Promise of Pleasure for Couples in Love,* written by Alan and Donna Brauer, who must own a very strong set of mattress and springs:

> A realistic first goal for most couples [wanting longer sexual climaxes] would be to extend your orgasms to double or triple their present length. That may mean twenty seconds instead of ten. It may mean a full minute or even two. Once you've established that new level of experience, you might reasonably consider a more ambitious program of working toward five to ten minutes of continuous orgasm. From that level you might decide to work toward . . . a full half an hour . . . [or] an hour or more.

Did someone say God is dead?

The Brauers list themselves as medicos from, where else, California, who claim that Extended Sexual Orgasm training can transform wimps into wowzers. They write that while sexologists Masters and Johnson found that the average male climax lasts six to ten seconds, and the average female a couple of seconds longer, that is kid's stuff. They insist the bar can be raised for both sides until the grunts and galvanization last all the way through a *Seinfeld* rerun:

> ESO is not merely extended foreplay. It is not simply "multiple orgasm." Nor is it some ancient system of subtle spiritual discipline. At its ultimate level, for women, ESO is deep, continuous orgasm of ever-increasing arousal lasting thirty minutes to an hour or more. For men, ESO at its ultimate level is first-stage orgasm, that momentary peak of intense pleasure just before a man feels he is going to ejaculate, extended in time for thirty minutes to an

hour or more. There is hard erection and copious secretion of clear fluid.

And, additional behoovement, the authors write that the extension can be accomplished without a partner, thank you. Progress is a never-ending river. Self-help for self-stimulators:

> A man, for example, can work toward lasting longer [hand job], setting five minutes as a goal, then ten, then fifteen, until he can maintain himself at a high level of arousal, near the point of ejaculatory inevitability, for thirty minutes. He should practice "peaking" himself—stopping just short of ejaculation—many, many times. . . . A man should be able to peak himself at least fifteen to thirty times at a single session. He can experiment with different positions, different strokes [for different people, verrrry different people], different locations, different lubricants . . . [learning] to increase the number of contractions . . .
>
> As a woman you need to realize first of all that self-stimulation is good for you. It's not a substitute but a supplement. It's healthy. It feels good. It allows you to learn how you like to be pleasured so that you can teach your partner. Best of all, it adds to your orgasmic capacity. The more orgasms you experience, the more you can have. Every healthy female is potentially multiorgasmic and is potentially capable of learning to experience ESO. That's your birthright. Why shouldn't you claim it? . . . And the most reliable preparation for ESO is self-stimulation.

Surely, this is breakthrough science. Best, the Brauers make it seem like a constitutional guarantee. The book is a couple of hundred pages; it can be read, skimmed, in about the length of an extended orgasm; and it gets clean down to every damn thing, like lubrication: "Lubrication is absolutely essential for ESO. Delicate tissues can't be stroked for thirty minutes or an hour without the

protection of a good lubricant. . . . We recommend heavy-duty lubrication, either a commercial lubricant such as petrolatum . . . or the inexpensive mixture of mineral oil, paraffin, and petrolatum [the recipe appears on page 26]."

For those who do not have an hour to waste reading before getting to the hour of boom-boom, here, as an emergency service, is a synopsis of ESO: Select a nice place, mood the lighting, stock in supplies such as vibrators, cut your fingernails, take a bath, sample some wine and Mary Jane if that's your thing, leave anger at the door, understand the difference between a peter and pussy, talk about your feelings, trust your debaucher, do a little foreplay (not much, you have to get to work in the morning), take turns, control your thoughts, breath correctly, change positions, employ "the Double-Ring Stretch Stroke" (I refuse to say more), yabba dabba do.

And don't forget the heavy-duty paraffin.

What to make of all this thunder-clapping coup de théâtre? *First,* anybody who says orgasms can be extended for an hour should run for president; Bill Clinton has retired to stud, depending on what your definition of stud is. *Second,* yes, some improvements might be made on the Masters & Johnson average, just as progress might be made in what parochial-school health-class nurses refer to as "erecto et distentio privities." *Third,* even if an hour's worth of orgasm were possible (and it's not possible by reading this dry river of a book, or for most people under any circumstance short of a chemical fix), who needs it? The French refer to the orgasm as *la petite mort,* a little death. Tempt not, for Christ's sake.

Besides, shouldn't the women be up and about fairly quickly, to do the ironing?

But, still, something nice about the ESO book: at least it seems earnest. There are other self-help sex publications that are merely amusing. Which brings up *Talk Sexy to the One You Love* by Barbara Keesling, Ph.D. The subtitle on this small volume (invariably there are subtitles on self-improvement books, probably because publish-

ers think readers need all the rhetoric they can get) indicates that subscribers can "Drive Each Other Wild in Bed," and never mind why they would want to, unless they believe that reality is embodied in little league fix-everything publications, or that Nurse Higgins meant it when she talked about erecto et distentio of a foot or more.

Dr. Keesling is described in the *Talk Sexy* dust jacket as having taught human sexuality at, where else again, Pepperdine University, the one-time locker room for beach bums and beer-keg muppets. Her résumé also includes the book *How to Make Love All Night,* which puts her way beyond Phase II of ESO practice. She looks in her photograph as if she has a whole lot of hair.

Keesling's argument is that "naughty can be nice." Were she a better writer, and had she handled a cute subject in a cute way, she might have made a positive contribution. As it is, she isn't, she didn't, and the result is a belabored effort to turn a four-word phrase into sixteen chapters.

Comedic chapters.

Tiresome chapters.

"What about you?" she asks, as if this were a Rose Mary Rogers Talks With Nora Roberts quiz. "What's your story? Perhaps to the outside world, you're a politically correct career woman, a dressed-for-success sophisticate, or a mild-mannered mother of two. But that's not at all how you feel inside, is it? No, no, no. Inside you feel sexy, incredibly sexy. You feel hot and wild, maybe even dirty and outrageous. A vixen. A smoldering volcano waiting to erupt."

The author assures us that she has come to understand this inside info from talking "to thousands of people about their sex lives" and working "personally with hundreds and hundreds. Human sexuality is both my vocation and my passion. And if there is one thing I have seen make more of a difference in the sex lives of more people, it is the language of [sex in bed]."

No, no, no: not merely "I love you."

Instead:

"I love to look at your beautiful penis."

"You make me feel so hot."

"I want to feel your tongue between my thighs."

Keesling says there's nothing like it in this lifetime, for dressed-for-success smoldering volcanos waiting to erupt. But she says it without style, thus without persuasion. She says she knows women will be nervous at first, but not to be concerned, because the understanding author will "put the words in your mouth." Words that have been lifted from a paperback thesaurus: "kiss, lick, nibble, tease, screw, bite, touch, suck, play, eat, chew, push, pull, brush, taste, rub, grind, stick, jam, blow, squeeze, fondle, smell, caress, grab, hump, swallow, spank, drink, thrust."

Bite? Tell it to Marv Albert. Other than that, it sounds like nothing so much as a George Carlin monologue ("piss, shit, ass, cunt"), and it's an unsettling reminder of the one-syllable theme of *Everything I Know I Learned in Kindergarten.* Plus, whatever happened to: "relax"?

Yet Dr. Keesling believes crude has a ring to it. And therefore we are reminded of the bells of St. Mary as she lists the alternatives for throbbing rod: "Weiner, weepie, pee pee, hot dog, sausage, trouser snake, serpent, lizard, monster, lieutenant, colonel, sergeant, and captain."

Trouser snake? You are lying in bed. You are rubbing your fingers on your partner's shoulders. Suddenly, she says, "You make me feel so hot, let me see your trouser snake."

And where is Dr. Chideckel practicing these days?

What is more, the author says the words can be mastered only through exercise. That means they have to be set to paper and repeated again and again. Dr. Keesling tells readers, step by step, to be sure, as if they really were back in kindergarten: "Go into your bedroom, bathroom, home office, or other private, quiet, soundproof room, and lock the door behind you. Take out your notebook and open it to the first page [uh, start at the beginning, kids, not the end, ha ha ha]. Enter

today's date. Write down everything you see on Sample Page 1a, just as it appears in this book. Savor each sentence as you write it:

"YES, I want to talk sexy!

"YES, I need to talk sexy!

"YES, I'm ready to talk sexy!

"YES, I'm going to talk sexy!

"YES, YES, YES, YES, YES!" Not to be confused with: No, no, no.

Then write down all the words you can think of related to "private parts." Testicles, for instance, are also balls, scrotums, sacks, and, as the *Washington Post* once said in regard to a White House pet that was neutered, "family jewels." Buttocks are also the butt, the buns, the ass. Keesling provides a full cast of other parts, such as pubic hair, foreskin, nipples, and what have you, midway through the book, before readers are sufficiently familiar with advanced synonymity.

Finally, the author urges, go for it. Once you have no trouble calling semen by another name—pecker snot doesn't make it, people—Keesling believes you are ready to matriculate to: *sentencing*. Go to your bedroom, bathroom, home office, or other soundproof place, lock the door, take out your notebook, and write: "I love the way your (adj.) (noun) feels against my (adj.) (noun)." "I need to feel your (adj.) (noun) inside my (adj.) (noun)." "I have to (verb) your (noun)." "I want you to play with my (adj.) (noun)." "(Verb) me like a (adj.) (adj.) animal!"

I'm not inventing this. It's removed verbatim from the material of this near-death-experience book and reminds us of the validity of the James Russell Lowell opinion that, "In general those who have nothing to say contrive to spend the longest time in doing it."

But, what the (noun), let me see if I have it right to this point. When my (adj.) (noun) comes to my house tonight for popcorn and television, I had better damn well greet her with: "Hey, (adj.) (noun), you horny (noun), drop your (adj.) panties, so I can get a look at your (adj.) (noun). You see what I got here? It's an (adj.) trouser snake. So, (verb) me. If you (verb) me on the (adj.) (noun), I'll (verb) you on the (adj.)

(noun), or, lacking that, on the (adj.) (noun). I need to feel your (adj.) (noun) on my (adj.) (noun). And if we do it the (adj.) ESO way, we can (verb) each other's (adj.) (noun) until the petrolatum gives out."

George Carlin, meet Victor Borge.

But be careful, author Keesling adds with a warning label. Talking dirty is potent stuff. "Don't ask for the moon if you know that he can only deliver a few shining stars [the moon is bigger than the stars?]. If, for example, your partner tends to ejaculate fairly quickly during intercourse, you don't want to ask for 'an hour of great screwing.' If he is concerned about his erections, you don't want to tell him how badly you 'need it big and hard.'" And never—no, no, no—tell him, "Well, gawd, Leroy, that there is the (adj.) (adj.) (adj.) teeniest pee pee I ever seed."

That explained, the only other thing you need worry about is if your partner calls 911.

(Verb) you, Barbara.

I ask again, Is there no low tide in the self-help market? Some more bottom fishing:

- Dr. Joy Brown, in her book *Why They Don't Call When They Say They Will,* writes, "If all the differences between men and women could be boiled down to one issue, it would be the differences between sex and intimacy." Wrong. It all boils down to money, personal growth, the passage of time, younger women, men with better stock holdings, flab on the butt, sometimes freedom. Sex and intimacy cannot logically lead the parade, because that would mean that everybody has problems with sex and intimacy, and that everybody would know it, and no one would choose to end one relationship for another with the same limitations. Check?
- In *Singles Ask,* author Harold Ivan Smith asks: "Did Jesus have to deal with sexuality as an adult?" And because he once saw Jesus in the shower, presumably, he answers: "Jesus Christ, the son of God, had genitals. Jesus understood our sex drives and our longings. . . .

Christ must have struggled with his gnostics in sexuality, much as we do. But there is an important difference. Not only does his struggle make it possible for him to understand our struggle, but his resurrection makes it possible for everyone who trusts in him to have a share in his victory over sin." Rot. Beyond that, it says zero. If Jesus had a trouser snake, did he use it? did he have wet dreams? did he feel uncomfortable when he stood pants-over-ankles with others during the physical examination for military induction? Open up, Smith old scrivener, did the Boy Wonder ever get an erecto et distentio privities?—and, if so, did the health-class nurse at the parochial school snap it with a pencil?

- In *What Husbands Expect of Wives,* Brent Barlow says there are four levels of sexual love for women: psychological rape ("against my will"), duty and martyrdom ("I'll submit"), labor of love ("I owe it to him to submit"), and Love Freely Experienced ("Verb me in the noun, YES, YES, YES!"). That's it, four. Period. In *This Was Sex,* a medical doctor of the last century is quoted as determining that "the positions for copulation are six in number, as used by different races at different epochs. They are: man above, man below, standing, sitting, lateral, or side by side, from the rear." Six. Period. Tempus fugit; nuts then, nuts now.

- Don Dinkmeyer and John Carlson write in *Taking Time for Love,* which expresses not so much as a gram of a new thought: "Seek professional help when you and your spouse both refuse to listen to each other." My guess: forget it, work it out yourself, or break up. "Professionals" are merely people—they are as mystified by relationships as everyone else (except when they write books); they are as angry, as impotent, as divorced as the rest of us. Further, I present this 1998 news clip, out of Fresno, California (where else? once more): "A husband and wife pulled guns on each other and shot it out at church during a marriage counseling session. Both were wounded. With a beer in one hand and a gun in the other, Michael Martin shot his wife [and] a bleeding Bonnie Martin pulled

a pistol from her purse and shot her husband in the shoulder. 'It's a good thing that he had been drinking because he could have hit her more,' said the Rev. Bud Searcy [one of the counselors, by training rich with insight]. 'He was a lousy shot.'"

Professional help? No, no, no. The better approach would be to lighten up a tad. Sex is meant to be hilarious, not serious. If you can't grin while you grind, you don't get it. "There was a young woman of Croft," says the limerick, "who played with herself in a loft, having reasoned that candles, could never cause scandals, besides which they never go soft."

Or, if you insist on being deadpan, read Susan Jeffers's *Open Our Hearts to Men,* a self-help sex book that promises no extended orgasms, no dirty talk—only wholesome "trust and appreciation affirmations." Author Jeffers says women who can't make it with their partners, who are worried about the sweat and saliva involved, who are scared, who are nervous, who are apprehensive, who aren't flat interested in (adj.) (noun) conversations, and who are forever coming down with headaches after the eleven o'clock news, should repeat the following mantra:

"Men are terrific!

"I love men!

"Men are strong!

"Men are kind!

"Men are loving!

"Men are caring!

"I love men!

"Men are fine!

"Men are delicious!

"Men are faithful!

"I love men!"

Guaranteed. It may not make you wild in bed, but it will make you a liar.

Better yet, don't say anything, don't read anything. Be still. Go blind. The good fairy who gave us intimate emotions did not intend for them to be sullied by gabbing and paragraphing. You cannot have better sex if you say balls instead of scrotum, you cannot achieve longer orgasms by sorting through the literature of lubrications, you cannot satisfy yourself or your partner with endless communications, research, gimmickry, or forced faith. If talk and print made it better between the bedsheets, traffic would cease in this babbling world, for everyone would be home having Alan and Donna Brauer's round-the-clock orgasms. As it is, as Mr. Sanford Teller said in his flash-back book, fucking is not in any way getting better, it's just getting more publicity.

Like sex? Be grateful, undress, lie down, and practice. *Don't like sex?* Stop fussing, get another hobby—watercoloring can be rewarding—and quit wasting other people's time. *Undecided?* Undress, lie down, and so on, because even six to twelve seconds is worth the try (and, if it turns out like road kill, recall the lines of Thomas Gray: "Full many a flower is born to blush unseen, And waste its sweetness on the desert air").[1]

Whatever your preference, go to your room, lock the door, open your notebook, and write: "Many a small thing has been made larger by advertising. Samuel Clemens."

> *Beds are*
> *The last resting place*
> *For relationships*
> *Too concerned*
> *With*

1. Statistics indicate that as many as thirty million Americans may have problems with impotency. What's to say? Keep working on it, talk again with the parochial-school nurse, send your dimes and dollars to Viagra R&D, and think of it this way: statistics also indicate that those with less to live for often live longer that those with more.

Explanation
Or
Explanation.

Afterword: Speaking of Samuel Clemens, who never said anything with which I disagree, he once wrote, "Man is a museum of diseases; a home of impurities; he comes today and is gone tomorrow; he begins as dirt and departs as stench."

Well that Sam had other talents; he would never have made it as a sex counselor.

Yet this viewpoint is storied, as it's concerned with relationships. Human beings are ugly alone, and worse when coupled, what with all the commixing of dead skin and head lice. As the song says: "What do you get when you kiss a man? You get enough germs to catch pneumonia." Or, as animal scientists explain, dog drool is cleaner than the rub of a grown man's finger.

So it is that for this reason, and for other reasons, not a few have wondered of solutions, and not just more use of soap. Commentators and groups through history have sought to eliminate sex altogether, for themselves in most instances but, in other examples, for everyone.

Catholic priests are among the few who have succeeded with the purge, at least most of them, at least in an adult, heterosexual sense, at least publicly. The starvation of the Shaker Community illustrates the many other attempts that have failed to trade the smash-belly act for a philosophical purpose.

I remember doing a newspaper column about one of the last male Shakers in New England. I said, "Do you miss sex at all?" He said, "Yes."

I said, "What does that mean?"

"It means yes."

"Can you elaborate?"

"No."

"What does that mean?"

"It means no."

Today, like everything else, celibacy is a movement. Those who practice it are lyrical regarding the benefits. A yogi named Thomas, for example, writing on an Internet page, says this about what he calls the joy of celibacy, the life force to enlightenment: "Once one has started to go upwards as well as outwards in one's focus of energy then there can be no going back as a transformed and purified nervous system, for instance, cannot be de-sensitized, and spiritual revelations flowing from the opening of the head and through chakras cannot be forgotten or ignored. . . . To sublimate one's sexuality one needs to know all the esoteric theory of the chakras and nadis, prana and chi/ki, the meridians and the significance of the spinal column as a channel for the sublimated sexual energy and fluids."

Comprende?

Yogi Tom has the makings of a self-help writer.

Finally, in this depressing afterword, I should mention the most insolent celibacy advocate of them all, Mr. William Godwin, a late-eighteenth-century philosophical anarchist who, though twice married, dreamed of a world without the requirements of erecto et distentio and fluid exchange. He detested regimen, paraded against authority, and believed so passionately in the perfectibility of human beings, and in their ability to reason, that he championed a proposition whose claim was that the happiness of people "is the most desirable [goal] for science to promote," and that such promotion should lead in the end to a world structured only of adults:

> The men therefore who exist when the earth shall refuse itself
> to a more extended population, will cease to propagate, for they
> will no longer have any motive, either of error or duty, to induce
> them. In addition to this they will perhaps be *immortal*. The whole
> will be a people of men, and not of children. Generation will not

succeed generation, nor truth have in a certain degree to recommence her career at the end of every thirty years.[2]

Historians say Godwin wielded a major intellectual influence in his time. Now he is mostly a forgotten footnote. Still, no children? Oshkosh, bygosh, the man was on to something.

Afterword number two: Weakened by the study of too many self-improvement documents, we can't help but offer our own suggestion for compatible, healthy couples having sexual difficulties.

Try a two-person orgy.

Give yourself several hours on a nonwork day. Start with a picnic, or a stroll in the forest, where you begin the stroking, not too much. Take some videos to watch later (if your partner balks at this, or any other part of the festivities, consider choosing one of the other six billion people in the world). Open the wine. Take a bath. Roll on the floor. Try the kitchen table. Try the binoculars. Whatever. By the time you get to bed, your lips should be swollen, and you should understand from experience the phrase: *politely ravaged.* Then continue to take turns bringing one another to the edge of the overhang, for a final hour or more—and, nice.

Notes. Don't do this unless both of you decide to subjugate your own joy to that of your partner (think about it). Don't do it so often as to cork the novelty. If, for any reason, it starts off badly, or begins to fail at any point, cease and desist, and save it for another day; but, at the same time, keep in mind that sex is a game for amateurs, and has no rules save mutual consent—don't get so good at it, or so programmed, that you penalize yourself or your squeeze for fumbling.

* * *

2. *An Enquiry Concerning Political Justice, And Its Influence on General Virtue and Happiness* (1793).

Afterword number three: It is against the American Library Association rules to write about sex anymore without a nod to the gay way. In this spirit, we'll refer to a book entitled *The Poisoned Embrace, A Brief History of Sexual Pessimism,* by Lawrence Osborne, which recalls that the Romans condemned homosexuality only when it was effeminate: "The active partner, being virile, was [fine]. But the other, the passive, was little more than a slave. In other words, when the homosexual was manlike he was acceptable. The man who was a surrogate woman was . . . disgusting. . . . [One historian] even gives the example of the Emperor Claudius, who disdained having a passive homosexual executed because it would have soiled the executioner's sword."

We hope this fulfills the American Library Association requirements.

CHAPTER FOUR

The Booms

❧ ❧

How many people have I known?
Let me count them.
Thieves in public life,
Nazis in neighborhoods,
Bullies,
Hypocrites,
Ruthless merchants,
Liars,
Philistines,
Helots, and
Pimps.

In addition, creatures who:
Promise God's blessings,
Drive trucks,
Profit from war,
Profit from divorce,
And profit from politics.

Finally:
Men who run in silver slippers,
Women who follow them in golden chariots,
Lawyers,
Mountain bikers,
Shoppers.

Save us,
From Boomers.

Now and then I have also known,
Worthy human beings,
Struggling,
With a disadvantage.
Obsolescence.

It seems fitting and proper that the group of softlings most respon-
sible for fueling the self-help publications delirium is the, ugh, I hate
even to type the phrase, *Baby Boomers.* This generation of fallow
Americans, born from seeds planted by the surviving participants of
the Second World War, is the first New World narcissistic class to
have about it the full whiff of the armpit. Affluent, inward focused,
swaggering, the only thing positive to be said about the persons is that
they define the only race of people that can still be openly despised
and slandered; not one of them, filing suit, could find twelve jurors
good and true who would support a claim of injustice.

Actually, the despising and slander are regulated obligations in this
nation. There is a law in Virginia, for example, that denies tax relief
to anyone who has lunch with a Boomer, or gives up a parking place
to an Acura Legend. Not many people know that.

Fifty years now, the class has been with us. There has not in the
time been an inch of social progress. Well, not a foot of it anyway.
The Boomers were created by otherwise thoughtful parents who,
along with their own mothers and fathers, labored to fulfill the
nation's destiny, which was: to use its resources and attitudes for the
general good. The Booms thus inherited the most munificent and
comfortable jurisdiction in history, a piece of ground occupied by
saints and heroes where the great battles had been fought and won,
where the great wants had been resolved into statistical curiosities,

where the great privileges had become not only expectations but entitlements.

So entitled, the Booms proceeded to trash the legacy with their thundering generational demands. They have fostered personal excess rather than public weal; they have gloried in self instead of community; they have turned cultural growth into cultural liberticide; and they have left a greasy and shiny trail wherever in science, government, business, and the federal penitentiary system they have wandered.

Call it claustrophobic self-absorption. The result is that the Booms, with doubtless exceptions, have failed their world, their country, their fellows—and now perhaps themselves. They lost the only real war of their time (Vietnam; Desert Storm was not a war but a Boomer-engineered hunting party); they sacrificed egalitarianism for castes; they overthrew the city of Washington, Jefferson, and Lincoln and occupied it with Gingrich, Clinton, and Jesse Jackson; and they reduced industry to a cannibalistic process where there will soon be but one giant bank left in the nation, ChaseNations, which will fund the final formation of one hardware store, one bookshop, one software company, one HMO agreement, and one aerospace firm.

ChaseNations will also nicely simplify the mortgage application process. No more running from bank to bank. We'll have one form to fill out, one chance, and the answer will be yes or no.

Now they are getting on, the Booms. They are losing their locks, having black-hearted bypasses, worrying about mortality, and displaying a fear and confusion that comes with the knowledge that they can no longer work their will on all things; and, worse, gasp, they have learned the hard way that they do not know today as much as they thought they knew a quarter of a century ago, when they laughed at the quaint customs of their elders, such as moderation, and when they believed they would live forever and rule what they once called Amerika for as long.

It is a satisfying spectacle to behold.

The whining Booms are breaking down.

And somebody said justice is laid up?

Here they are: in the unemployment line, at the plastic surgeon's office, over to the Betty Ford Center, and browsing the library shelves for emergency repair scripts. Their debts are high, their sex appeal is gone, and their children are a pain in the ass. They are ready-made for easy answers, do-it-quickly advice, and self-improvement literature. They are begging for better ideas, they are financing advice writers such as Deepak Chopra and Elaine St. James, and, in the overall, they are trying to fill their empty character vessels with the wine of no-pain promises.

What to do when Mom and Pop start subscribing to the Hemlock Society's newsletter? Why does Junior, now twenty-seven, and wearing a watch fob attached to his pecs, spend so many evenings with Father Fitzgerald? Where does one *go* when one loses the keys to the executive washroom? Can we get cancer from can opener filings? And how come iceberg lettuce is $2.00 a head?

There is no shortage of answers, as the self-improvement gurus respond with frenzy to the emerging audience. Elaine St. James tells the Booms to (slap forehead) "Keep your sense of humor." The impenetrable Chopra says (finally, relief!), "A lot of effort is wasted whenever you put up resistance." And Stephen Covey notes in *The 7 Habits of Highly Effective People* that Number Two is to "Begin with the end in mind." How about that? Covey is reported to be working now on Number Eight: "Say anything in print so long as there is someone with an Acura and a bypass, and a spouse named Tracy or Brent, who will pay to read it."

The Booms are gorging. They are plotting their comeback through self-fix-it enrapturement. Tomorrow is by God going to be just like it was when they were twenty-three and looking for mates who had bell-bottoms. An allied author of a work entitled *Heal Your Body* even provides mental exercises that can cure such negatives as warts; Louise Hay, writing for a publishing company called Hay House, writes that

readers should concentrate their brains on positive "Points of Power" to deal with defeatist maladies.

When suffering nausea, for example, Ms. Hay says the mental thought of healing should be: "I am safe. I think the process of life will bring only good to me." See how easy it is?

More:

Nervous breakdown: *"I am well."*
Nose bleed: *"I love and approve of myself."*
Urinary infection: *"I release the pattern in my consciousness that created this condition."*
Warts: *"I am the love and beauty of life in full expression."*
Influenza: *"I love my life."*
Sciatica: *"I move into the greater good."*
Blisters: *"I gently flow with life and each new experience."*
Body odor: *"I am safe."*
Constipation: *"I allow life to flow through me."*

You get the drift of this tide. Should there not be brisk punishment for this sort of intellectual mugging? Is Ms. Hay serious? Nuts? Maybe you *can* talk life into flowing through you, but stools? And why would someone spend $20 to have St. James tell them to keep laughing, or for the New Age Chopra to prattle on about absolutely nothing at all? The Booms are frantic, I hope, and in this regard are paying for their past crimes against the rest of us.

Here's one for free, Boomer person: *You Are One in a Million.* That's the title of a Book for Booms by Marianne Clyde.

But she underevaluates by a few zeros. You are actually one in six billion. This means Boom status and 75¢ will get you a candy bar in a vending machine.

I am making light of an entire class here—ain't it fun? It's necessary to drive home a point of order. The point is: perspective. I do not like the world as it is, where we write books for Booms with warts,

while ignoring the half of humankind with terminal invisibility. I denounce the nation concerned almost exclusively with improving the lives of the Haves. I don't give a blink if a Boom wants an answer for constipation, when others of my neighbors are alone on the ice floes.

Think of Africans with no food, Asians with no medical attention, Latins with no shelters.

Some people, as a learned observer has written, believe that all the world should share their misfortunes, though they do not share in the sufferings of anyone else. And, adds Cincinnatus: "That man who lives for self alone, lives for the meanest mortal known."

Yet, for the Booms, it figures. They glory in selves and have been rewarded for the blasphemy. Autumn has approached them with drying leaves, but the culture still caters to their wealth and evergreen whims. Self-helper Barry Ellsworth, preaching to the choir in his romantic book *Living in Love with Yourself,* tells the Booms of the terrific "sense of self bubbling up all over this planet," and never mind the second-grade metaphor. Say it aloud, he insists:

"I am enough."

"I am deserving."

"I am worthy."

"I can have it all."

Isn't it awful? And it marches in an immodest cavalcade. There are books to help the unfortunate Boom stop smoking (Chew licorice sticks and work on crossword puzzles, says the author of *The No-Nag, No-Guilt Do-It-Your-Own-Way Guide to Quitting Smoking*); books to eliminate anxiety ("Tell yourself the situation will soon come to an end," suggests a passage in a book for folks who are afraid to fly, to which one might add: yes, but how hard?); books about how to acquire everything there is to acquire ("List 20 beliefs you have that keep you from having all the money you need," says *How to Have More in a Have-Not World*).

What, you want to do details?

If we must; the last two named books.

Coffin Spikes

When Tom Ferguson, M.D., published the original version of his anti-tobacco book, he stamped it with a name (*The Smoker's Book of Health*) as musty as the breath of an old dog who lives under the house. He changed it, according to documents on file in the FBI's Self-Help Perps Division, when the publisher threatened to sue for restraint of commerce.

"What's wrong with it?" Fergie asked his editor.

"It's dull," the editor replied.

"Dull?"

"Like a weekend in Delaware."

"What do you suggest?"

"Something choreographed."

"Choreographed?"

"Like dinner at Jack in the Box."

So the title of the book was changed to: *The No-Nag, No-Guilt, Do-It-Your-Own-Way Guide to Quitting Smoking.* It's not known if anything was rewritten to justify the alteration, but, if so, it stopped twenty-seven miles short of Memphis. Readers who work through Ferguson's acknowledgments (he gives thanks to 140 people and groups, including the entire Yale University School of Medicine) find that the author nags and assigns guilt according to the teachings of the Amalgamated Federation of Self-Improvement Authors, Fixers, and Pseudologists (AFSIAFP).

Tom Ferguson, M.D., takes more than three hundred pages to tell readers how to quit smoking. He pulls out all the stops, including the Gregorian line "Quitting is easy—I've done it hundreds of times." He provides charts, logs, graphs, a quiz or two, and chronic advice such as "Go for a long walk," "Listen to music," "Drink lots of fruit juice," and "Drive to work by a new route."

In the end Tom Ferguson, M.D., says everything everyone else has said about the matter and nothing beyond that. Because the only thing

to say aside from what has already been said is against the bylaws of the AFSIAFP—i.e., the truth: *One doesn't need gimmicks to quit, just grit.*

I've never smoked (cigarettes). My sympathy for those who do is limited to those over fifty. The rest of the addicts started after the health risks had become well known and have no excuse (except in the courts, where some juries are awarding rooms at Fort Knox to litigates who wish they'd never started smoking two packs a day, then three packs a day, then four packs a day, because, come to find out, it's not been good for them at all). Furthermore, smoking has not since the 1950s been either sexy or sophisticated. Tom Ferguson, M.D., is at least right in nagging in his non-nag volume: quit to avoid a substandard existence.

How? It's not so difficult as the lore insists. Otherwise, tens of millions would not have already done it. Surely, nicotine is addictive, but not in the way other narcotics are addictive (when was the last time a Marlboro junkie beat someone over the head to get money for a carton?). Smokers have for centuries decided to stop, and then stopped, without the DTs, without the breaking of function that accompanies hard-stuff withdrawal, and without thirty pages of charts, logs, graphs, and sunbeam advice. If one listens very much to the overstated stories of failure, and becomes further apprehensive at the prospect of crawling through the minefields of a ten-step program, or some such, one can conclude that a risky future is preferable to a crippling present.

Decide now, yellow fingers. You can gnaw through a wall, if you have to.

Getting Yours

How to Have More in a Have-Not World is written by Terry Cole-Whittaker, a woman characterized in the book as "an inspiring min-

ister and host of a popular nationally syndicated TV show," which gives us call to dismiss her out of hand. The first page of the small volume is headlined: "Getting What You Want." The second paragraph claims, "You [apparently, every person on earth] can have what you want. Having what you want is being wealthy. Being wealthy isn't being extravagant or wasteful, it's having exactly what you want."

Which is to conclude that we can each of us be happy, if we want.

Be successful, if we want.

Be healthy, if we want.

Be young, if we want.

Be free of fear, if we want.

Be desired, if we want.

Be good-looking, if we want.

And live until the universe is no more.

It's the Boomer Zion. The Land of Everlasting Clover. Terry Cole-Whittaker, the inspiring minister, promises everything, even that we can be magnanimous. She dedicates the book to: "My former husband, Leonard. I am eternally grateful for the opportunity for us to have been together and to have assisted each other through our mutual love and support. The Holy Spirit brought us together for our healing, and when it was complete at that level of awareness we were released into a new life." Translated, it implies: "Len, you were the spousal equivalent of a cold sore, but this paper clip of Baby Boom touchiness might help sales of the book and do double duty as an apology for the time I hit you in the ear with the Cuisinart."

Anyway, fellow greeds, let us hasten on to the material stuff. Silver, for a start. Author Cole-Whittaker promises that each of us can be rich, if we want. In a chapter called "Money, Money and More Money," Cole-Whittaker tells us that "financial success is available to everyone [again, every person on earth, even those drawing $200 a year as earth scratchers in Burkina Faso]"; that "this doesn't have to be a have-not world"; and that "it's all there for you; all it takes is creating it through you, through your thoughts and declaration."

She lists four declarations (steps) to the vault combination:

Step 1. "Write down your beliefs, thoughts, and fears about money. Write down what is good and bad about money. Examine how you talk about money in each of your dealings."

Step 2. "Face the truth. What is the exact condition of your finances? By writing out a financial statement listing all your assets, and . . . debts, you will arrive at an accurate picture."

Step 3. "Take responsibility for cleaning up any mess. It won't go away on its own if you ignore it. That which is incomplete or a mess keeps you from having what you want and living fully. The energy that is available to you in the present is used for the past."

Step 4. "Create your ideal financial picture in writing. Set money goals for one month, six months, one year, two years, and five years. If you reach them faster, redo your time line. I want you to be the cause of your finances, not the victim of them."

Where did I pass out in this reading? Sometime before I learned anything about how to acquire "Money, Money and More Money." What about the way to get a job in Burkina Faso? What about the way to suck up to the boss in Flagstaff? What about the way to get a million from what C-W calls our cellular association with Jesus, who must do well in the markets?

But, no, midway down page 154 Cole-Whittaker is telling us, for the love of Mike, that God doesn't give to us, we have to give to God. She says we must make the contributions to "transcend our fear about not having enough," which will plug us "into the system of prosperity." Said more clearly, she wants readers to "give 10 percent off the top for God's work." I mean, hey! I haven't earned a sou from the advice so far, even though I'm a card-carrying member of the cell family, and already I have to dole out change to The Great Genome?

Maybe if we turn the page. The good stuff must be coming.

Page 156: "Work out a payment schedule for each bill that you can afford. Find ways to increase your income. Keep your inflow higher than your outflow."

Page 161: "Play the game of manifestation. As you observe your-self and money, be willing to let your presence disappear, and dis-solve your current belief system . . ."

Page 164: "The truth is you want what you want and you can't stop that—it springs up from within you. What doesn't work is to believe that you have to do anything other than say what you want, be com-mitted to it, and create the context of having it already."

Maybe if we keep turning.

Page 165: "The Four Corners of Truth. [One] Abundance and wealth are natural. You merely have to claim it. It's yours by right of your saying it is. [Two] There is always a way and a solution. Every idea or dream you have . . . has everything in it to produce itself. [Three] The only inevitable part of life is love. . . . There is no plan for your demise and downfall; you make that up. [Four] You have what it takes. It all comes out of you as a channel or vehicle of God's power. You are a fountain of infinite supply and creativity, fed by an inner spring."

Maybe if we give up.

There, that's better.

Terry Cole-Whittaker is an inspiring minister who pulls our chains. She hasn't a nickel notion how to make Money, Money and More Money, other than how to make it for herself as an inspiring minister in a Boomer-stuffed nation that mistakes rapacity for respect and loot for living.

She has written a book, poorly, that hurts. Half of humankind knows nothing of the abundance she says is everywhere. But she is not writing for that half. She is writing, and ministering, and shoot-ing off at the mouth for those dead souls who, like her, believe they are entitled to have what they want, because they want it, and because God wants it; personally, I'd rather be in Burkina Faso than in this inspiring ministry; poverty wants many things, as it was said before the Boom Butts made their impression on the world, but not as much as avarice.

* * *

And the beat goes on.

The Boomers have a rhythm for remediates.

There are, gawd, even books that counsel Booms regarding their parents. This, a representative snippet from *Do Your Parents Drive You Crazy?* by a forgettable Colorado author who notes childishly on the dust jacket that she lives 1,352.7 miles from her mom and pop:

> You've had it. You've absolutely had it. If you get one more phone call from your parents that contains the phrase, "it's been almost a month"—or "week" or "year" or "half hour"—"since we last saw you," you're going to scream. And if you hear 'em say one more time, "We know how busy you are, so don't worry about us (sigh), we'll get by somehow," you'll need major psychotherapy. They've pushed you too far.

First: The writer's use of *'em,* for *them,* indicates, I guess, that the Booms have a folksy side. Second: Is there nonmajor psychotherapy? Third: I don't think there is a bloody parent in the nation, outside the city limits of Poor Writing, who sighs: "We'll get by somehow." Fourth, most important: All of the Boomer parents I know would be delighted to have the troubled tweaks live 1,352.7 miles away and get only Christmas cards, if it meant freedom from having to listen close-up to the moaning and groaning of snots concerned with their Intel stock portfolios.

Or worried about their roped necks. There is a growing library of books written for Booms who are creating new riches for plastic surgeons. And here, they are at least partly fired by reality. Americans love youth more than they do celebrity, if that is possible, and it's wantonly common for sixty-five-year-old corporate chiefs to jettison fifty-year-old mid-managers for the sake of "business image." There is not much research to support the conclusion that people with crow's feet are repellent to large groups of American consumers, yet there's no room to quibble.

Thus the Booms are totally up against it, as the personal develop-ment writers put it, "appearance-wise." And the resulting books on boob-lifting are out there, soaring on thermal drafts. Tummy-tucks, wrinkle renovation, cheek implants, nose jobs: "It can be a new lease on life, and Blue Cross may pay for some of it," says a Boom genera-tion physician who has given a manuscript to me for comments. "Take a two-month 'vacation,' and find the fountain of youth."

As well, the fountain of nugacity. We have no uncertainty that a beak can be repaired, or forehead spots removed, all for the good. And truly nasty features can be safely remodeled according to the dictates of harmless egotism and public consideration. But, come on: men who get hair transplants seem to one and all as men whose new look sug-gests they mightn't have bothered; women who have their eyes rounded seldom seem a fraction of the fee more beautiful for it and would do fine instead to lose some of their weight and mascara; fi-nally, full makeovers routinely leave their victims looking like wax-work figurines and promise little except more rapid deterioration in the heat of the aging circumstances.

The truth is painful.

That's why Booms won't face it and why fix-it-yourself writers will not mention it.

If the above-mentioned would wed the evidence, would face life squarely, would join the entirety of history, they would forget about fustian twaddle regarding the prospects of having it all (after the stitches are removed) and learn instead that nothing lasts, we are all dying, and the only part of it that makes it worthwhile, somewhat, is to find a hand to hold, which most of us can do, or a great work to produce, which most of us can't.

Also making it worthwhile: A person can lift himself off the car-pet time after time, providing he has sufficient opportunity between the occasions to profit from standing.

Also: Excuses are not acceptable, but they feel good.

Also: The worth of a person's life is revealed to him the instant he

wakes each A.M. If the moment presents anticipation, or even accept-able routine, life is good. If not, life is still good.

Also: The rich and the poor die the same. Other explanations are propaganda.

Also: When one loses everything, he still has more than many.

Also: Everyone is frightened and helpless, and alternatives pass swiftly.

Also: Aging is what gives youth meaning, and class.

Also: Aging does not last long.

Also: Aging is a crock.

And: Robert Redford has a roped neck.

And: Marilyn Monroe would have, but she died too soon.

You can get rid of a turkey neck with simple surgery. If you do, you have done nothing. Joan Didion: "Most of our platitudes notwith-standing, self-deception remains the most difficult deception. The tricks that work on others count for nothing in that well-lit back alley where one keeps assignation with oneself." And Grandma Moses: "If I didn't start painting, I would have raised chickens." It's not your flesh, it's what's under it.

Afterword: Speaking of dying too soon, Benjamin Spock has gone to his reward as I write this chapter. At age ninety-four. We needed him for decades more. Dr. Spock, an acquaintance, was only inciden-tally the author of a book that rivals the Bible in American sales. He was more happily a man who learned late in life the value of life, that it should be lived and not merely experienced.

The first time I met him was in the 1980s. I had gone to his Man-hattan apartment to talk about what had become of his plan to over-throw the government, at least somewhat. His wife of forty years let me in. A few months later, Spock would leave her for a woman half his age.

I wrote of him then:

Bertrand Russell believed that the fundamental defect of fathers is that they want their children to be a credit to them, and insofar as that is correct it might be said that Benjamin Ives Spock, wherever he is, might be somewhat surprised by his son, Benjamin McLane Spock, wherever he is. The first Spock was said to be a man of reserved attitudes, narrow social concerns, and black-and-white politics, which is to say an establishment lawyer; he was a New England puritan and a Calvin Coolidge Republican, and he might naturally have wanted his boy to follow his prints through an America of unbending tradition, a nation resolute in orthodoxy . . .

And for a long time the boy did just that. Young Ben kept his nose and his record clean well into middle age. He went to Yale University, he voted for Herbert Hoover, he started work as a pediatrician, and be became a bit of a commercial success. We are speaking of "Doctor Spock" now. He wrote the parental primer called *Baby and Child Care,* in which he told mothers to trust their own judgments, and he would sell 32 million copies altogether [50 million today], become wealthy, and take a privileged position as one of the country's most respected personalities.

Then he rebelled.

His father, God rest him, might say he got naughty.[1]

Spock was that exceptional human commodity, a person old enough to know better who did. He came to recognize with age that (the self-helpmeisters hate this) we should be at least as concerned with others as we are with ourselves. I will not recount his rise from the penthouse to the jailhouse, in the name of human compassion, or the fact that the cost was dear by way of wide misunderstanding (book sales dropped like a nut from an oak); but I renew my appreciation

1. *American Tapestry* (1988).

of a man willing to do the right thing in a nation where that is still often defined as peculiar.[2]

That said, I must add a discordant note to the music that plays in memory of a grand man. Spock, after all, was the pediatrician of the Booms. In this post, he helped nurture the greediest and perhaps the weakest generation of malcontents since the English landed at Jamestown. Yes, they led him to the ramparts, because Booms will protest anything, but they left him there (from whence he was removed to prison) in order to get on with their lives of materialism and fat fighting. In other words, Spock's Babies never took the doctor's best medicine; in the end, they flatly rejected his cure for the unhealthy human heart; when they got old enough to know better, they gave up on others to concentrate on themselves.

Where did the doctor go wrong?

The jury is still out.

The Boomers will soon be reaching the age where Ben Spock, like Saul, was transformed by a vision of something better than Ben Spock. If the Booms do the same thing, I will reconsider my conviction that they are poops.

Afterword number two: With all of the bullragging on this green earth, with all the breaking on the wheel of the poor and the subjugated, syndicated newspaper columnist Charles Krauthammer has worked his way through the list to put his penetrating gaze on a group that has been tragically overlooked. He writes that it's time to start

2. When President Andrew Johnson was impeached on wild charges of, essentially, being a traitor (following the Civil War, he refused to further wound the South), he was tried and acquitted in the Senate. He was acquitted because seven of thirty-five Republicans did the right thing, broke ranks, and voted judiciously. All of those men suffered from subsequent ostracism, the hoots and hollers of the people, and none of them was ever again elected to the Senate.

paying attention to the decomposing economic circumstances of America's physicians, most of whom are Boomers (which may suggest why more of us than ever are dying these days).[3]

Krauthammer says that "the doctors are drowning," Krauthammer says they "are being driven out of business." He says the rents they pay for offices, the salaries they pay for nurses, and the premiums they fork over for malpractice insurance have resulted in a "decline of medical economics" that has prompted his own patch-pocketed practitioner to observe that the "quality of life in medicine is worse today than at any time in my 15 years of private practice."

So the writer has a solution. He says it is "a simple, though fairly radical innovation" that might keep brain surgeons off the bread lines. He wants patients and insurance companies to pay $1.00 a minute for phone consultations. He says the money would fairly reimburse the doctors and nurses for services that are now free. He says the payment is "not terribly much more than calling Aunt Sally in Topeka," and he even has a name for the fee: "The Physicians Rescue Act of 1998."

"Hello, Doctor Boomer's office. Nurse Evans speaking."

"Nurse, my son has his thumb in an electric socket!"

"Do you have Blue Cross?"

"Yes. This is Mrs. Jones. I'm a regular patient."

"I don't recognize your voice. Can I have your mother's maiden name?"

"My son is turning red!"

"Oh, all right. I'm turning on the Physicians Rescue Act Phone Timer."

"All the lights just went out!"

"Is it his left thumb or his right?"

"The left. The LEFT!"

3. July of 1998.

"Hmmm. This is more serious than I thought. I have to put you on hold . . ."

Krauthammer, like most media pundits (I was one), is stuffed with silly. And I have an alternative suggestion for him. If the doctors charged $1.00 a minute for the time they keep sick patients on ice in their overstuffed waiting rooms, they would be able to buy gas for the Mercedes, keep current on the club dues, and forgo the weary tax-write-off trips to St. Kitts.

And for Krauthammer, the Commentators Rescue Act of 1998: a fee of $1.00 every time the op-ed pages cause Johannes Gutenberg to roll over in his grave and wish he'd stuck to his original trade, goldsmithing.

CHAPTER FIVE

Toxic Intimidation

❧ ❧

There are faces on the rocks in the mountains,
If you look with an open mind,
And not just of Indians,
And presidents.

There are profiles of the people in our lives,
Parents,
Spouses,
Children,
Friends,
And others, viewed when we look back in reflection.

If they are smiling, and kind, and cooperative,
Good.
If they are not,
Good just the same.
Be concerned only
If you do not see
Faces at all.

Susan Forward, Ph.D., is said to be a therapist and writer, the author of several self-improvement books—including what her publicity describes as a number-one best-seller (*Men Who Hate Women and the Women Who Love Them*)—and I have had a dream about the woman.

I dreamed that when she was trying to decide how in the world she could follow the astounding success, and the nasty title, of *Men Who Hate Women,* she held the following conversation with her new agent, Izzy, vice president of Amalgamated Literary Properties and Canned Goods:

"I don't know, Izzy," she says. "How in the world can I follow the astounding success, and the nasty title, of *Men Who Hate Women?*"

"Not to worry, babe," Izzy replies.

"Not to worry? I have mouths to feed."

"I repeat: be not fluffeled."

"Izzy, pahleeze: Dot, dot, dot, dash, dash, dash, dot, dot, dot."

"SOS. Dazzling. I love it. Babe, you are a writer and therapist."

"I'm clever when I'm on death row. Now, do you have any ideas, Izzy?"

"Correctomatum."

"I'm listening."

"Get this: *Women Who Hate Men, and the Men Who Love Them.*"

"Been done, Izzy."

"Just a test. I'm throwing out footballs."

"Well, toss a completion. While we're still young."

"Correctomatum. I'm thinking."

"This is serious, Izzy, *everything*'s been done. Stress, impotency, bad breath, dysfunctional UFO abduction, you name it. When I got into this business, there were problems that were untouched. It was a bazaar. Sex. Drugs. Government auctions. Now, look."

"Be not fluffeled."

"There you go again. For this you want 15 percent?"

"Babe, I got it."

"Oh. Hot dog."

"If the old problems have been done, we nail new ones together."

"Speak English. This is Burbank."

"I'm talking *exaggeration*. Be creative, babe. Exaggeration works."

"Exaggeration?"

"Magnify. It's the new millennium. I spell: E-M-B-E-L-L-I-S-S-S-S-H!"

"You mean . . . ?"

"Correctomatum. Listen to Izzy. This is big. I mean big."

Susan put her hand to her chin. "E-m-b-e-l-l-i-s-s-s-s-h?"

"Dazzling."

They put their arms around each other's shoulders.

"Izzy," says Susan, walking into the night on the foggy tarmac, "this could be the beginning of a beautiful friendship."

And so, in my dream, it came to flower. Susan Forward started work immediately on *Toxic Parents, Overcoming Their Hurtful Legacy and Reclaiming Your Life,* a work of unsurpassed imagination. Not only would the author introduce an under-embellished category of dysfunction, she would couple it with a previously vague category of victimization. She would explain in excruciating detail that there are a dreadful lot of dreadful parents, many of whom have a dreadful lot of problems, and since there are also a dreadful lot of children—gosh, almost all of us have been children, isn't that right?—who also have a dreadful lot of problems, it is clear that two and two equal something.

"All parents are deficient from time to time," the author declares on page 5 of *Toxic.* She even allows that she made "some terrible mistakes" with her own children, which means she knows her subject inside and out. She says many of these deficiencies, even the terrible mistakes, are normal, and it may not necessarily mean that the parents are monsters. But then she lowers the Brobdingnagian boom:

> There are many parents whose negative patterns of behavior are consistent and dominant in a child's life. These are the parents who do the harm. As I searched for a phrase to describe the common ground that these harmful parents share, the word that kept running through my mind [and Izzy's] was *toxic.* Like a chemical toxin, the emotional damage inflicted by these parents spreads

throughout a child's being, and as the child grows, so does the pain. What better word than toxic to describe parents who inflict ongoing trauma, abuse, and denigration on their children, and in most cases continue to do so even after their children are grown?

What better word, indeed. It's formed in inch-and-a-half letters on the book cover. It's repeated again and again over 327 revealing pages. It's loud. It's tough. It's infuriating. It's the worst thing she could say about mothers and fathers without going to jail for it.

And who are these poisonous parents? The author rightly announces that fathers who beat their kids, and mothers who have sexual relations with them, are not going to get gifts on their birthdays. Then Dr. Forward takes a step backward and enlarges the bubbling mix with parents who have criticized their children, parents who have gotten drunk or used drugs, parents who have been severely depressed, and parents who have been so frightening that their kids were afraid to express anger in return.

That means Dr. Forward has uncovered a toxic ant heap, and fingers just about everyone on this side of the Ring Nebula, with the exception of Ward and June Cleaver.

And that's only part of it. The author also lists the *victims*—verily, an even more shame-ridden and multitudinous population. She says the children of toxic parents may well be those who have found themselves in destructive or abusive relationships; those who worry about getting close to someone who may skip town; those who get angry or sad for no particular reason; those who are perfectionists; those who feel anxious though successful; and those who have a hard time knowing who they are, what they feel, and what they want.

Recognize anyone? By my count it makes six billion of us.

Izzy, you were right. It's dazzling.

There is no overstating our debt of gratitude in this. Everyone who has ever been on one end of a family or the other can now know what has really been troubling them all of their unsavory lives. In addition,

Susan and Izzy have conspired to assist in the rescue of the self-help business from the potential of moribund limitations; penetrating writers can now guide us to the newfound knowledge that it may never be too late to have a happy childhood, if one first recognizes that the childhood they had was unhappy, and if one puts the blame squarely on those toxic progenitors: Mom and Pop, who were always tight with allowance.

Besides this, Susan's juicy use of the word *toxic* gives new direction to our storehouse of knowledge regarding Woes Incorporated. It does away with any misconceptions we had about our torments and our tormentors. Parents are not just careless, or even just abusive, they are toxic—like oil spills, like acid rain, like landfill leaching, like strontium 90.

No wonder the self-betterment oracles, not a group to miss a good bet, have embraced the adjective. And they have one by one applied it to other hateful evils, mostly things that fit—sometimes with a shoehorn—between the covers of do-it-yourself instructionals. There are toxic kids as well as toxic parents, you should understand; there are toxic grandparents, toxic lovers, toxic employers, toxic employees, toxic friends, toxic thoughts, toxic talk, and toxic memories.

John Bradshaw, a high-magnitude star in the self-improvement Milky Way, swears honest-to-injun that there is even *toxic shame.* And why not in this bunchbacked society? Bradshaw, who is often pictured on his book covers wearing plain-folk sweaters that approach pestilential, says that "all of us have a smattering of neurotic and character-disordered personality traits," and never mind a little foaming at the mouth. But: "To truly be committed to a life of honesty, love and discipline, we must be willing to commit ourselves to reality. . . . Such [a willingness] requires a good relationship with oneself. This is precisely what no shamed-based person has. In fact, a toxically shamed person has an adversarial relationship with himself. Toxic shame—the shame that binds us—is the basis for both neurotic and character-disordered syndromes of behavior."

87

And Bradshaw should know. With the zeal of the pimp-turned-preacher, he confides to his fellow-feeling readers: "I used to drink. . . . I drank to relieve my shame-based loneliness and hurt." He says this is how he discovered the "core demon" in his life, toxic shame, about which he writes in *Healing the Shame That Binds You,* describing it therein as the "fundamental problem" in "our compulsions, co-dependencies, addictions and the drive to superachieve, resulting in the breakdown in the family system and our inability to go forward with our lives."

The *fundamental problem?* Number one? First and foremost? Really?

But let's leave alone the problem with the fundamental problem. There is a more important consideration to ponder in Mr. Bradshaw's New York–to–New Delhi statement. The word *superachieve* does not exist in the English dictionary.

He should have said "overachieve."

And yet, don't forget, John is saving humankind. As a self-help veterinarian, he is talking turkey, not precision. He is talking affirmations and visualizations. He is talking "social and personal breakdown [and] offering new techniques of recovery vital to us all." Us all!

So what is grammar when toxic compulsions lurk inside our shame-based loneliness? I'll tell you what. Grammar in the fix-up writings is as dated as the idea that people are basically sound. Grammar is a traffic tie-up at the corner of Emotional Trauma and Destructive Forces. If Bradshaw & All worried about gaffes such as *superachieve,* they would not have the quixotism to talk about *the fundamental problem.* When you are trying to convince everybody that something is wrong with them, language must be as flexible and expandable as the disorders themselves.

Eric Blair spoke of this in another time. He was the London man who wrote books under the pen name George Orwell. He had a judg-

ment on the use of the English language that was often lame ("Never use a long word when a short one will do"), and if followed by all would have meant a world without Shakespeare; but he was less Pecksniffian and more instructive on the matter of the politicization of words, the use of vocabulary to further narrow interests (people are governed, which is a way of saying manipulated, more by language than by law).

In this respect he might have written *1994,* rather than *1984,* for that is a middling year in the age of Dysfunctiana, not Oceaniana. Had he done so, he might have used J. Bradshaw or S. Forward as Big Brother or Big Sister (WE KNOW BEST!), he might have foreseen everyone railing about Toxic Parent Emmanuel Goldstein, and he might have used the We're Okay but You're in Trouble Publishing Association to mutilate the language for purposes of public intimidation (sanity is insane, normal is abnormal, victims are victimizers).

Do I exaggerate with this comparison? Not much. The self-help literature is weighted with magnified terminology meant to worry. Bradshaw, for example, divides the pages of *Healing the Shame* into small segments, each one with an explanatory headline, because he does not trust the concentration skills of his audience. Then he salts his prose with words and phrases that shock (metaphysical boundary, self-alienation, compulsive masturbation, depersonalization, reactive formation, anorexia nervosa, rage addiction, lost inner child, functional autonomy, multigenerational abandonment patterns) because he wants the reader's frightened attention.

The result is that readers may not know what Bradshaw is talking about, exactly, but they feel they'd better damn well listen. The result also is that he is saying so many things that some of it is familiar; hence, it likely has personal application. Compulsive masturbation? How many times is that? Once a day? Once a week? If you wanged off twice on a second Sunday in February, you might be living with toxic shame, even though it seemed okay, being February.

Then if you are shamed enough, perhaps, you'll not want to read anymore, which means that you must fight that reaction by buying another self-improvement book, because not to do so would be another symptom of your shame, and—what have we here?—Izzy, call me today.

Of course, Bradshaw is quiet about another consequence of all this. It is that if we search hard enough for embellisssshed solutions to embellisssshed problems, we can soon use the embellisssshed process as a response to everything that goes wrong in our lives. One can't get along with Dad, because, hell, he's toxic. One can't make it in bed, because one is self-alienated, after all. One can't bank a million, buy an airplane, fly off to purchase property in Barbados, there to wed an understanding woman, with whom one will thence have-it-all, because, drat, one has exceeded his metaphysical boundary, while looking for his lost inner spirit, and is beating meat too much to have the time to find a job to earn the money to initiate the shame-ending procedure.

And from there we sink as a people into rage addiction.

Once, so help me, Henrietta, a man came into my bookstore to complain about a volume he'd purchased to help his wife diet. He said it didn't work. He said she was gaining, not losing.

I said, so?

He said, "It's not worth the money."

I said, "Did she read it all?"

He said, "Every page."

I said, "Did she follow the directions?"

He said, "She ate everything in the book."

"The cover?"

"That too."

I was tempted to dismiss the fellow as a crank, a leftover from the Sid Caesar show. But I recognized him as a seasoned self-helper, because he knew how to manipulate and color terminology. He called me a piss-butt.

I have good eyes,
And bad ears.
And since I cannot see sounds,
Or hear pictures,
I am disadvantaged,
When I look into the face
Of this circumstance,
Where words have little movement,
And images no longer speak,
Absent, as they are,
Of meaning,
And restraint.

So, it's 1994. Two plus two equals whatever the self-improvement ministers tell you. And the language is Newspeak. I'm going to list two examples of that language, found in fix-it-yourself sentences throughout Dysfunctiana, and I will follow John Bradshaw's format of heading the segments. You may have noticed that I have many times in this critique drawn from the formats of self-help books; if so, you at least have no trouble with toxic myopia.

Toxic Worry

Okay: you have lost your job, spent your savings, missed three months of mortgage payments, can't afford gas for the lawn tractor that will soon be repossessed, and have arranged yet another employment interview that could mean the difference between solvency and full ruin.

Don't fluffel.

There is Newspeak self-help repair for this Newspeak self-help despair.

William Hewitt says he can help. He writes in his book *The Art of Self Talk* that what you need to do is have a preinterview conversa-

tion with your own fears. He says of course that there will be other rules to follow during the occasion itself (do not wipe your nose with your tie), but preliminary chatter preparation—like an actor preparing for a role—is decisively important.

Sit down with yourself, he says, and tailor this conversation to your situation:

> On (state the date and time) I am going to be interviewed for (state the specific job/purpose). During the interview, I will be relaxed and calm. I am confident that I can fill the job with excellence, and I shall display my confidence. I will talk easily and comfortably and I will answer all questions honestly and fully. I will listen attentively and will ask questions about the job and company. I will balance my talking and listening to about fifty-fifty [*sic*]. Here are my qualifications and what I have to offer. . . . Here are some questions I want to ask at the interview.

Hewitt says you should say this twice a day preceding the interview. The guaranteed result? "YOU WILL BE HIRED!"

You know he means it because it's in capital letters.

Author Hewitt describes himself as a teacher and counselor, who as a child of the Great Depression learned "to live life to the fullest by always maintaining a sense of humor and never giving up." He has written several other self-help guides, including *Hypnosis, Beyond Hypnosis,* and *Astrology for Beginners,* titles that indicate you can trust what he says about almost anything.

What he says about talking yourself out of fluffel is that one's mouth is a liberating mechanism, and the good use of it can be reduced to a formula: Mouth Power + Word Power = Personal Power. He has therefore packaged many of humankind's most troubling circumstances in plain-brown-wrapper jingoism. He says, "The greatest barrier to human growth is the illusion of helplessness and powerlessness [toxic worry]." But all of us "have a great power inside

[us]" that can make [us] "a winner every time." He concludes, "Your mouth is a powerful tool."

Hewitt believes that talking yourself into serenity is the secret. (There is always a secret.) He says his book is "not another one of those pie-in-the-sky, Pollyanna-type, world-through-rose-colored-glasses books that says a lot of nice things, though you never know quite what to do with them"; then he proceeds for 180 paperback pages to present a pie-in-the-sky assortment of a lot of nice things that one never knows quite what to do with, except discard quickly.

Example. Let's say you worry about how to get along with your contrary spouse. Hewitt says that before you hire a hit man, you should talk to yourself about it. "Yell and scream the words, if you wish. Be emotional. Get it all out." Here's the script: "What in the world is your problem (spouse's name)? Today in the supermarket you acted as though you didn't have the brains God gave green apples! You embarrassed me and humiliated me. Your behavior was totally unacceptable. I do not deserve that sort of verbal abuse and you know it! You accused me of wasting money on magazines. Well, I enjoy my magazines and I have a right to some enjoyment. And what about you? You waste money . . . and I have never denied you anything you enjoyed. Let's be fair about this."

Example. Now that you have put the old bastard in his or her place, you are worried about your smoking habit. Hewitt says you are a "chimney mouth," it does not put a glow to your cheeks, and you should start a thirty-day self-talk program of reform. On the first day, smoke a little, but: "When you get up in the morning, stand in front of your bathroom mirror, look yourself in the eyes, and say out loud to yourself the following words three times: 'Today is the last day I will smoke tobacco in any form.'" On the second day, stand in front of the mirror and repeat: "Yesterday I stopped using tobacco forever. I am a non-smoker and proud of it." On the third through thirtieth day, stand in the same innocent bathroom, looking into the same red eyes in the mirror, which should by now be both embarrassed and

humiliated, and say: "Hi there, non-smoker. I'm proud of you for not smoking."

Example. Well, you have a job, you have disposed of the old bastard, and you've stopped smoking. Now you're so clean the only thing left to worry about is your temper, which, truth out, got you into all the jams in the first place. Hewitt says the self-talk solution is to throw a tantrum at yourself, slamming a newspaper on a table: "I AM SICK (SLAM) AND FRIGGING (SLAM) TIRED OF THIS CRAP! (SLAM) THE I (SLAM) R (SLAM) S (SLAM) SHOULD BE CATCHING CROOKS (SLAM) INSTEAD OF PICKING (SLAM) ON US LAW-ABIDING CITIZENS (SLAM). MY JOB SUCKS (SLAM). IF HIGHWAY TAXES (SLAM) WERE USED PROPERLY (SLAM) WE WOULD NOT (SLAM) HAVE (SLAM) THIS DAMN (SLAM) TRAFFIC CONGESTION (SLAM)."

There. See?

Author Hewitt even has a suggestion if the traffic remains (slam) congested. Put down the newspaper and talk this time with God. Gently, now. Hewitt says prayers should (a) be spoken out loud, (b) be spoken in a creative place (alone in a car is nice), and (c) be spoken with eyes rolled upward [in the car?] to "trigger alpha brain activity, where the most powerful prayer can take place. A detailed explanation of this phenomenon can be found in my first book, *Hypnosis.*"

There. See?

Toxic Pain

The statistics argue that more than a third of Americans suffer from some variety of intractable pain. And there are raging tussles as to why it is so. Reformists claim almost all pain could be chased away if the medical establishment would be more aggressive in administer-

ing chemical relief (many doctors worry about the long-term effects of industrial-strength painkillers—addiction, for example); they also say the meddling government should yield to the evidence that some illegal products, such as cannabis, have helpful as well as harmful properties.

The contentions might be resolved if the antagonists would read *You Can Relieve Pain,* by Ken Dachman and John Lyons. The authors are psychologists who write that "guided imagery" can help "reduce pain or eliminate it altogether." They feel our agony, in other words, and have, in a mere 155 pages, endeavored to escort us out of the awesome bad weather of sufferance:

> For too many who suffer with chronic pain, forces not unlike hurricane winds make life a daily battle against seemingly overwhelming odds. Our fragile armor of skin and bone is, after all, meager protection against a hurricane. Ironically, at the center of a hurricane's murderous spiral—in the eye of the storm—all is calm. Winds are light and pleasant; the air is clean and dry. Often, the sun is shining. This book will guide you to the serene center of the storms of pain that rage inside your body. Deep within you is tranquil sanctuary. From this unique vantage point you'll be able to rally the skill and energy necessary to control and, perhaps, banish, chronic pain.

Right next to this sunny assurance, the authors have placed a drawing of a human brain affixed with a "Pain-Control Scale." They instruct the reader: "Focus your mind [on the scale]. Use all your senses to develop an image of the dial and all that's behind it. Make that image as real as you can. Reach out and grasp the control dial with the fingers of your dominant hand. Feel its metal surface and the rough ridges and grooves of its outer edges. You can use the dial to lessen your pain, to turn it down until it hurts less and less, and then, not at all."

Bear witness. This material has been penned by medical professionals.

Concentrate on turning the dial to the left, counterclockwise. At first it might seem difficult to budge, rigid, too tightly coiled. But keep trying. As the dial begins to turn, the back indicator bar will move slowly downward . . . millimeter by millimeter. Yes, it's slow going, but be patient. You hear a faint "click" as you move to each new level on the scale, accompanied by a perceptible decrease in the magnitude of your pain.

Ken Kesey, we have a situation.

The premise of *You Can Relieve Pain* is: mind over matter. The book tells people how to talk themselves out of such things as arthritis, migraine headaches, ulcer cramps, bone fire, dental terror, and amputations. The authors quote Agrippa, a man not otherwise valued for his beneficent philosophies: "So great a power is there of the soul upon the body, that whichever way the soul imagines and dreams that it goes, thither doth it lead the body." Then they restate the opinion with a lower trajectory: "You trained yourself to walk, and you can train yourself to control [pain]."

Have you had enough from Doctors Dachman and Lyons?

I'm not finished with them.

They list fourteen exercises you should master on your way to the serene center of the storm of pain, one of which is this: Imagine that: "You are walking in a forest. The sky is blue. A canopy of green leaves and twisted branches is stretched out over your head. The air is fresh—it tastes clean when it hits your throat. Feel the wind—it's light, and it's rustling the leaves above you. You lean against a tree for a while, and watch the birds fly from branch to branch. When you feel like it, continue your walk. You push through some low-hanging branches and you find yourself on an old dirt road. Walk down the road. Where does it go?"

Where? Mainly to the end of the fourteen exercises (all of which are shallow as a sidewalk crack), where we get a quote this time from Charlie Brown, who once said in the funny papers that "pain is where it hurts," a line that explains why he's not grown an inch in thirty years.

Now you are ready to eliminate the discomforts of the hemorrhoids that have bothered you since Eisenhower was president. The authors have taught you to "take responsibility for your pain," to concentrate on better images such as air hitting your throat, and to grasp the pain-control dial in your mind and turn it down until everything hurts less and less, and then, not at all.

Somewhere along the way, the psychologists admit that it "sounds too easy, doesn't it?" But they banish one's doubts in the end. After you practice guided imagery for a while, "small steps become a great leap." And they conclude: "Control of your chronic pain can become as spontaneous and automatic as the control you now exert over voluntary physical functions. It can be as simple as taking a step, or raising your hand, or just saying 'stop hurting.'"

Some scientists are said to have exposed themselves to disease in order to test the antidotes they've developed (Paul Ehrlich, for one, to syphilis). Would either Ken Dachman or John Lyons be willing to assume the deforming joint heat of a woman in her eighties in order to demonstrate the comfort that can be achieved by imagining a reduction on the pain-control scale? If not, they should write a less Aesopian and harmful book, such as: *After Failing to Relieve Very Much Mental Suffering in the Nation, Why Do Psychologists Presume They Can Credibly Turn Their Playful Attentions to Physical Disorders?*

Here's the last sentence in this Tartarean book:

"You can imagine yourself free of pain."

The authors, so far as we know, are still working.

Afterword: Let's revisit Dr. Susan Forward, before she writes another book. What does one do if one's father is responsible for every-

thing bad that has happened in one's life, including the recent layoff at the plant and that awful secretary who is threatening a paternity suit in lieu of a cash payment? Dr. Forward says that she is "a big advocate of writing as a therapeutic technique"; and so a letter to Papa "provides a wonderful opportunity to organize what you want to say" to the pond scum; and it is "also safer if you're dealing with a potentially violent parent," ah-hem and hem-ah.

"A confrontation by letter works exactly like one done in person. Both begin with the words: 'I am going to say some things to you I have never said before,' and both should cover four major points: 1, This is what you did to me; 2, This is how I felt about it at the time; 3, This is how it affected my life [including the layoff]; and, 4, This is what I want from you now."

And if that doesn't work, try a face-to-face confrontation [after notifying the police].

And if that doesn't work, try running cold water on your wrists.

And if that doesn't work, try remembering that life is not a poem written by the angels; mothers and fathers can make as many mistakes as their children; the minimum daily requirement for family success has not been established; love has four letters but many variations; you can be good and fail; you can be healthy and die; and adults who are consumed by the events of their youth might do well to stop thinking about Mom and Dad and start thinking about growing up.

Afterword number two: It happens that I may qualify as a boy with a toxic parent. My father, now dead, was a man to be understood rather than embraced.

He was a fellow of the depression-era High Plains, a stone-faced South Dakota person with limited education, vision, and social implements. He loved my mother but could not show it; he may have loved me but did not know it. We passed the years of my youth without engaging in a full conversation. We did nothing together except eat.

We shared a home but no treasures. At Christmas he would leave $5.00 in an envelope on the tree, unable even to present a gift with personal grace. He was emotionally retarded; he failed in most of his employment endeavors; he had few interests, fewer goals, no friends. Years later, when I called home, and if he would answer before my mother, a cramped development, he would ask, "How are you?" After I answered, he would pause, in his box, and, not knowing what else to say, he would ask: "How are you?"

When he died, my grief concerned the waste of his life. Since then, I have come to miss him for what he was, a misfit. In any case, I do not resent having chosen him as a parent and do not associate him with my own toxic faults. It helps that my mother is now first to answer the phone, each time, and has been everything my father was not. She is a saint. He was a loser in all respects except for his association with her. I've learned from them both—our instruction must be pleasant and unpleasant or we would be crippled in life—and I'm grateful that the pair of them, different from one another in all respects, conspired to give me a chance to consider and love them together.

Addictive Admonitions

❧ ☙

Tomorrow is another day,
They say.
Oh?
Tomorrow will not come,
While today will not go,
And today,
Burning,
Broken rocks,
Dislocation
May never end.

During the Vietnam War I was asked a few times to help wounded men compose letters of explanation to their ladies back home. I was honored to do so but reluctant, particularly when the letters were to address amputations, paralysis, or blindness. I would advise the soldiers that it might be better to wait until all the ramifications of the wounds were known, until (if) they made important personal adjustments, and until they were certain that their sweethearts were still waiting for their return; it might be provident to wait, plainly, until the best arrangements might be made, and even then perhaps the news should be delivered gradually, to avoid a searing impact: first, "I'm wounded"; second, "In the arm"; finally, last in the series, "It's been removed."

Still, what did I know? What does anyone know, other than the victim, about this kind of hallucinatory chicane? It's daft to imagine there is reason to behold at every crossroad.

So, there I was one evening, seated at the bedside of a teenager from Michigan who had lost both legs a short while before. He said he'd stepped on—or someone had stepped on—a Claymore mine, the GI's generic term for any trip-wire device that, detonated, fills space with flying shards (sometimes as basic as nuts and bolts) that, at best, mutilate, and, at worse, kill.

"I was, shit, like I didn't even know it," the warrior said.

I said, "Right."

"I didn't hear it."

"Right."

"Shit."

He was a small person, from what I remember, swaddled in hospital sheets and the scent of antiseptics. He had been in Vietnam for half a year, straight out of a high school graduating class, and his face was marked with burns, tiny holes, red pimples, and sutures.

He lit the remaining inch of a marijuana cigarette.

He snuffed it after a draw and put it back inside a matchbook cover.

"Her name is Kathy," he said.[1]

"What do you want me to say?"

"Say I got hit."

"How long have you gone together?"

"I met her at basic [the initial military school]."

"You've been writing?"

"She does, all the time. I can't spell any good."

"You engaged?"

"We talked about it."

He started to cry.

1. The conversation here is only representative.

At that point we were joined by a man who carried files in his arms and called the wounded soldier by his first name. He was a civilian, I believe, maybe from the Red Cross, on an administrative duty. He was a pleasant man, too pleasant given the scenery, and, apologizing, he said he was required to get some information for this or that or the 201 files.

The soldier said, "Yes, sir."

"Do you need anything, my new friend?" the man said, overdoing it very much.

The soldier shook his head.

The man made notes. I said I would come back later, but the soldier asked me to stay; he was polite, he wiped his eyes with his thumbs; I made him to be a believer, a boy who had been scared but excited to be drafted, a lad who had hope in God, and in Michigan and America.

The civilian asked questions like a welfare officer.

"Did you work after high school?"

"I came right into this shit," the soldier said, reference the war.

He took what was left of the joint from the match cover and lit it again.

The civilian stopped writing.

I saw his look of surprise and said, "Let it alone."

"You can't smoke pot," the man said.

I said, "For Christ's sake."

The man said, "They'll have his ass."

Nurses had been passing. Doctors. They said nothing. They knew. They understood. But the pleasant administrator was stunned, insistent, and blind. Here was a youngster who a few months earlier was eating pizza slices at varsity baseball games; now he was lying shattered in a world that, for its incomprehension, might have been a science-fiction subject at the shopping mall movies, and he was struggling for any potential support. Too, he was surely the son of a working family, for that is the category that danced throughout the enlisted

ranks in Vietnam, and if that marijuana roach had been a can of beer, the administrator would have denied it as well.

The soldier stopped smoking, and the civilian took the butt, to field-strip the paper.

The wounded man resumed crying.[2]

All of us talked for a few minutes more. Finally, the man said he would return at a better time. Thinking back on it, I can't now condemn him. He was a nice fellow with a tough job, a set of rules, and a bureaucrat's lack of wiggle. Nevertheless, I hate today—as I hated then—his ordinariness. On departing, he turned to the soldier on the bed, who now felt guilty in addition to feeling victimized, and said of the stumps below his waist: "It's not as bad as it seems."

Not as bad as it seems. An eighteen-year-old double amputee.

Ignorance is the night of the mind, said Confucius, and without moon and stars.

I don't know what happened to the soldier who lost his legs. I want to think he recovered, opened a software firm, sold out to Cisco Systems, and now lives in a mansion along the Strait of Juan de Fuca. Men with serious war wounds occasionally make it big. Harold Russell lost a pair of arms in World War II and then won an Academy Award. Bob Kerrey lost a leg as a Navy SEAL and has represented Nebraska in the United States Senate. Max Cleland is an especially accomplished veteran; he gave up two legs and an arm in Vietnam and, in turn, became head of the Veterans Administration, secretary of state in Georgia, and a U.S. senator.

Others fail to make it. I was friends with a man who was paralyzed in Southeast Asia, who lived a few years with intractable pain; he

2. This man was not crying for himself. Not for himself alone. When we weep, we weep for us all; for Kathy, for those who can't spell any good, for those who are hurt, and confused, and facing the shadowy places where reside misfortune, ignorance, carelessness, and inequality.

could not concentrate enough to do much other than roll through the streets of destiny on the spoked wheels of disconsolation; he never made accommodation with a prospectus that included decades without the response of a woman in pleasure; and, one cold day, he shot himself in the mouth. I didn't blame him in the least.

And what about that Red Cross administrator? I don't know what happened to him either. But he seemed to have had credentials for the self-help industry. He did not have enough neurons to sense that sometimes, in some cases, anything goes. He doubtlessly felt he was saving the lad from himself by saving him from a marijuana high. And, in a windup courtesy to antediluvian correctitude, the only thing he could think of saying to that frightened and butchered soldier was "it's not as bad as it seems," which is the theme of ever so many of the bathos improvement books that people purchase, hoping the bromide is so, even while knowing it is not.

To illustrate. Psychologist and therapist Ed Nottingham has in fact written *It's Not As Bad As It Seems,* which is subtitled "Caging Your Sharks of Irrational Thinking." Dr. Nottingham, in good health apparently, and a member of the right-thinking establishment, would agree with the Red Cross man that running away from one's problem, with a drug, is a man-eating irrationality.

Nottingham calls this opinion: "a thinking-straight approach to happiness." He says on page 10: "Outlook, as well as belief, attitude, and self-talk, will play the most important roles in this book. You will learn that how you feel and react in a particular situation (and often, how 'happy' you are) is not based on the external factors but is largely the result of how you think, what you believe, and what you tell yourself about that situation."

Then he pins our shoulders on the very next page:

Start today. Begin to keep a diary or journal in which you log those daily situations when you find yourself feeling an emotion quite strongly. You may find yourself feeling very angry, frustrated,

anxious, or depressed. Or you may be feeling intensely happy, excited, or enthusiastic. In your diary, pick up on each of these emotions, and answer the following four questions for each situation:

1. What is the feeling?
2. How strongly did you feel the emotion (on a scale of 0 to 10)?
3. What was going on immediately before you started feeling the emotion?
4. And finally, what was your "outlook" in this situation? What was going through [your] mind right then when [you] had that feeling.

Old Ed never gets into what all this is about, except to say it is how we can, as he puts it in his best James Joyce prose, "pick up on [our] thoughts," meaning, I expect, being aware of them, which is in the same pocket as teaching someone how to seek a towel when they get wet.

In all of this runaround, Ed Nottingham makes the principal error endemic in most self-improvement works. He talks thin about skinny. He uses a good many words; he has page upon page of case-history conversations, exercises, pronouncements, and all that; but this is wafer stuff for the searching soul. Certainly, it is easy to know that things aren't so bad when things aren't so bad, as when a girlfriend moves out, or the only thing in the freezer is butter brickle. But what of the real problems of life: the death watches, the violence, the debilitation, the chain reaction explosion of endless reverses that incinerate the joys and faiths in the human breast?

What about losing both legs?

Even with amputation, my argument is that most people can (and historically are supposed to) muddle through their dilemmas if left to their own devices. The kid in the hospital did not have access to the "ABCs of thinking straight," as author Nottingham calls it, but he had a stash of grass, much more helpful at that hour on the clock.

It was no cure. It would not put him on his feet again. Still, often—very often—merely lasting to dawn is as necessary as it gets.

Make way for a personal example. It happened in Georgia, a state where the sun shines but sheds no light. A barbarian with a thick neck and thin soul took a swing at me in front of a gaggle of men whom he employed. The fellow had a deserved reputation for low standards, even in Georgia, and, angered, I took him to court. A mistake, it turned out. The judge in the case was a friend of the defendant, and the prosecutor was not only involved with him in business matters but was himself facing a similar charge of fisticuffs violence. Further, the barbarian's eyewitness employees stood up for him, each and every one, imagine that, and the brute was acquitted.

Even with all my experience, two million miles through the Georgias of the earth, I was appalled. I was forsaken by the system, and I was as much as labeled a liar in the verdict. I couldn't eat, I couldn't sleep. I retreated inside my property, erected a gate at the entrance to the driveway, and became a hermit for a time, seeing no one, trusting nothing, almost deranged.

The self-help authors would say I should have—what?—counted the blessings in my life or consulted the ABCs of thinking straight. Instead, I broke the givens of prudent behavior and honed a hatred for the barbarian that became cathartic. I collected a drawer full of information about his personal dealings, to use if he violated me again; I gave him a more likely and sinister identity, to depersonalize and demonize his pose as a person; I solicited stories about the blob from everyone who hated him as much as I did (an army) to buttress my considerations of his wickedness.

And, success. I decided over this passage that the brute was merely a redneck cartoon; I likewise decided that I was becoming almost as derisory, and it came to be that none of it was worth additional attention. Today I can't remember his name. He no longer exists.

Was I right in this reaction?

Some prisoners of war say they survived incarceration and dehumanization by loving and forgiving; others say they survived by pissing on the names of the captors scratched into the cell floors.

Whatever works. People are not mathematics. They are not wired the same. Gain can come from following protocol, or from putting it aside. The only rule is do no harm to others.

Yield to the truth: there is little truth. If you don't think you know anything in these concerns, you know more than many people, including the self-help people, a confederation of gowks. Have faith in yourself. Go your own way. At bottom, your odds of success are not bad.

Here are some more alternatives to the way everybody insists that you ought to behave:

Light Up

One does not think quickly of Arianna Huffington as a self-improvement operator. One thinks quickly of her as an opportunist, as a Republican mouthpiece, as a wealthy, privileged ho-hum. Yet she has written something called *The Fourth Instinct,* which aspires to be a manual on right-wing fix-yourself New Agism, which in turn is the revelation of—here we go again—the "secret power" that is domiciled inside Everyone.

Huffington, you may know, is a Beautiful California Person who hangs around the regnant centers, to lunch with the swells, and her idea of Everyone is limited to those who, like herself, have Cambridge educations and godzillians of dollars. Thus she writes in *The Fourth Instinct* that she stumbled across this secret power while on a *Grecian holiday.* She suggests she tripped over the "forgotten truth" in the chichi vicinity of Mount Athos.

The author claims the fourth instinct is the rock "on which every major religion and successful recovery program" is built. She says it

is the "still small voice of a soul trying to be heard above the static of our busy lives." She drones on: "Like the legendary Lost City of Atlantis, the Fourth Instinct has long lain buried in our common culture and in ourselves."

Say again: lain.

She credits her Mount Athos discovery with being, jeepers, "the next step in evolution," and promises that its acceptance and understanding will at last permit us to "exceed ourselves."

Reading further, the fourth instinct turns out to be a combination of will and common sense. But Huffington, bathed in lavender oils and Cambridge complexity, does not reduce it as such, for that would spoil the arguments that it, one, has been forgotten, and, two, is awaiting the evolutionary process of worldwide renewal. Grit has been as plentiful as neutrino activity for quite a while; and human beings graduated to common sense when they learned to stop at, rather than step over, the edge of cliffs; but today's personal-development books are born only when authors repackage yesterday in the paperings and the ribbons of tomorrow.

That said, this too: I have no quarrel with Ms. Huffington's fundamental premise, which, wiped of its Greek mysticism, seems to champion individualism. However, I do object to her exaggerated sense of it. If you have the money to muse at Mount Athos, and the influence to lunch with the swells, okay, you may well be able to control much of what you wish to control in your life; if you are one of the rest of us, here on Lonely Street, day after day, it's more accurate to know that you have no control in your life overall, and have only some control in the details.

That's why I believe that the legless soldier was right to smoke the marijuana and the Red Cross stickler was wrong to rob him of the relief. The stickler and Huffington would agree that the boy should turn instead to his inner self, and yet that's very much what he was doing in his own way. He was looking for a crutch of courage. He found it in a joint. Don't argue.

Yes, I know, marijuana is *illegal*.

Hands up!

There's a joke about this. The man in court says, "Judge, I want you to know how very sorry I am that I was arrested for using pot. This stuff is going to be very expensive in prison."

So, the point. Don't listen to the pinheads, listen to your own fair perceptions of expedience. Understand that reasonable answers to problems do not always have to be right or wrong, so long as they are reasonable answers. Too often there are no answers, of any kind; when there are, whatever they are, we should encourage their utilization, and we can sort out the morality, et cetera, the next time we are on a Grecian holiday at Mount Athos.

Herewith, then, in this respect, a brief brief for cannabis.

Marijuana, called hemp, has been cultivated on earth for at least five thousand years, probably more. It was grown initially to make rope, then it became a folk medicine, and moderns use it as a recreational drug. George Washington is said to have grown it for toothaches. Americans were once able to purchase its chemical essence from pharmaceuticals. It was marketed in the early 1900s in various forms of candy; mothers gave it to unruly children; medicos prescribed it for everything from piles to arthritis. Only in the current century has it been stigmatized as harmful.

The stigma is more wrong than right. Its prohibition was initially engendered by racism, and by Big Government manipulation, instead of by public health concerns. Lawmakers at the turn of the twentieth century began to view the plant as a hedonistic opiate for such lowlifes as the Hispanic field workers; and the government, which had for decades previously taken a laissez-faire attitude about intoxicants, was pressured by the edification evangelists (the religious right of the time) to, for God sakes, do something to stop people from feeling good outside of church.

That something was overdone in the extreme. State and federal statutes now classify the stuff in the same legal listings as cocaine and

opium. There is no flat evidence that marijuana is addictive; it does not produce the outrageous behavior that can be found in a bottle of rye; a joint does not fry the brain, cause hallucinations, or originate violence—yet its possession is not permitted in any state, except for some few medical reasons, and the penalty for planting what President Washington planted can be on a level with that of manslaughter.

Sure, there *is* a medical consideration. Hashish has a down side. All drugs, including Alka Seltzer, have down sides. Cannabis may create psychological dependence, as, say, No Doz may create psychological dependence, and the produce can induce panic, create anxieties, mix negatively with some prescriptions, and occasionally lead to a loss of self-control.

You should not use it while breast feeding, therefore.

Keep it out of your automobile.

And if you are a heart surgeon, please, not before a bypass operation.

Otherwise, it's up to you—legal, schmegal. If the brown grass helps, it's correct to be disobedient when the law is catatonic. If you are an adult, your decisions should be respected. I would not suggest excess, in this or anything else; I would also warn you to avoid it if you have even the slightest adverse reaction; finally, the relaxant is merely an aid, certainly not a remedy.

But let's assume you have a serious problem and require something to lean on. Assume further that the problem is sexual functioning. Your fourth instinct is not worth a postcard from Greece in something like this. But if marijuana is not an aphrodisiac, nine does not precede ten.

You might now take Viagra for the condition, a chemical that has been tested for a few years, or you might take cannabis, a crop that has been observed and consumed for centuries. Your choice. Viagra can make men hard, and aggressive; marijuana can make them hard and sensuous. Viagra affects the dipstick; grass, the engine. The first

brace is legal; the second is not. In other words, it's okay to take Viagra to get a stiff-on, but don't dare try to do it with ganja. Anyone who still believes in the rationale behind drug regulation, or that the authorities and the self-helpmeisters are in the best position to order our existence, please read this paragraph again.

It is true that you must qualify to use marijuana effectively. Your brain must be right side up. If you are vastly impressed with the rigid order of public opinion, forget it. If you are not, some suggestions for the ride: Smoke it; do not drink it in tea or eat it in muffins, unless your idea of refreshment is a Big Gulp. Go easy; the stuff is well grown today and potent in small quantities (a couple of pinches). Do it inside; the forests are for bears and hikers, there are men with badges on the streets, and, other than that, space can be disconcerting when you are levitating.

MJ is foreplay with a match.

Be kind when engaged.

And do not name the child after me, regardless of your gratitude. I can't afford to send a gift at graduation.

Drink Up

So the Irish preacher says to the drunken sinner: "Look at yerself, lad. Don't yer know that Drink is the worst thing in this world. It makes yer quarrel with yer missus. It makes yer fight with yer landlord. It makes yer take a shot at yer boss, and it makes yer miss."

Is there any self-help or otherwise meddlesome admonition that has greater currency and universality than that aligned against rum? The Muslim Koran says there is a devil in every grape on the bush. The decorous Scot, Thomas Guthrie, said there is nothing like whisky to preserve a man when he's dead. Ben Franklin, one of America's first self-betterment revolutionaries, cautioned against eating to

dullness or drinking to elevation; and a temperate, anonymous poet of the early 1900s was moved by his dislike of the spirits to write:

> *You are coming to woo me, but not as of yore,*
> *When I hastened to welcome your ring at the door;*
> *For I trusted that he who stood waiting then*
> *Was the brightest, the truest, the noblest of men.*
>
> *Oh, William, how it crushed, when first in your face*
> *The pen of the "Rum Friend" had written "disgrace";*
> *And turned me in silence and tears from that breath,*
> *All poisoned and foul from the chalice of death.*
>
> *If one spark in your bosom of virtue remain,*
> *Go fan it with prayer til it kindles again;*
> *Resolved, with "God helping," in future to be*
> *From wine and its follies unshackled and free.*
>
> *And when you have conquered this foe of your soul—*
> *In manhood and honor beyond his control—*
> *This heart will again beat responsive to thine,*
> *And your lips free from liquor be welcome on mine.*

It may be, of course, that William did make the pledge, if only to nail this chick. Abstinence is ever cited as the reason for suitable compensation. When Gary Cooper, playing Alvin York (in the movie), walked into the Tennessee mountain church, after being scolded by nature (a lightning bolt) for inebriation, the congregation rose as one to celebrate his sudden journey into sobriety, and, well, the record is that a new and much better Sergeant York went on to kill or capture 127 German soldiers during World War II.

Of course, the flood-level self-righteous have a lengthy manifest as concerns personal choice and the commonweal. They have at one

time or another decried the temptations of books, chewing gum, films, dating, Christmas,[3] automobiles, dancing, lipstick, orchestras, pomade, radio programs, higher education, and colored underwear. And they don't always wait for Alvin York to repent in front of the good folks. It says in the newspapers that some abortionists have been murdered by bombs in order to bring closure to their variety of dysfunctioning.

John Wesley, a man who knew everything there was to know about wanton disregard, said in the 1790s that even tea was "a wasteful, unhealthy, self indulgence . . . no other than a slow poison . . . abhor it as a deadly poison, and renounce it this very hour." Later, there was a Parson Davy, writing in a jolly document called *The System of Divinity* (1803), who said tea was a "too fashionable and pernicious plant, which weakens the stomach, unbraces the nerves, and drains the very vitals of our national wealth." This begs a question, but I apologize for not knowing if anyone has ever been bombed on the way to having a cuppa.

Still, in spite of the mad prevalence of Liptons and red panties, booze remains on top of the bill of societal malignancies, at least in the United States. In 1998, for instance, a Colorado school principal was removed from his position after allowing eighth-grade students to taste a wee amount of wine during a class trip to Paris. The principal argued that the purpose of the trip was to teach the students about the French culture, where taking a sip is cultural if not Eucharistical, and where children learn to drink responsibly through such conditioning as early tasting. But a casuistic superintendent heard of the criminality and lynched the principal in the name of whatever it is that also directs an anti-abortion Christian to waste adults to rescue babies.

The book *You Are What You Drink* goes directly to the besotted issue. In it, a couple of authors, Allan Luks and Joseph Barbato, write

3. The holiday was banned in early Massachusetts for being rooted to pagan customs.

about alcohol as if it were distilled from uranium 235. They say like Chicken Little that: more than two drinks a day doubles your chances of developing high blood pressure; one and one-half drinks a day increases the risk of breast cancer; more than one or two drinks a week promotes aging (one or two?—rot!). How much is too much, they ask? Nobody can say, they answer, closing the door on anything but the accepted socio-medico-politico shelter in the storm: "There is no accepted standard of safe drinking."

The writers claim in one way or the other that they are not attempting to promote prohibition. They acknowledge, faintly, that there are ninety million people in the United States who drink. They say they are merely trying to publish the facts, to help people make their own judgments, which in their book and in most others of the derivation is much the same as telling someone that he or she is free to go out in the winter if he or she is prepared to die of exposure.

Luks and Barbato have nothing reasonable to say about liquor except that it seems to have a sizable fan club. They do not mention that, consumed modestly, there are as many health benefits as health worries, and they do not mention that for every dummkopf who abuses the availability of booze there are four or five others who keep it around quite without incident, four or five others who serve evidence that there is after all an "accepted standard of safe drinking."[4]

Winston Churchill comes to mind at this moment. He said that he took far more out of alcohol than alcohol took out of him. The same can be said for seventy or eighty million Americans almost daily, along with a couple of billion human beings over the rest of the world.

And one thing that can be taken from it is relaxation.

This the remedy that addresses more human aching than all other medicines combined.

4. And what is the accepted standard for not drinking? Hitler was a teetotaler. It's said that nothing aggravates the temperate more than a successful drunk.

And here is where Winston and I would urge you to be good to yourself if you overworry about popular vigilance as it concerns indulgence. We speak to you in the assumption that you are healthy and disciplined, if maybe depressed or under stress. Reading another David Dwyer book will only strain your eyes; having a highball or a glass of wine can open them. Walk out to where the sun is setting, sit on a rock, have a drink, reorganize, decelerate; sorry, Dr Pepper won't work, because you have to generate a little (say again: a *little*) buzz.

Or maybe your problem is not one of depression or stress. Maybe it's serious, like war or television reruns. Get blasted, if it will help, and ram the admonitions that insist that you do not. (Think again of Churchill: "Yes, Madam, I am drunk, and you are homely, but tomorrow *I'll* be sober.")

Be sagacious enough to know that the wassail will not fix anything except the temporary. The happy thing is, that's often sufficient. Many people who drink while they're down take a public position that they are ashamed of their weakness and so on, but if there were no censure attached to the activity, they would instead admit that it helps them get through, regroup, and carry on. That is no different than a $5.00 pill from the pharmacy; and it's safer than the pill; Louis Pasteur said wine is the most healthful and most hygienic of beverages, and Louie knew more than, ah, that anonymous poet of the early 1900s.[5]

Which, whatever happened to friend William in the anonymous poem of a few pages ago? We believe that, chastened, he climbed on the wagon. Unfortunately, sources say, the woman had a change of heart, ran off with an Absolut vodka advertising artist, had several children by her houseboy at the vacation villa in Spain, and was in-

5. Louie also knew that it's not for everyone. Some people cannot safely consume alcohol, owing to complex physical or psychological compositions, and should (must) avoid it.

terested to learn in the papers one day that a very dry William was arrested carrying explosives near an abortion clinic.

> *If only we kith,*
> *If only we kin,*
> *Be as much fun to be with,*
> *As we be with our gin.*
>> —*Sailing tune*

> *"A blonde drove me to drink, and my only*
> *regret is I never thanked her."*
>> —*W. C. Fields*

> *"Deo optimo maximo."*
>> —*Benedictine prayer*

Get Mad

On page 13, in *Overcoming Hurts and Anger,* Dwight L. Carlson, M.D., recites one of those absolutely authentic medical case histories that clutch at a reader's heart and conscience.

"Joe," he writes, "is a 26-year-old machinist. One thing is sure—he doesn't have any trouble expressing his feelings. He makes it quite clear he is angry—a little *too* clear. Everyone was quite aware of the fact that he was angry when he broke his guitar into a thousand pieces just because his friend criticized his playing. His son knew he was angry at him for leaving his bike in the driveway, because Joe deliberately drove over the back wheel of the bike. His wife is very aware of his anger when he breaks windows, doors, dishes and furniture."

Dr. Carlson, described as "a well-known psychiatrist," believes that Joe is "applying the vogue of late that says that if you just get your feelings and anger out in the open, you'll feel better and everything

will be fine." Dr. Carlson says this is a miscalculation that is hard on the guitars and bicycles of the nation. Dr. Carlson says Joe has fallen prey to the tempting myth that if you let everything hang out, and bust somebody in the chops, inner peace follows.

The writer goes on to explain random other misconceptions about anger. His conclusion is that everyone should be brothers and sisters, we all must handle ourselves better, and: damn it, all, anger is nothing but big-ass proof of your tiresome immaturity and peppercorn lives!

And the likelihood is that William Stringfellow, Esq., would agree. William Stringfellow, Esq., is (or was?) a New York attorney, Christian soldier, and the author of several books that stand fixed against anger. In fact, the book stands fixed against every human emotion, except ardent faith in God, which William Stringfellow, Esq., believes stands fixed by itself.

Take the anger of being all alone in the pulverizing world. Stringfellow writes in *Instead of Death* that we should not waste our time on secular hope. He asks: What good is it to try to find release in work, for that will only fill the time but not the void; what good is it to have a drink, for that will only allow you to forget that you are forgotten; what good is it to find sex, for you may not then be alone but you will still be lonely; what good will it do to exercise positive thinking, for you will only hypnotize yourself into believing things are all right; and what good will it do to see a psychiatrist, who will only search for someone else or something else to blame.

No, Stringfellow, Esq., claims that if you have this problem (no money, say), or if you have that problem (no pulse), your objective should be fervent prayer. "Prayer," he says, "is nothing you do, it is someone you are, it is not about doing, but being." And now that he has those details cobbled together, he adds: "In prayer you cannot be [fill in your unresolved dilemma]."

Recall, this moralist is (or was?) a self-improvement author, a Christian, and a lawyer.

It means he can't help, is sanctimonious, and charges $300 an hour. If God were really good, he would instruct his followers to keep their eccentric spiritual opinions to themselves, and he would assign everyone with a law degree to the center gladiator ring at Rhadamanthus.

Without that, the rest of us should resolve to think for ourselves. Jesus is busy clipping his nails, and the self-help provided by others is guesstimation. Of course the Joe in Dwight Carlson's book is a ruffian who uses anger incorrectly. And William Stringfellow, Esq., is 8 or 10 percent right in noting that men and women who fill their time can still leave empty their character. But anger, like all human influences, has its glimmer, and that can be to punish the world for hurting us—a futility, in effect, but one that may take the edge off the sorrow.

The self-improvement books are wrong when they say we should not blame others, harbor hated, and rage loud in the dark. The planet is not yet secure for human beings who believe in the perfectibility of personality. It's better to admit infirmity, to admit fallibility, and to use our corruptions to advantage. We can't do anything if we don't do what is necessary to continue.

There is no case made in all this for bloodlust. Only beasts and political candidates chew on one another. The purpose is to point out that, as someone should say, anger can approach the prerogative of virtue if it is directed toward virtue. We should not rage at our fellows, we should not rage blindly, but we should neither forget that a fit of anger can prevent worse eventualities, like violence, like myopic disorientation, like the sure-fail condition of trying ever to be temperate.[6]

6. Observant readers will note that I have previously taken to task a self-helper who preaches that getting angry (slamming a newspaper on the table) is a fixative. And here I seem to do it myself. My excuse is that there is a difference between generating calculated anger according to a self-help formula—a step-by-step tantrum, something childish—and the human requirement to commit healthy, unstructured disgust.

Withdraw

Just prior to the midpoint of the nineteenth century, Ralph Waldo Emerson took a boarder into his Massachusetts home. The young guest was educated but threadbare, for he felt separated from a commercial community where, as he was later to observe, "Most men, even in this comparatively free country, through mere ignorance and mistake, are so occupied with the factitious cares and superfluously coarse labors of life that its finer fruits cannot be plucked by them." Taken by this sensitivity, Emerson taught the boarder to look at life in a new way, and to liberate himself from his pedestrian dilemma by reminding him, "All the world lies within you. . . . In self-trust all the virtues are comprehended. . . . Look in your heart. . . . Trust yourself."

So, listening now to his own piano, the boarder borrowed an ax and went into a forest near Concord, where he built a cabin, trusted himself, and wrote of his observations on independence.

"The mass of men lead lives of quiet desperation," he noted in one of only two works that were published in his lifetime.

> What is called resignation is confirmed desperation. From the desperate city you go into the desperate country, and have to console yourself with the bravery of minks and muskrats. A stereotyped but unconscious despair is concealed even under what are called the games and amusements of mankind. There is no play in them, for this comes after work. But there is a characteristic of wisdom not to do desperate things.
>
> When we consider what, to use the words of the catechism, is the chief end of man, and what are the true necessaries and means of life, it appears as if men had deliberately chosen the common mode of living because they preferred it to any other. Yet they honestly think there is no choice left. But alert and healthy natures remember that the sun rose clear. It is never too late to give up our prejudices. No way of thinking or doing, however ancient, can be

trusted without proof. Whatever everybody echoes or in silence passes by as true today may turn out to be falsehood tomorrow, mere smoke of opinion, which some had trusted for a cloud that would sprinkle fertilizing rain on their fields.

How to consider Henry David Thoreau? He was thought odd and impertinent in his time. Convention today reviews him as dysfunctional. Perhaps he had toxic parents. Perhaps he did not hug his fellows enough. My oh my, we think: one does not isolate himself on Walden Pond to come to grips with one's concerns; one turns to friends and family, one seeks group counseling on Thursday evenings in San Bernardino, one overcomes alienation by applying the Twelve Steps to Greater Understanding, one networks, keeps in the swing of things, and joins an exercise club.

Or, in the up-to-date view of Tim Timmons and Stephen Arterburn, one gets *Hooked on Life*. Timmons and Arterburn are self-improvement authors. *Hooked on Life* is subtitled "From Stuck to Starting Over," and the dust jacket features a happy fish lounging on the bend rather than the barb of an angling hook. Its authors would say this fellow Thoreau was obsessed, a condition they blame on "inner space invaders." Obsession, they say, is another bad word for *self*: "'What am I going to become?' 'Who will I be?' 'How can I do more?' 'Why do I feel so small?' 'How can I overcome?' The self is in shambles, and obsessions confirm the destruction."

The authors claim that "unresolved emotions" are behind obsessions: guilt, fear, and anger. If Thoreau had learned to "get unstuck" from the emotions, like a smart tuna, he would have resolved his feud with the marketplace and worked his way up in his father's pencil factory.

"Alienation and total isolation accompany the obsessed state," the gentlemen insist. "The person feels that the struggle to survive must be fought alone. Accompanying this are feelings of being misplaced or out of place. The alienated long for a geographical change in order

to find a place to belong. For a person in the state of obsession, belonging does not occur."

Apparently, then, Luther was also dysfunctional.

Timmons and Afterburner (I know, I know, a play on spelling; I like to think I'm Billy Crystal) offer three steps to end this coarse condition. They suggest that Henry Thoreau could have saved himself from a good many tick bites if he had practiced: one, public confession; two, group communications; and, a really big three, a commitment to starting over.

And if that were not revolutionary enough for the Concord Outsider, he might have followed the directions laid down in another book, called *No More Fears, Fight Your Fears with Nutrition.* The author of this blockbuster, Douglas Hunt, M.D., believes that supplements such as vitamins, minerals, and amino acids "affect our emotions, even the way we think," which is to hint that Thoreau and Luther could have used a little niacin amide.

Thoreau was obsessed with the fear of being "plowed into the soil as compost" by the workaday requirements, hence Dr. Hunt prescribes some B_1 (thiamine mononitrate), a tad of chlorine, regular calcium, and day-upon-day helpings of gamma-aminobutyric acid and glutamine.

How much better Thoreau could have lived in the twentieth instead of the nineteenth century, where he could consult Dr. Hunt and shop round the General Nutrition Center at Concord's indoor mall. He might today be an investment broker, on riboflavin. He might be an attorney, working for Trent Lott. And he might be as terrified as the rest of us of breaking from the grasp of the pack.

He might even be writing self-improvement manuals. And surely he would agree that problems must be worked out within the system. Do not retreat in anger, fear, injury, or emotional fragility. Do not withdraw into self in an uninformed attempt to resolve your brittle circumstances. Do not drop out, take off, or run away, for how can you hug your pals that way?

Listen to reason. Nutrition, for instance. Or group communications.

After all, even Thoreau resigned to give up his withdrawal and rejoin the herd. After twenty-six months at Walden, the writer came home. Yet, lacking supplements, he was crazy as ever, huzzah! "I left the woods for as good a reason as I went there. Perhaps it seemed to me that I had several more lives to live and could not spare any more time for that one."

And this, read it well:

Let us spend one day as deliberately as Nature, and not be thrown off the track by every nutshell and mosquito's wing that falls on the rails. . . . Why should we knock under and go with the stream? . . . If the bell rings, why should we run? . . . Let us settle ourselves, and work and wedge our feet downward through the mud and slush of opinion, and prejudice, and tradition, and delusion, and appearance. . . . Be it life or death, we crave only reality. If we are really dying, let us hear the rattle in our throats and feel cold in the extremities; if we are alive, let us go about our business. . . . Time is but a stream [we] go a-fishing in.

Have an Affair

Did someone mention pornography on the Internet? The stuff that shows purple vaginas is nothing. To be really taken aback, go to www.dr.luanne.linquist. This woman describes herself, proudly we add, as a self-help specialist who has been seen on *Oprah, Geraldo, Montell Williams,* and *Hard Copy.* And if that is not enough to chase her from the ranks of inveterate human beings, she has a Web site given over to the counseling of suffering Americans *by e-mail.*

Getting divorced? Lost your curls to chemotherapy? Thinking of sending a mail bomb to an intellectual opponent? Let Dr. Luanne

help. Tell her your pain, if you have a modem. Open up your heart to her, if your AOL bill is current. Dr. Luanne offers confidential counseling through the magic of cyberinteraction, and, great gold grapefruits, what won't they think of next?

Yes, the doctor—Oprah's pal, Geraldo's confidante,—can even help you with your illicit love life, providing you give her access to your credit card account. She says she is an "extra marital expert," which means she knows that when you get tired of your own spouse, when the creep takes to letting hair grow in his ears or forgetting to put the stay-fresh pads in her panty hose, you can and probably should find solace in the scented bed of someone else.

Return path: redhot@communitychest.com
Dear Dr. Luanne:
I have been married to Ralph for 18 months, and, talk about a letdown, he has taken to letting hair grow in his ears. So I have sought solace in Wayne, who is a Roto-Rooter man who I met in the pasta department at Safeway. The last time we did it was on the kitchen floor, next to his tools, and the only other times were in his van, and on the pitcher's mound at a Little League ballfield, if you don't count that first handjob in the pasta department. Wayne is a wonderful man, with his own route, and he has very clean ears. But I'm still married to Ralph. Can you help?

Return path: dr.luanne.linquist@selfhelp.com
Dear Redhot:
I have carefully analyzed your problem. As a counselor I have talked with many married women who consider straying when their husbands do not live up to their expectations. I tell them that it is a Big Step To Take. The question then is whether the Big Step is in the right direction. As a counselor I know that these

decisions are hard. You obviously admire Wayne, because of his tidy habits, but you still remember that you are married to Ralph. It seems to me you are thinking about it in a non-toxic way, and I congratulate you. As a counselor I have met women who act more on impulse. Whatever you do, remember: I will appear on *Hard Copy* on Wednesday next.

It could not be any easier than this, fellow persons. Done correctly, the computer can be of assistance in everything except cleaning up the sheet drips. Dr. Luanne will tell you how to hook up with someone just as helpless as you; she will give you profound suggestions on how the coupling can proceed successfully ("Be discreet"); you can then browse any number of talk sites for a partner with your interests (butt moles); and the pair of you can bring yourself to arousal at two A.M. by typing trash, threesomes, toe-sucking, and other quotations from *Ulysses*.

Or you can be more mature. Marriage is not a prison; you are not an inmate. Screwing between adults is seldom a debate on the end of your vital signs; and all of us fail in our ceaseless search to ever do The Right Thing. Some animals mate for life; others change partners daily. People are somewhere in between, and the only rights and wrongs in the variations are that persons alone must take responsibility for their choices and for the experimentations that they must make, which may propel them forward, hold them still, or pull them back.

As stated previously, my doctrine in these things is to do what you must do to remain stable, but I'm married for life to the limits prescribed by doing no harm to others. Spousal cheaters will therefore have to look elsewhere for support; however, those who are honest with their husbands and wives (also themselves) can get laid fairly anywhere they wish, so far as I am concerned, and good luck—you may need it.

Good-bye, Cruel World

Is there anything that can be said sentimentally about suicide? Only a skinny little. It is a mephitical alternative made worse by its public adherents, the likes of Derek Humphry,[7] who enjoys explaining how he helped his wife take her life, and who remains alive himself from the money he earns telling others how to die; and Jack Kevorkian, the Michigan humorist who ought in conscience to remove himself from the rooms of his victims, lest his be the last face they see on earth. (Have you noticed? Mr. K bears a startling resemblance to the Jesse Duplantis concept of Old Scratch. Sharp features, angular ears, let-me-eat-your-liver smile. What a way to go.)

Yet better men than these have considered the matter of self-murder, and understood. The Roman philosopher Seneca described suicide as the last act of a free will. Charles Caleb Cotton knew that this form of destruction "sometimes proceeds from cowardice, but not always; for cowardice sometimes prevents it; as many live because they are afraid to die, as die because they are afraid to live." And François-Marie Arouet (Voltaire): "When we have lost everything, when we have no more hope, [when] life is a disgrace, then death is a duty."

For myself, without editorial comment, I would consider jumping out of an airplane if I were rendered horribly disfigured, if I were condemned by Jesus to a terminal period of pain and humiliation, if I lost the use of my dick, or if I were not terrified of flying in the first place.

In living, there are no ready solutions.

Except perseverance, if you have the stomach for it.

* * *

7. Founder of the Hemlock Society, the name taken from the kind of Jonestown Kool-Aid the doomed Socrates was supposed to have been forced to consume.

Afterword: Back a bit, I made light of William Stringfellow, a man who has the audacity to be a puritan *and* a lawyer. It was, on second thought, reckless. Lawyers are not to be taken lightly.

Lawyers are Jack Kevorkian in better suits.

I'm thinking sadly of a schoolboy who worked for me on a newspaper I once owned. He was an excellent student, with a good heart, who went on to Georgia Tech University, where it took him several years to decide what he wanted to be as an adult. When he told me he was entering law school, it was as if my mother had eloped with F. Lee Bailey, and I sent him the following, distraught message:

Here is what a lawyer is. A kills B, everybody knows that A killed B, and C is the attorney who takes A's case in the name of D, justice. C has no responsibility to see that D is observed in the overall, only in the confines of the advisory system, which releases him from any burden to assure that B's killer is punished, that the streets are safe or that people can sleep well in their homes, and obligates him merely to find a reasonable doubt, quite possible, that A was not in the neighborhood when the hatchet murder, necrophilia and cannibalism took place.

O.J. Simpson, it's tee time.

CHAPTER SEVEN

God's Help?

❧ ❧

I don't have much faith in man.
But more in him than in God,
Who promises more than man,
And provides less.

Among the reasons I'm a cynic is that I've seen the elephant. Another may be that, as Lord Chesterton maintained, ignorance is often a necessary part of worldly experience. Suffering on a small graph may propel the innocent to the pages of self-help books; but the witness to planetary suffering may rather conclude that the misery is beyond explication, beyond remedy.

Say again. We insist as a group in believing there are solutions for our problems. This is in part because we have revised our definition of problems. A soccer mom searches for advice regarding *menstrual cramps;* an indebted businessman is introduced to *positive thinking;* a wino begins the first of the seven steps to—what?—*sobriety or another category of inebriation.* Meantime, a large chunk of the world's authentically troubled population is poised alongside dilemmas of which we remember nothing: invisible, inescapable evilness.

Problems? Stand down, Mom. Some notations from 1998:

Two in ten of the world's residents are chronically underfed.

Ten million children work in fields, factories, or brothels.

The world's four hundred richest people earn more money than the world's 2.3 billion poorest.

Fifteen percent of the world's people live in the twenty-two nations where the annual income is above $25,000. For everyone else, the average income is $600 a year.

Twenty million people are homeless and stateless owing to forced migration.

One billion people have no reliable source of safe drinking water.

Two poor families compete for every low-cost dwelling that comes on the U.S. market.

Six dozen shooting conflicts are waged on earth in a given year, and, though the cold war has ended, more money is spent on arms production and purchasing than is given over to education in all countries combined and to social programs in most countries combined.

The numbers scream. The cry is for moral comparisons. Inequality is the oldest crime of humankind. The starving have eaten dirt in the sub-Sahara, while investor Warren Buffet's net worth exceeds the gross domestic product of the nation of Costa Rica; pensioners in Russia resort to selling household belongings on the street, while Microsoft's Bill Gates earns so much money per hour that, arithmetically, if he dropped a thousand dollars on the ground while walking to his office, it would not be worth his time to pick it up; individuals are killed every day for being Muslim, Hindu, Catholic, or Protestant, while religious shills in the pulpits, in the convention halls, and in the television studios survive to pick more pockets in the name of Jesus.

Yet who in America addresses inequity anymore? Governments do not. Religion does not. There are no self-betterment tomes concerned with the question of egalitarianism and, say, Australia's dispossessed aboriginals, exclusive of research and policy papers that, regrettably, do not usually work and, as much as not, make things worse. After one hundred years of studies regarding American Indians, history notes, the tribes made little progress until they finally found on their own a weakness in the majority culture's confiscatory greed: gambling.

The dead at Wounded Knee should have known about draw poker. There would be no reservations if Bingo had been discovered in the 1850s. Fishing rights? Paleface, place your bet.

Anyway, equality is beyond the scope of the discussion here. So then, on the subject of real-world dilemmas, what can we make of something like wretched repression? And why do the least deserving and most destructive among us prosper with such outrageous consistency? The ghastly offenses done to people by other people are almost always recorded in water;[1] it's tolerated that the strong rule the weak by force; justice remains a convenient experiment, intellectual eyewash for all but those who can pay for it; and if it's true that bad men generally get theirs by dying, the same is true of good men, the difference being that we remember the thieves in songs and legends, and forget their victims soon after we divide their leavings.

A news reporter has talked with a Ugandan agent who served his heartless sovereign as a jailer, which meant that he had hung prisoners on hooks forced through their jaws; deadpan, he said that it was easy work, the pay was good, women feared him and submitted routinely, and the only negative he could mention was that he did not fancy picking up body parts for disposal.

"Body parts?"

"Ears or fingers. It's useless anyway when it's done like this. [If] you take off a foot, or an arm, [a prisoner] can die. Cut a woman's

1. In 1999, the United States championed a murderous nineteen-nation war against the Slobodan Milosevic regime in Yugoslavia. Billions of dollars worth of missiles were expended. Some of the people bombed were innocent civilians. When women and children were killed, the militarists called it "collateral damage." Beware governments that use euphemisms to describe slaughter. Also, if the notion of the war was to get rid of the malignant Milosevic authority, it would better have been done by getting rid of Milosevic; there are forces for hire that would have rubbed him out, also some of his aides, sparing everyone else the horrors of the proceedings that occurred. (As it happens, United States law prohibits the government from assassinating foreign leaders; killing nonleaders is entirely another matter. Lawyers understand this business.)

[breasts], she can die. They are no good dead. If you want to kill them, kill them—use a gun."

"You do this every day?"

"Noooo. When they tell me to."

"Why?"

"I'm a policeman. I have a family. I like people—I have nothing against these people."

Worse than this is an American acquaintance who once worked at a lofty level in the nation's efforts to decide when and where to use chemical and biological weapons in time of war. In interviews, he explains that he was detached emotionally from and protected patriotically by what he calls "the responsibility." He says that anthrax is no more morally indiscriminate than saturation bombing, and that using it is no more repulsive than the activity of the airplane pilots who drop bombs on people they can't see. Further, he says, as if he is comforted by saying it: "I trust God. He would not have led me into it if it was wrong."

Mind that, the evasion in the last sentence. Jesus is ever the plea bargain of the beguiling and befuddled. Religious conviction is famously trotted out to explain away wickedness. Caligula believed he was God. Stalin believed, credibly, that he was above God. The assorted moralists who fall between the extremes have regularly nominated themselves for posts among the Almighty's anointed. God, if all this is true, which it may or may not be, can be a shit.

Yet it is fitting that vermin seek sanctuary in the misuse of the church. It's a universal failing. When reason flags, prayer has potential. And the lesson is not lost on the authors of self-improvement books, who rarely fail to cook acceptable notions of goofy good feeling. It is always auspiciously correct, even if it's not in any way helpful, to further the blessings of spiritual assistance. If you are broke, if you are lonely, if you are in any way out of sorts, worship.

Verily, even if you are impotent. There are Christian self-help sex books. They explain that the union of men and women in coitus is

divinely inspired; they say that God invented sex to secure marriage; and while it is true that Jesus was not himself created from the missionary position, fucking is a tool used in his name, so activity within reason is to be permitted, to be encouraged, for the sake of multiplication. And while God wants men and women to get it on, all he asks in return is that they support the word, read Matthew 19:12,[2] and—no dirty stuff.

That point made, here are three other books that reveal God's ideas of self-help:

The Wholeness Handbook

This softbound work, subtitled "Care of Body, Mind, and Spirit for Optimal Health," was written by Elaine Emeth (said to be a spiritual director at a Maryland health center at the time of the writing), in collaboration with Dr. Janet Greenhut, a physician. It seems Greenhut provided the medical content, while Emeth contributed the ideas regarding Jesus, inner peace, and humbug.

Nice people, I'm sure. We'll do a number on them anyway.

The authors' theory is that good health is not just avoiding calories, fats, and unprotected fisting. They say devotions should be taken along with other vitamins. "The wholeness paradigm is integrated, not dualistic. Rather than believing that body and spirit are separate (dualism), we look at the human person as an integrated, inseparable whole. Health means wholeness; it must address the physical, emotional, spiritual and social dimensions of personhood."

Yes, *personhood*. Yes, *paradigm*. Yes, *dualism*.

This is not a book to take on a wild-hair vacation.

2. "Some are incapable of marriage because they were born so; some, because they were made so by others; some, because they have renounced marriage for the sake of the Kingdom of Heaven. Whoever can accept this ought to accept it."

Nor is it a book for particularists. The authors say the brand name of your spiritual convictions is of no import. "Our perspective is an inclusive one. . . . Our intent is to offer our readers the opportunity to respond to the movement of God within them, within their own faith traditions." So breathe easy if you're a Zarathustrianist. Stone worshipers are also welcome.

Big stuff follows:

Page 32. "Death is not necessarily a personal or medical failure; it is part of the human condition. . . . The death that concerns us here in our consideration of healing and wholeness is the refusal to be fully alive. This kind of death is exemplified in 'living in neutral,' going through the motions of everyday life mechanically and emotionally untouched, or even in the will to die."

Page 35. "We can name attributes of God, such as Live in the universe, Love, Truth, Justice, Mystery, and Wisdom, but we cannot name or define God. God is infinite, beyond our ability to know or even to imagine. The unpronounceable name, YHVH, respectfully attempts to refrain from reducing God to something manageable for our finite minds to grasp."[3]

Page 66. "In order to provide health care that enhances finding meaning [sic], the physician must be priest/shaman as well as doctor, or else he or she must be assisted by an interdisciplinary team. Since unconscious concepts are powerful in influencing our sickness and health, the team should include persons who are gifted at facilitating bringing the unconscious to the light of conscious awareness. . . . The images can then be brought to counseling and prayer."

Page 79. "True healing is more than a cure of a specific complaint; it affects every dimension of the human person. . . . First, there is the

3. Rib-ticklers believe that YHVH is the most ancient of spiritual names. They swear to Betsy it is short for *Yod He Vau He,* words that are not merely words but "universal law."

honest recognition of need: the person articulates his or her problem, accepts responsibility, and acknowledges his or her dependence on God for healing. Second, there is a pilgrimage or sacred journey to a consecrated place: a temple or healing shrine, a treatment center, hospital, support group, retreat center, or the sacred 'inner space' of one's own interior."

Page 82. "Sabbath, solitude and silence create space in our lives to listen for the 'still, small voice of God.' Discipleship requires the discipliner of attentive listening. Listening is at the heart of obedience, since it opens us to receive God's word, grace, and power in our lives. We would do well to follow the Jewish observance of Sabbath."

Page . . . oh, blow it. Emeth and Greenhut have written an oblong book that is mostly circular. Any page reprocesses the other pages. They say no one, and they mean *no one,* can be well without faith, and though they provide no evidence of this, they say it over and over.

And over. Infidels have feelings, too.

If you happen on the book, tear out the first 115 pages, those devoted to Emeth and her relentless religious considerations. The rest of it is by Dr. Greenhut, who gives fair if widely available advice about health maintenance and does not put the name of God in every sentence.

Hey God, What Should I Do Now?

The authors of this canticle of literature, Jess and Jacqueline Lair, are said by the publisher to have leaped to international celebrity with a previous publication entitled *I Ain't Much, Baby—But I'm All I've Got.* That first book is listed as a richly inspiring account of how the authors survived and prospered from their personal problems, not the least of which was the husband's heart attack. This second book is also a richly inspiring account of how the authors survived and prospered from their personal problems, not the least of which was the husband's heart attack.

This is what happens when self-help publishers print first books by weak authors. They print second books by them to show they still don't care about giving readers any provisions.

The *Hey God* book is written in richly inspiring trade-off chapters. Jess writes one, Jacqueline the next, and so on.

It's a test for those of us who do not believe in manslaughter.

The publisher says the couple—real folk, same as you and me—"are happier now than they ever were, because they have evolved a working philosophy for a rewarding, meaningful way of life, the 'secret' of which they share with us in this deeply personal and searching book."

Jess: "As I lay on that cart [after the heart attack], I thought deep and clear for the first time in my life. I realized my whole life was screwed up. . . . As I lay in that hospital room waiting for my wife to come I felt a deep calm. It was as if all my distracting thoughts had been cleared away and my mind and soul could concentrate all their energies. . . . I thought that my whole life had gotten way off the path. It was like coming to a fork in a road and taking the wrong fork."

Jackie: "I submit. I never was a fighter. Down to the [hospital] waiting room. Oh God, where are you? It's so lonely in this paneled room, in this leather chair. I look down on the lights of the city. It is dark and snowy and cold. What time is it? Why don't I ever wear a watch? I must have three at home in my drawers somewhere. Look at all the traffic. All of those men going home to their families. Why wasn't I a better wife? Why did I get so angry at Jess . . . ?"

Jess: "One of the thoughts I had [about when he was previously screwed up] was that my brother, who wasn't making nearly as much money as I was, had a deer rifle and I didn't. I had a huge home and cars and was spending lots of money. But I didn't have the hundred-dollar deer rifle that I had always wanted."

Jackie: "By the end of the day panic and exhaustion had set in. I knew I couldn't handle the children, the house, the hospital, and the business, too. . . . That night, our first night together without Dad, was

difficult. I set the table in the dining room and we all sat down in our usual places with himself's place conspicuously empty. This was too much for Jess Howard Lair, age nine. After fidgeting in his chair for a few minutes, my black-haired little eminence picked up his plate and marched to the head of the table. As he climbed into his father's chair he looked at me and said, 'I'm sitting here 'cause I'm the oldest boy.'"

Jess: "I realized [pre–heart problem] I was doing a bunch of things I didn't believe in. I found myself saying to myself 'I'm never going to do anything [again] I don't deeply believe in.'"

Jackie: "Damn, damn, damn. He is stupid. I love him, but for a smart guy he sure is dumb. He doesn't know how to relax. He's so damned tired. . . . He has to run, run, run."

The pair continue like such, damn, damn, damn, turning a scary, if entirely personal and all but ordinary medical experience into badly rendered tedium—and then, Jess finds Jesus:

> So now [post-hospitalization] I have come to believe in a very personal God who listens and speaks in my life, so I frequently during the day say, "Hey, God what should I do now?" And that question usually gives me a feeling for what to do. And it usually keeps me out of the sick games I have played so much—and still find myself playing sometimes. So now I have a different feeling about my religion. . . . I used to think I had to be more pious and holy. Today I'm saying, "Hey God, what should I do?" And then trying to do that as well as I can.

Richly inspiring, what?

One. Everyone who has a Just-for-Jesus decal wants to relate the story behind it. And every story is a tale of living wrong, discovering revelation, and then becoming happy ever after.

Two. Even when the stories are true, attitude is at least as responsible as religion. Folks can change ever as profitably by deciding to work for the poor or entering honest politics.

Three. A thoughtful religious person would not respond to the greedy question, "Hey God, what should I do now?" People, as all animals, are supposed to think for themselves; otherwise, life would be naught but a series of stiff and binding regulations. Besides—frequently—there are no answers; there is—frequently—only the need for thoughtful remedial consideration. A man stops on a street at night to be confronted by a lunatic with a gun. Jess Lair tells us he would ask, "Hey God, what should I do now?" Would you? Not hardly. You'd run. Good.

Transform Your Life

Little about the Rev. Dr. Barbara King would suggest that she would practice juvenescense. She is founder and minister of a chapel in Atlanta, and her photograph represents her as mature, sophisticated, and well turned out. Yet the author of *Transform Your Life,* subtitled "From Fear to Faith, From Loneliness to Love, From Self-Doubt to Self-Discovery," writes as if she were a child who has learned that butterflies are beautiful and so takes the information to Show & Tell.

In this case, the Rev. Dr. King has discovered that God rides a golden chariot, and she wants to make sure everyone gets a ride. She is dazzled by biblical words that have been around for some time; she is amazed that there is a divinity that loves us all; and she wants to show that if we will accept This Love in our hearts, if we will put Jesus before everything, before our mothers and fathers, before our sisters and brothers, before our spouses and children, even before ourselves—blessed be correct priorities—he will guide us through the strain of existence, just as he did with (on page 1, so this book runs quickly past the wicket) "Daniel in the lion's den."

Not that the Rev. Dr. King is altogether on her knees in this endeavor. She stands up to a degree for the modern as well as the his-

toric version of YHVH. She calls him (and her) the "Father-Mother God . . . because since everything was created from this one source, then clearly both male and female are contained within It." Ergo she suggests that golden charioting is an equal opportunity employer, and the world it serves has a new proper pronoun: "It."

It is watching over us.

From the capital of the Kingdom of It.

That departure made, the Rev. Dr. King gets right back to Show & Tell. She divides her book into fifteen chapters (actually, it's two books; the volume enfolds an earlier canonical masterpiece, *How to Have a Flood and Not Drown*), the contents of which she dusts liberally with scripture and with the kind of religious rodomontade one hears on Mississippi Sundays.

Chapter One. "What Are You Afraid Of?" The Rev. Dr. King writes movingly of the little-known Last Supper, at which Jesus told his disciples: "Truly, truly, I say to you, he who believes in me will also do the works that I do, and greater works than these will he do, because I go to the Father." In other words: "The miracles that Jesus performed are ours to perform."

Chapter Four. "The Power of Prayer." The Rev. Dr. King writes that we can all stop worrying: "Take a moment and say, 'God this is (state your name); need I say more?' What you are saying is 'There is nothing else to say!' God loves you. God appreciates you. So there is nothing else to say but 'Here I am . . . I simply acknowledge that You and I are one [a nuclear It].' Even this simplest form of prayer can become your way of being in touch with the Lord."

Chapter Six. "Turn Your Water into Wine." Now we're getting somewhere. The Rev. Dr. King remembers that when the wine gave out at a wedding party in Galilee, Jesus had the servants fill the jugs with water, and, behold, Jesus, Son of It, turned the water into wine. The Reverend Doctor takes this to mean that "if something goes wrong or there is not enough of some good thing in your life, you have within you the force that will change the circumstances."

Chapter Seven. "Relationships." The Rev. Dr. King says, "Don't wait to get the new relationship—begin now to know that wherever you are you deserve the best. Increase your faith in God and strengthen your prayer life ["God, this is (state your name)"]. . . . As you plant this affirmation . . . it will bring forth abundant fruit. I also found the first verse of the twenty-seventh Psalm to be helpful: 'The Lord is my light and my salvation, whom shall I fear? The Lord is the strength of my life, of who should I be afraid?'" Neat—can a Psalm get us a date for the movies?

Chapter Fifteen. "Where Do I Go from Here?" The Rev. Dr. King notes inventively that "it is easier for a camel to go through the eye of a needle, than for a rich man to enter into the Kingdom of God [It]." Fortunately, she explains that this doesn't mean you will go to hell if you die on your yacht. "If we are willing to put God first in our material quests, then we don't have anything to worry about." The pope, with all those ermine duds, should read this passage with relief. The rest of us should read it with wonder. A soft D at Show & Tell.

It's fine for the Rev. Dr. Barbara King to believe life can be a chariot trip. She makes a living selling tickets. But it's a poor preacher who instructs others according to winning words alone. There's a great deal of pulpitry in this book but no soul, and, for most people, no help.

If there is anything worse than a misdoing self-help author, it's a misdoing self-help-and-god author; a step below that is the he or she who sticks the Father-Mother in everybody's eye.

The reviews are over for this chapter.

Be kind now, and hold still for some accessory rampaging.

The addenda is necessary because the atman continues to insist on ruling as an unseen specter. And because religious workers and writers continue to get paid for telling us that it shouldn't matter if he fails

to make appearances at press conferences. There's a pesky dubiety in this. Let's offer one drachma, plus the Book of Common Prayer, to anyone who can prove a concrete worldly intercession by the Father-Mother, Sister-Brother, Holy Ghost, YHVH, or It.

Let's extend the offer as well to those of auxiliary religious beliefs; there are peoples who worship totems, fish, shoes, cloud formations, the stock exchange, and Diana Spencer, all of whom are sure that their faith is the true faith, founded on the usual recipe of inspecific wonders.

In fact, the Christian Commander has a more checkered record than some of these other Godheads. The Old Testament does not conceal the brutalities of Jehovah, a bloodthirsty totalitarian who, we are to believe, during one rainy season, murdered everyone on earth save Noah and his animals, because the victims were not sufficiently righteous. That means there was not one innocent child, not one caring little old lady, not one neighborhood do-good who was worthy of what in the New Testament would become the accepted entitlement of omnipresent charity, a notion much easier to merchandise than bolts-of-lightning bludgeoning.

Yeah, the flood business is known by educated Christians to be only a parable. But what is the lesson in that? Sunday school children are taught that the God who at one moment could drown everything save a miserable pair of each species was at the next moment, one hundred pages later, helping the lame to walk and the blind to see. He was in other words, over time, a bad cop–good cop; this is not so different from what the hoodooist sees as the Father-Mother Cloud Formation religion that brings the drizzle first, followed by the sunshine.

And even as the God of Abraham became the Christ of Nazareth, the softened stories are unnerving. The biblical Jesus was smarmy, conceited in the overall, and largely without warmth: "If thy right eye causes you to sin, gouge it out . . . if your right hand causes you to sin, cut it off." Keep in mind that he warned that the greatest sin was

not believing in Jesus. That is to note that if you have any question about the way and the light, any slight misgiving, you should cut thy eye out of its socket. Wonderful. And very Christian. This chap said, more or less, to do it his way, or else, and he did not speak of degrees of guilt, but just guilt, including innocent guilt, and would have flooded the earth, to weight his argument, if his patrician had not already played that tune.

> *We celebrate*
> *Passover*
> *When God saved the Israelite children*
> *From the sword,*
> *Forgetting,*
> *Not caring to remember,*
> *The innocent who were slaughtered,*
> *In this religious experience.*

The book *Ain't Nobody's Business If You Do,* by Peter McWilliams, points out that Mr. Christ was so unlovely and careless, at least in biblical narrative (modern language), that he brushed off his family. For example, he ran away at age twelve (Luke 2:44–48), he was distant from his brother (John 1:29–34), he paid no particular attention to nuclear kinship (Mark 3:31–35), and, so far as he was concerned with his virginal mother, she was not very special, ho-hum:

When a woman in a crowd blessed the woman who gave Jesus birth, Christ said, "Blessed rather are those who hear the word of God and obey it" (Luke 11:27–28)—a snotty act by any measure. And when he was dying at crucifixion, his mother grieving below, he said nothing of tenderness but merely introduced her to another man, told her the man would henceforth be her son, and told the man, "Here is your mother" (John 19:26–27)—a swell enough gesture, it should be concluded, had it been accompanied by: "Mom, I love you, and I always will."

Well, author McWilliams is being uptight in this rendering. And me too in its retelling. The Bible, like all writing, is shorthand. The truth known, Jesus may have shared his cat's-eye collection with James and devotedly served Florida pecans to his mother on the veranda. Yet if the preachers and self-help scriveners can quote the Gospel for their ends, in their interpretations, the field is open to all shooters. Jesus is less than lovable in scripture, and his pop is the greatest grump of all time. Considered together, it is no wonder that some theologians have preferred totems and rocks, and see God as a phrase—time and nature—a neutral Hobson's choice.

The venerable philosopher Charles Hartshorne is old enough, according to the joke, to have known God personally. He was one hundred in 1997 and one of the few great souls of his calling to have an old-fashioned if rational belief in the Maker. His thinking, called *process theology,* is that God is great in spite of the withering, ancient, and errant doctrines surrounding his existence. In this respect, Hartshorne believes that God may have limits—may not, for one thing, be aware of every leaf that falls—but is permanently engaged in the compassionate process of human oversight.

Oh, to believe that! After all, the purpose of religion is to bequest hope. The faithless say that was also the reason for religion—a packaging of promises, so that the leadership could keep the miserable in check, from butchering the leadership, for one thing. Beyond this, we all must have something to have and to hold, to belong to, and the Soroptimists at this level don't cut it.

What is more, the belief can be impressive. I've met at least two saintly women in my life, Mother Teresa of Calcutta and Mother Angelica of Tennessee. About the first, there is nothing to add to the record (Jesus would do well to follow her example). About the second, she runs a nunnery and a television station on the edge of Nashville, and I was introduced to her when she was trying to get the studio into operation. Angelica had a bad leg and a beautiful personality then as now, as well as a countenance to light up dark nights, and when I

asked her how she could afford to take her belief in Jesus to the airwaves, to gather the money to finance a satellite broadcasting facility, she said: "He will give me what I need."

I wrote that down at the time, because it made a good story, telling the readers that this seraphic broad, who did not know a megahertz from a melon, was using God as an venture capitalist—successfully. She put together the first Catholic television outlet of its kind, costing millions of dollars, all by way of the numen's generosity, she said. "When I need something [the satellite dish in the backyard of her convent], I pray for the money, I wait, and there it is."

"Where?" I asked. "On the doorstep?"

"Maybe in the mail," she replied.

"A check from Jesus."

"You might say so."

In fact, Mother Angelica's shift into nonecclesiastical capitalism was financially more complicated than she admitted. If YHVH does not have deep pockets, many of his minions do. The good mother's studio was bankrolled in the end by faithful business people. But let's not pick it too close. Angelica thinks God *told* his fat sheep to contribute, thus providing indirectly; and one is left to admire her confidence, although it fails to meet the smell test of dialectics.

For those not ready to gamble on the Bread of Life's holy concern for show business, I recommend a visit to a humble evangelical church. That's where they get the shakes and hot flashes at the mention of Jesus. The florid television ministers are in my mind dwelling in the sewers of faith (Angelica excepted); they are frauds who would worship sport utility vehicles if there were donations to be had from it; but the men, women, and children who speak in tongues or pick up snakes in the nation's rural churches are no-doubt devoted, and I think the finer for it. They are peculiar, they are obstreperous, they practice unbridled reasoning, and we can make light of their abstruse ignorance, but they have the best of what religion has to

offer: confidence. And I hope to God they get their reward for it, a chariot ride with the Rev. Dr. Barbara King & Company.

I can't personally succumb to the temptation, though.

My own judgment of theism is too harsh. Show me.

Here again, we offer our pocket change for a scrap of proof. People see the imagery of Jesus, or more often of his mother, in everything from grottoes to garment cloth (Lourdes to the Lady of Guadalupe). I can't see anything at all in the view from my tall mountain in Virginia.

And please don't shout at me about faith. That's the escape route taken by the charlatans. It's a trail with no end. In the 1980s I wrote a newspaper column about a Catholic priest in Arizona who went to Medjugorje to see "the Madonna." He claimed she then came back with him to Prescott. He wrote a pamphlet about the conversations she had with his parishioners and quoted her in ways that were lifted from the hoary language of the burning-bush Gospels.

She said (he said) things like "flesh of my flesh," and "unto his body," and "light the way," and blah, blah, blah, as if it were still two thousand years ago and close by the Mount of Olives.

I asked the priest about this inability of the First Babe to talk in modern terms. Why so much of the conversation could be found in a thousand-times-a-thousand other writings. Why, bothering to go all the way to where the Apaches once ran with the buffalo, she did not say anything new, anything interesting, or so much as inquire why it is that boys now wear jewelry in their eyelids. The priest, a television wanna-be with many of the mannerisms of Elmer Gantry, said only, "I do not have to explain Mary, or myself." He doesn't? All right, good-bye.

Blind faith. It is, as someone has written, mere superstition where evidence is absent. And the conclusion should be considered by self-help readers who are serious about discovering solutions for problems. Close your eyes, and your mind, and make all the wishes you want; God does not meddle. If he did not or could not rescue Nanking under

Japanese occupation, if he does not or cannot save the Tutsi at the hands of the Hutu, he will not leap from the contents of a book to put a woman in touch with a man who is sweet, or a man in a place of full employment.

> *It is good form, when*
> *One person in one hundred survives,*
> *To believe that providence intervened*
> *Mercifully;*
> *And the corporate citizen*
> *Thanks heaven for favors*
> *When he invests his prosperity in himself.*
>
> *Yet faith shall not be cited*
> *When the crops fail,*
> *Or a child stops breathing,*
> *From disease,*
> *And the street wretch cries out*
> *For consideration.*
>
> *God has to be good.*
> *He cannot be suspect.*
> *And we are left to guess,*
> *Who is regulating the adversity?*

With apologies to philosopher Hartshorne, there is no good reason to think that God is minding the store. Quite the reverse. The only evidence at hand—the ten-thousand-year triumph of heartless inequity and insensibility—is that he is on permanent leave. If the wackies are right, and Jesus is coming again, we should make a citizen's arrest; he should be charged with incompetence, found guilty of false advertising, and sentenced to community service.

For many, religious expectation is a tidy way to mislay personal responsibility; and passing it down, from generation to generation, promotes a community of baffled cripples, millions of unfortunates who have been led to understand that there *must* be caring gods, there *must* be celestial Merlins, there *must* be supernatural answers, only to find, when experience is the instructor, that reason and goodness work just as well and they are commodities grown on earth.

Further. If God intervenes at all, it seems often on the wrong side. Who are the rich, and the famous, and the powerful? Routinely, they are the damned, the dirty, and the disgusting. In witness of this, when my own life has bottomed, I can argue that God may help those who *take* for themselves, and I envy (fleetingly) they who are without scruples, without conscience, who are on top of the world, paying their bills without effort, and enjoying life to the fullest.

At the same time, we need be fair in this reflection. Christ may only be a victim, as are most of the rest of us. He's chosen not to make commentaries on the six o'clock news; what we know of him is what others have told us to believe. Maybe all that he really talked about on the sands of Mesopotamia is what people should do for themselves, and the message has since been twisted, as everything is eventually twisted, by freaks and zealots in the employ of self-interest.

Maybe he said there is no life after death, but only the present from which to profit.

Maybe he said doing right is a reward surpassing idolation.

Maybe he said, candidly, that all we can expect is what we freelance.

However, this is not so bleak a prospect as it may seem, except for those who do not function easily inside their own tissue cover. For them, condolences. For the rest, you are deputy gods, in this scenario, with instinctive rather than magical powers to plot your directions. Recognize only that your powers are limited and pledge to bitch about that all the way to the grave. It will make the journey more compelling, more satisfying, and, if not less difficult, less discontenting.

And if there is a God, and he has any genuine concern for any welfare other than Robert Schuller's, we would be nicely advised to lean on and communicate with the chap realistically:

> *A prayer to the God*
> *Who does not show himself*
> *Often enough.*
> *Leaving wonder,*
> *Of the opportunities*
> *Prayer affords.*
>
> *However.*
> *Please endeavor from now forward*
> *To elevate human existence*
> *Beyond the fears*
> *Of events*
> *And time.*
>
> *Institute justice,*
> *Which is the triumph*
> *Of cooperation,*
> *And the incarceration*
> *Of greed and subjugation.*
>
> *Arrest those, also,*
> *Who practice intolerance,*
> *Who injure others as policy,*
> *Who are mendacious and without mercy,*
> *Who steal the moments of the flowers.*
>
> *Force us together, in this work,*
> *Rather than apart,*
> *Through,*

Mandatory application
In Mutual Service.

Stop the horrors,
Promote the trust that history condemns.
That is your job,
Is it not?

Amen.

Afterword: A journalist conducted a journalist's street poll in the 1980s that was concerned with the enthusiasm with which people embraced religious faith. He asked, (*one*) Do you believe in God, and (*two*) If so, would you demonstrate that belief by dying for God, right now, today.

He talked with sixty passersby. A third of them would not respond. Of those who did, nine in ten said they believed in God, and all but three of them said, yes, they would lay down their life for Jesus. Of the hesitant three, a man said he loved the idea of God less than that of his family.

The results were not unexpected; neither were they, maybe, allusive. People often respond to questions like this in a reactive way and avoid contradiction. If one believes in God, one would die for God; it's expected. And since the test is imaginary in a poll, it's also safe.

Further, God may be watching. So sacrifice here is not only expected, and safe, it's smart. People who believe in God believe in absolute power. Best to maintain the insurance premiums.

Certainly, some of the respondents may have been willing to drop over. Millions of religious people may be willing to drop over. But, reader, if you are not prepared to die for your God, *this instant,* it's a hint that you don't really think the personal-development jockeys are

on top of anything when they insist that deities fix your teeth, or build Catholic television stations.

Afterword number two: Abraham Lincoln once said, "I have been driven many times to my knees by the overwhelming conviction that I had nowhere else to go." Even cynics and atheists pray when words fail. Providence may be sleepy, and random, but, please, it can't also be deaf.

Yet what do we pray for, the Lincolns and the rest of us?

For mercy, for the most part.

Help us find food, stay well, have enough money, avoid surgery. The Lebanese poet Gibran noted that we pray always in our distress and our need but seldom in our joy and abundance. The ratio reflects the baneful sadness in God's world. There's more of the first part than the second (we are given a death sentence along with our birth certificate—in other words, no free bus fares), and so long as there is we might do well not to count much on the ears of heaven.

Dear Jesus: Why did Stalin and Mao die of old age in their beds?

Afterword number three: The principal instruction in the Christian church is that Jesus suffered and croaked for us. And the business on the cross is thundered as the most painful event in history. The crown of thorns digging into the man's head. The procession featuring the dragging along of the execution instrument. The pounding of nails through flesh and bone. The crucifixion icons in Mexican churches carry this message most graphically, with painted wounds and rivulets of blood designed to prove that here was a guy, or was it a guy-girl, friend of all in any case, who so loved his constituency, "sufrio agradecido por nosotros."

Oh?

Christ did not go happily, remember, and complained he'd been forsaken. Nor did he die any worse than the thousands of other people who were crucified by the Romans, people never mourned or recorded, people who were often good, kind, and exemplary. Further, his pain was not so great as that experienced by millions of human beings, before and since, many of whom have taken years rather than hours to die, and without the soothing conviction that they were the son of God and that all of that hanging-by-the-arms was temporary twaddle.

There is a revealing line in the splendid Australian film *Breaker Morant*. George, one of three colonial soldiers on trial for murdering Boer outlaws, tells the others that he does not want to die, and Morant, a poet, replies: "Every life ends in a dreadful execution, George. Yours will be quicker and less painful than most." The same could be said of the death of Jesus Christ.

I don't stoop to dismiss the torture at the cross, or the lesson, whatever it was (the system stinks?). But I would have Christians feel more about the pain of their fellows, if no less than that of their divinity. If I understand it right, the divinity should characteristically agree.

In 1998, a young theology student named Warren Helm rushed to help a stranger who was being beaten by eight thugs at a bus stop in Washington, D.C. The gang then turned on him and, while other onlookers did nothing, punched, kicked, and stabbed Helm to death. The world would be a better place, and we would require fewer self-improvement documents, if we remembered the last moments of Warren Helm as we remember those of Christ. But we do not, God save us.

Afterword number four: Even separating the idealistic version of Jesus from the mixed messages in the books of the Bible, it puzzles

how so many women (see the Rev. Dr. Barbara King) cling to scripture. If the phraseology of the Gospels often treats humankind with belly wounding, it can be especially foul-tempered regarding women. The girls, according to the Bible, are here to service the boys and keep otherwise out of the way. Even Mary has little identity in the pages.

I Corinthians 11:7–9. "For a man indeed ought not to cover his head, forasmuch as he is the image and glory of God: but the woman is the glory of the man. For the man is not of the woman; but the woman of the man. Neither was the man created for the woman; but the woman for the man."

Sirach 25:26 (Catholic Bible). "If thy wife does not obey thee at a signal and a glance, separate from her."

Ephesians 5:22–23. "Wives, submit yourselves unto your own husbands, as unto the Lord. For the husband is the head of the wife, even as Christ is the head of the church. . . ."

This scriptural infamy has not been historically overlooked, of course. Free women have regularly charged that the biblical renderings have shaped social and institutional options that are short of progressive. One of the most significant modern complaints was put in two books published in 1898, *The Woman's Bible* (I and II); the now obscure works were written by Elizabeth Cady Stanton, who with Susan Anthony founded the National Woman Suffrage Association.

Stanton's assessment of the Gospels was as burly as the Gospels' assessment of women. "Here is the Bible position of women briefly summed up," she wrote in the introduction: it teaches that "woman brought sin and death into the world, that she precipitated the fall of the race, that she was arraigned before the judgment seat of Heaven, tried, condemned and sentenced. Marriage for her was to be a condition of bondage, maternity a period of suffering in anguish, and in silence and subjection, she was to play the role of a dependent on man's bounty for all her material wants, and for all the information she

might desire on the vital questions of the hour, she was commanded to ask her husband at home."[4]

And this: "Take the snake, the fruit-tree and the woman from the tableau, and we have no fall, nor frowning Judge, no inferno, no everlasting punishment—hence no need of a savior. Thus the bottom falls out of the whole Christian theology."

The Woman's Bible sold briskly. But Stanton's success was costly. She and the women who collaborated on the writing were denounced not only by Christian authorities, but also by many religious members of the Woman Suffrage Association, who, at an 1896 convention, and over Anthony's impassioned objection, voted 53–41 to condemn what they said was an atheistic work, and removed Ms. Stanton as the group's president.

(To his credit, or the credit of his biographers, Christ is not quoted as demeaning the rank of women. The accounts of his contacts with women portray him largely as a democrat. Women were not brought into his confidence, not even his mother; otherwise, he is clean.)

4. *American Heritage,* September 1998.

CHAPTER EIGHT

Doing Injury

❦ ❧

We shrink from death,
While alive,
Rationalizing.
It will hurt very much,
If in silence.

But, too, existence has conspired
To punish us,
For embracing it,
Which is to say surviving.
And this also is painful.

We must decide,
Therefore,
Which is the more injurious,
Accepting this,
Or that.

Choices.
They are often poor.
Expect it.

I have mentioned before in these pages my occasional contact with the late Doctor Benjamin Spock, the patrician pediatrician who be-

came as well known for his civil reform activities as for his do-it-thouself books (*Baby and Child Care,* etc.). During one of our conversations I maneuvered his attention to a public-issue story I had written about a rural woman's effort to remove controversial publications from a school library in Tennessee.

I told Spock that the woman did not want to become known as just another fascist book burner (even though she qualified as just another fascist book burner), because she felt that she was morally honest in her motivations and because she had organized her censorship campaign around the argument of the greater good.

She had said, for example, that she was not after books with dirty words or evolutionary theories; instead, she denounced books that she believed had the potential for "doing injury."

Such as: *The Adventures of Huckleberry Finn.*

The woman said her community had many minority residents, that Huckleberry's black friend Jim was stereotyped, and that teaching the word *nigger* can be a corruptive lesson.

I had told the woman that the Mark Twain book was a story of its time, and history should not be hidden. She replied that there are other ways to coach history, in which instructors could use the tool of quality control; she said thirteen- and fourteen-year-old children who read the book merely as an assignment may learn only that black people are largely roughneck and always to be reproached.

"There are reasonable restrictions on many things we do in this country," she insisted, "and there also have to be limits to freedom of the press. What if somebody wrote a book called *Set Fire to the Sister You Don't Like*? What if someone wrote *Putting Poison in Hospital Food*? What if someone published *How to Kill the President of the United States*?"

I asked Spock what he thought.

He smiled and said, surprisingly, that the woman had a point.

I said, "Ban *Huck Finn*?"

He said no. But he said it with a qualification. He said kids and

adults—sometimes adults especially—can be impressionable and easily misled, and books *can* do injury, particularly if they are popular, or written by authorities. He said: "No one should think I know everything because I'm a medical doctor. They should use their own judgments when they read my books. If you let someone else [like Ben Spock or Mark Twain] do your thinking, you get into trouble."

I have been thinking of Spock's assessment while writing this critique of the fix-yourself business. I will therefore forgo the call for a Fahrenheit 451 solution to such publications as *Life's Little Instruction Book, The Science of Self-Confidence, The Art of Exceptional Living,* and (I'm weakening; hand me the matches) *Clean Out the Closets of Your Life.*

Rather, I'll refer you again to Spock's last sentence. Beware. The people who write self-help books and provide other personal-repair instruction are only occasionally evil, but they can commit evil anyway, and they can do injury. It is not simply that their programs are spectacularly commonplace or ineffective, it is sometimes that they are bitingly counterproductive as well. They are tinkering with our emotions and with our brains—which are sensitive enough—and they are also posturing as authorities who are qualified to do all of this impersonally, sight unseen, in the leaves of books, by way of audiotapes, and from the fusion of those little colored dots on the television screen.

To illustrate, Dr. Susanna Hoffman is the creator of *Men Who Are Good for You and Men Who Are Bad,* a destructive paperback that represents the perils of categorizing human beings by paragraphs. Miz Susanna, a cultural anthropologist who has let the thrill of publication get the better of her professional discipline, says that there are twenty-two distinct types of men on earth. Not twenty-one, not twenty-three, but exactly twenty-two, most of whom, it turns out, are assholes.

To list them:

The Short Affair and Quick Escape Artist. The Woman Hater. The Male Supremacist. The Woman Hitter. The Compellingly Intense (But Crazy) Man. The Amoral Passion Monger. The Hustler. The Baby Chaser. Mr. Genius. The Idle Lord. The Disaster Broker. The Man Who Would Be Mogul. Gay Man One. Gay Man Two. The Father Knows Best. The Sugar Pie Honey. The Courtier. The Kid. The Secret Manipulator. Intimate One—The Loving Traditional Man. Intimate Two—The Loving Many-Faceted Man. Intimate Three—The Loving Limited Partner.

Even reading the titles should be discouraging for any woman on the loose. Nineteen of Dr. Hoffman's folks are ferrets, leaving only three with some human potential. Applied evenly to the general population of the United States, that implies that roughly 85 percent of the people with three legs should be buried in landfills, and that America's 130 million women have only about 8 million good men at their disposal. It also means that Dr. Hoffman should not be given a YMCA membership.

"A man may seem wonderful at first," Susanna writes, gracelessly, "only to turn into a criticizing woman-hater once a woman is truly committed to him. Other times a man who comes on with a rush of loving care only means to spend a quick six weeks enjoying a woman's companionship and body. Others charm a woman with a portrait of the exciting life they have to offer, obscuring how they will always think they are more important. Perhaps under his beguiling smile a man really wants support, financial and otherwise. He remains a perpetual child, or he turns a woman into an angry shrew with his relentless, saccharine kindness."

I'll review the selection, selectively.

The Male Supremacist. "[He] feels that men not only have precious paraphernalia, they have inherited superior qualities and special privileges. They possess a singular hold on intelligence, ability, and rank.

They have an exclusive right to mastery, mainly over the opposite sex. And they are free to do what they want, while woman simply aren't." Hoffman goes on to point out that this kind of cad dresses with his pants low on his hips, is jealous, prefers flashy cars, "sleeps on a bare mattress and wipes his face with yesterday's shirt," and shows his biceps to his partner to demonstrate that women cannot match the muscle development of men.

The Idle Lord. "He leaps onto your stage like an outlaw or a trickster. He knows what's wrong with the whole wide world, or at least the half he's living in. He can show you that what others think is right is most definitely in error. He disdains compliance with the 'normal' ways of acting, and especially with common toil." Dr. Hoffman warns that the Idle Lord thinks the world and its women owe him a living. She says he sometimes buys clothes from Goodwill, wears Samson-style hair, carries no car insurance on his vehicle, and women who dally at all with such a man might profitably "withdraw from all sexual relations for a while."

The Kid. Dr. Hoffman says this is the man whom the time machine froze between youth and maturity. He's nice, everybody likes him, but he's a Beetle Bailey who does not pull his weight in the army of humanity. Therefore, "he runs no risk of promotion." Women will know who he is when he stumbles into their lives and takes them out for hamburgers. They can also tell him because parts of his body are eternally adolescent ("his feet were meant for someone bigger"). Also check his skin; Hoffman claims "it's a disaster." And he bites his fingernails. And he has a cowlick under his baseball cap. And he has old tires on his big van. He eats Cheerios and prowls garage sales. And the only time he's sexual is if he drops his ball, you bend to pick it up, and he "accidentally falls on top of you." As Father Knows Best would say, tsk, tsk.

So now you know. A pretty bleak lot it is, it is. And thank the morning light that Susanna Hoffman has fallen on top of the numbers. Stay away from guys with low trousers, musty smells, or long

hair; stay away from Al Einstein, Bill Gates, and Robert Young; stay away from permanent tykes who have big feet; stay away from everyone except those few fellows who merit Hoffman's blessings (excluding those who are married, under twenty, over ninety, or in jail, there are at least forty to fifty of them on the planet).

Oh, Susanna! Where did you get your degree in cultural anthropology? And why do you want to injure the majority of men on the planet who are less than perfect? There are male supremacists in abundance who would lay down their lives for their women. There are baby chasers who merely look, as their ancestors looked, for the strength of youth in their mates. There are idle lords who take rather nifty care of the home and the children, thank you; and there are eternal kids who help prevent everyone from growing up too damn much.

Twenty-two categories?

There are thousands.

Three of my own drawing, for perspective:

The Breadwinner. He works all his days for his wife and family. He gets up at five for the construction crew, or at seven for the bank position, so that the children's shoes are purchased, the home is heated, and there are presents available on the holidays. No one offers congratulations. Nobody writes about him. But he is the rock on which this nation rests, he is the fellow who builds the bridges, fights the wars, and furthers the institutions. And if he has a calendar of faults, if he has a cowlick under his baseball cap, he is a true hero, Dr. Hoffman, even if not considered that way by women searching for, say, your ideal "Loving Many-Faceted Man."

The Boy Scout. He marries a woman of twenty, who changes perceptibly at thirty, and is a whole-nother person at four-zero. Where once she was intimate, now she is busy with the dried flower business; where once she was full of fun, now she is muzzled by Valium and PTA intrigues; where once she adored him, now she thinks chiefly of her children, none of whom think about him at all, except as an old guy who is mostly in the way. Yet he trucks on. He does not

chase around, he does not check out. He may overprotect, he may bite his fingernails close, but when he still calls her babe after all the alterations, we can assume that he means it for the good.

The Struggler. Nothing comes to him without a knot in the string. He fails regularly and succeeds occasionally. He is overlooked and underpaid. He turns old when yet young. He drinks, he gets somber, he feels trapped behind the door, but he cannot be defeated. He picks up when knocked down, he tries when others would quit, and he shares, and provides, and warms. He holds his spouse as she cries, he secrets dollars for his kids' education, he mends the roof, he repairs the car, he works the fields, or the marketplace, and he is the stuff of masculine legend that Susanna Hoffman has forgotten, or, if I fathom her fairly, has never known, great pity for her.

Dr. Hoffman is a wee writer with large knuckles. She does not explain men so much as grease them. In doing so, she injures women as well. Those who read her book for advice on compatible coupling find instead a rad-fem sigh regarding The Unbearable Burden the Ladies Have to Hoist. With all the idle Lords, in their Goodwill suits, driving uninsured cars, sisters, it's plain to see why the convents are under an enrollment siege.

Susanna is entitled to her warped interpretations. Readers are entitled to full disclosure. Authors who dislike men or dislike women should be honest about it. Somewhere, plunging into this harmful book, the reader discovers that Hoffman does not think any men, even the few she lists in her minority assessments, are worth preserving; let's castrate male babies to save trouble.

Sure Things

The best part of being a God Person is the lack of complication in being a God Person. Where those of lesser faith must spend their lives turning over rock upon rock to find solutions to the disorders that

come in the same folder as birth, the God Person simply turns to, as the Dead End Kids used to say, the heavenly fodder. Money troubles? Heartbroken? Got ichthyosis? Ask God; he'll provide, so they believe, as long as your heart is pure and you pays you tithe.

In the 1970s I wrote about a Christian mission in Boston that claimed it could make productive citizens out of homosexuals. The minister in charge of sexual perversions said God knows with whom we are reaching orgasm, and is standing by to keep it on the up and up. The claim has more recently been adopted by several God Groups, such as Exodus, which holds that Jesus wants to save gays from a lifetime of disease, sin, and other destructive behavior:

"Studies show a high degree of destructive behavior among homosexuals, including alcohol, drug abuse and emotional and physical violence. . . . Still, many have walked out of homosexuality, into sexual celibacy or even marriage. How? Often because someone cared enough to love them, despite where they were, and to confront the truth of their sexual sin. For the Christian, that love comes in the person of Jesus Christ and motivates our commitment."[1]

In words of a different kind, then, God can do everything. He can even put one's dick in the right place. He is a sure thing. The view begs a contrary wonder, of course. If Jesus is really Mr. Fix-it, why is it not clear to everybody? If the answers to our dilemmas were so simple, it would be more obvious than it is; everybody on earth would just pray for deliverance, and that would end the wars, the famines, the hatreds, the evils, and the bends that consort with age. (There would be no aging, dammit. Everybody would be twenty-three. All of life's crap starts at twenty-four.)

And yet, doesn't it at least seem sweet on the tongue? The notion of the sure thing? If there were easy answers, if there were guarantees, everything would be all right, and Lucille would come back to take care of the kids. Such is the seductive lure in religion, and such

1. Newspaper advertisement, July 1998.

is it too in the secular self-assistance industry. Nobody writes a repair book with a preface that admits to hesitant prospects; instead, they promise results; that's the temptation and part of the sham.

The title of a Norman Monath paperback makes this point by itself: *Know What You Want and GET IT!* It does not say Know What You Want and TRY TO GET IT! or Know What You Want and GO AFTER IT! The pledge is explicit. The words GET IT! are printed two inches high, occupy a third of the book cover, and make the compact that if you fork over for this "practical guide," it will show you how to achieve your goals and "get the most out of life."

The author is described as a person who "started in the Simon & Schuster mail room and grew to become the founder" of his own publishing house (as fate would have it, it's a self-help house). This amazing progression apparently enabled him to learn "all the top techniques for achieving success," and eventually he took the time, thirty or forty minutes at least, to list all of the top techniques in—if we are to accept the trope—one of the most overlooked books of our age.

Monath says that the top techniques include: determining what you really want, attracting good luck, putting the strength of others to work for you, concentrating on the present, thinking "three-dimensionally," controlling your life, thinking creatively, knowing why some people make it to the top, wishing for what you want, and making everything the best.

Suddenly, bells are ringing in the chapels.

Monath has cut wide paths for human direction.

Let's go right to the lesson on attracting good luck. The author says the way to do it, success seekers, is to recognize great opportunities, expose yourself to those great opportunities, and then respond, or GET IT! He talks of the time that Walt Kelly (the *Pogo* cartoonist) came to Simon & Schuster with a question about music. He says he recognized the opportunity in that, he then exposed himself to it by

talking further with Kelly, and this led to a GET IT! collaboration (a book and record album) that put him on his meteoric course.

Arresting, what? This is the kind of material that makes you want to found your own publishing house. And maybe you can after you read the chapter on making everything the best. Monath writes: "I call this chapter 'Make Everything the Best,' instead of 'Make the Best of Everything' because the [rejected title] implies settling for the status quo rather than trying to change things for the better. Change and rearrange—that is the key to getting out of the rut and onto the road that leads to where you want to go."

So now, having recognized the enemy (it's semantics, Pogo), the author draws again from the top techniques he mastered while climbing out of the Simon & Schuster mail room to advise us that we can make everything the best by: one, knowing that we have power to "turn liabilities into assets"; two, knowing that bad luck "can be a blessing in disguise"; three, knowing that we can "weather the storms of depression and make the transition from frustration to satisfaction"; four, "not playing destructive games with ourselves"; five, acting "as if it's impossible to fail"; and, last but not least (well, okay, least), snatching victory from the jaws of defeat.

New paths, for sure. What a way he has with words and ideas!

Norman Monath uses up nine pages in the chapter on making everything the best. About eight and a half pages reflect examples of his own exhilarating success in life, or borrow from the writings of other self-help prophets (all of whom write better, and say more, which is neither writing much better nor saying much more). For his own points, he lists First Principles that have been in circulation on the planet since the days before fire enabled Oscar Meyer to (as Monath might explain it) recognize and respond to the opportunity to get people roasting hot dogs.

On the last page of the book Monath says: "I have presented all the information I have gathered through the years on how to know what

you want and get it." Closing the cover, one can only sympathize with a man who, despite a rocket life, despite the golden days with Walt Kelly, despite making only the best of everygoldarnedthing, admits more than he knows.

And anybody who is helped by his book still needs help.

For the latter readers, another suggestion. You might try a British publication entitled *Direct Your Subconscious,* which, if nothing else, tells us that royalism isn't the only example of confused thinking in that nation. The book is authored by Paul Harris, whose credentials are not revealed, which is too bad for those of us who want to know from whence people come who can freely make statements such as: "Having led you through the following pages, I know you will possess the knowledge to enable you to succeed in every aspect of your life."

This fellow writes with a pow-crunch conviction that indicates he may have started in the mail room of Ticknor & Fields. But he soon puts our minds to ease about it: "Re-reading the sentence you will probably realize that this is a promise without limitations. I would hazard a guess that you have already begun to restrict what this book can actually teach you. Your habit-conditioned mind has rejected the possibility of truth in [the] statement."

Fools. "If you are wise you will cast aside failure-oriented doubt and deadly self-limitation long enough to learn how I propose to fulfill my promise . . . you must accept the possibility."

Here's a bloke who means business, dearie. Habit-conditioned minds. Failure-oriented doubts. Deadly self-limitations. This stuff is on target like a William Tell arrow. Like Henry at Agincourt. Like Rumpole in Old Bailey. The book is deep as the Thames, wide as Windsor arrogance, and we shall delve into the details in the following segment concerning Secrets.

Meantime, we can first decide that authors Monath and Harris are ninnies, and their references to sure things in the self-improvement literature are moronish, and possibly injurious. When one promises

most things, without delivery, one merely breaks a confidence, or a compact. When one promises help, without justification, the result can be physical or emotional dislocation.

Who buys self-help publications? People who are, or feel they are, in trouble. It can be said reasonably that people with a sense of failure might purchase *Know What You Want and GET IT!* It can also be said reasonably that judging from the title and the inside rhetoric, they should be able to expect a shot at success. Then they read it. Then they find there is nothing in it that helps, that, to be sure, there is nothing in it that they haven't tried before, and before, and before. In the end they may be so discouraged they do not even retain the motivation it took to look for the book.

"What are you doing with that poison, Wally?"

"I ain't never going to be nothing."

"Who says?"

"Norman Monath is who."

"You read his book, and didn't GET IT!?"

"Yo."

"Here's a spoon, Wally."

Hush-Hush Secrets

Anxiously, we return to Paul Harris, an Englishman cut from the fabric of William Shakespeare and William Gladstone, both of whom called sausages "bangers." No one may accuse Harris of literary evasion. In his book *Direct Your Subconscious and Drive to Success,* he lets everything hang out. He writes on page 11 that not only has he discovered the "secret" to success, and to power, which is the same thing, he hastily lets us in on what he knows is the secret behind the secret:

> The fact is that the principles you are to receive have worked, without exception, for everyone who has tried them. In the process of

my research I have uncovered numerous success stories. However, the true extent of its success is uncertain. As is always the secret with power, those who are fortunate enough to have gained it are in no great hurry to broadcast the formula. They would rather keep the powerful advantage that they have received to themselves.

So that's it! Here we are, the mass of us, struggling to get a few lumps of coal to put on the fire, while the louts who are raking it in are keeping to themselves the secret reasons for their riches. It takes a guy like Harris, whoever he is, to toot the bugle. Shakespeare learned us about lawyers. Now Harris puts the lantern on the selfish. May there always be an England.

More, Harris goes Bill one better. He says we can cope with the arrogant by joining them. He says that the "secret power is comparable to any one of the natural energy sources (electricity, gas, wind etc.)," and thus all we have to do is understand how to "plug in and utilise" it. He says if a reader will plug in and utilize the secret power of his "subconscious reprogramming techniques," a distillation of the secret powers of success, the reader can overcome any limitation, from obesity, to alcoholism, to nail biting, to impotency, to insomnia, to poor memory, and "will never again look at a particularly successful person and think 'I wish I were as lucky as he is.'"

And what is the secret power? Harris breaks it down into ten chapters. They include: "Defining Your Goals," "Understanding the Mind," "Positive Reprogramming," "Utilising Your Unconscious Mind," "Stress Relief," and "The Elimination of Fear." Where have we seen these chapters before? Sure, in every other book written on the secrets of success. That would be 600,000 books, and even more secrets; it's awful how this stuff has been withheld by the successful.

Ergo, we salute Paul Harris for British pluck. As he ruminates about the secret power of, say, defining goals, or stress relief, he again insists it should be taken to heart: "At this point I would like to say just a few words to the sceptics amongst you. During your study of

[my book] . . . there will undoubtedly be a few grumblings and mutterings of 'mumbo-jumbo', 'it couldn't be that straightforward' or words to that effect. Well it *is* straightforward, and if you do not give it your undying attention, and actually TRY the techniques I have outlined, you will have deprived yourself. . . . The only thing that may prevent you is your existing inadequate self-image."

That last line hurts a mite. The English can be blunt as well as loving. So, not wanting to put the Stars and Stripes to shame again, let's overcome our self-image, and plunge into a second revealing book about secrets, maybe the most secret-revealing book on secrets in our self-help library: *10 Seeds of Greatness: The Ten Best-Kept Secrets of Total Success,* by Denis Waitley.

Unlike Paul Harris, Waitley is merely an American; there is no evidence that he has a personal relationship with Shakespeare, or Gladstone, given the unfortunate occasion of his birthplace; but he is listed on his book cover as "a national authority on high-level performance and personal development," something Richard III would appreciate ("They that stand high, have many blasts to shake them. And, if they fall, they dash themselves to pieces.").

We can tell Waitley is a national authority in the very first line of his work. He says, "This is the last self-help book you'll ever need to read."

Right away, he deserves the benediction of all humankind, British as well as American.

Eagerly we go to the second line. Then the third! The author reveals how his grandmother told him to plant seeds in life ("the seeds of Greatness are attitudes and beliefs"), how a dog named Buckwheat taught him about love (he looked like a giant rat, but he had a heart), how dreams are the gifts of the gods (and it don't matter none if nobody else has 'em).

Then, seamlessly, he reveals in full detail what he has learned as a national authority on high-level performance and personal development; what we already knew from Paul Harris has been shamefully

hidden from us, the ten best-kept secrets of total (not partial but total) success:

One. *We must feel love inside ourselves before we can give it to others.*
Two. *Our minds cannot tell the difference between real and imagined experience.*
Three. *Our rewards in life depend on the quality and amount of our contributions.*
Four. *A large vocabulary characterizes the more successful person.*
Five. *The reasons most individuals fail to achieve goals is that they do not set them.*
Six. *A touch is worth a thousand words.*
Seven. *Life is a self-fulfilling prophecy. You get what you expect.*
Eight. *The good old days are here and now.*
Nine. *Winners work at doing things others are not willing to do.*
Ten. *Perception, how we see life from within, makes all the difference.*

Uh, secrets? This slag? It may be that Denis Waitley has been too occupied as a national authority on high-level performance and personal development. It may be he should get out more in traffic where he would learn, for example, that the necessity of having respect for oneself is not a secret but a cliché; that a principal ingredient in everybody's baby milk is setting goals as a prerequisite for achieving them; that William Shakespeare and William Gladstone used to soldier on about the importance of education, vocabulary, and that they were merely repeating the directions handed down from the days since men and women found out about the repeating sun.

The only secret on this list, then, is that "a touch is worth a thousand words."

I thought it was a *picture*. But I'm not a national authority on anything.

If Denis Waitley had really listened to his grandmother, he would not plant the seeds of prevarication in the title and in the pages of his

book. And he would not have grown the weeds of false hope. The author started with a lie, and ended with a lie; so his instruction has no meaning.

A defining disposition of our time is that too many people search for answers that are not there. When they can't find them in reality, they turn to other sources. The self-help industry works on this weakness by offering the other sources. The authorities on high-level performance, on high-level relationships, on high-level weight reduction tell us that after years of research, after peeking into the crevices of human history, they have at last found the Lost-Secrets-That-Fix-Everything and will share them with us for the price of a paperback and the surrender of reason.

The worry in this is a reminder of what might be called the Laetrile Medical Syndrome.[2] If an apricot pit can be popularly marketed as a cure for cancer, desperate people will get in line, maybe at the sacrifice of real treatment, and everyone loses except the reptiles who vend the product. This does not argue against alternative medicine, for the victims of cancer or for the victims of personal inadequacies; but contrary to D. Waitley, life is anything but a self-fulfilling prophecy; it is a road to the unknown, and unknowable, where we cannot expect to fix cancer with counterfeit hope, where we cannot expect "secrets" or "secret powers" to steer us from anything except sobriety.

A sidestep. Okay, admission, there *are* still secrets in our surroundings. And there *are* many people-rescuing discoveries yet to be made. It's possible that something useful will be discovered in the apricot pit, and that there are as yet unknown answers in the universe to as

2. If you package a curative, and it doesn't work, you don't admit it doesn't work; you say the government is suppressing it, not allowing it to work by not allowing it to be sold. That gives it a wreath of the forbidden, and it becomes a *secret* potion. This encourages an admass of victims to obtain it illegally, completing a cycle that revolves on and on until the packager turns his attention to other misrepresentations.

yet unknown questions. But philosophy is not a clear horizon on this outlook. Even if we learn to better manipulate the brain, and regulate the body, we will still be dealing with human limitations, among which are frailty and emotion. Learned men and women have tried for thousands of years to sort through this combination; they have succeeded only a little; and not one of them has left behind a secret, or left behind directions that suggest secrets to come, to alter the meager legacy.

Afterword: I mentioned above the Tennessee woman fixed on removing a Mark Twain book from her public library. She asked, in defense of her censorship philosophy: What if someone published [a book about] *How to Kill the President of the United States?*

It's time after all these years to answer. I might not read it, but I would not ban it. Words are not threats unless they are kept from discussion. The law does rightly censor some words, such as "How to Kill John Anderson, 1515 Main Street, Pleasantplace, Indiana," because that would be an invasion of Mr. Anderson's privacy. But regarding the president, he is the most intensively guarded individual on earth; his security force includes thousands of human beings, rules that prohibit air flight over his dwellings, and every useful weapon known to the militarists; yet, as a *public person,* he cannot constitutionally seek protection by the suppression of thought.

As for the story of Huckleberry Finn, the references to black Jim do indeed sandpaper today's sensibilities. But the moral of the story was far more important in Twain's time, and it still is. When the law was looking for the scalawag Jim, Huckleberry was told that he would go to hell if he did not cooperate in the hunt; yet he would not squeal, therefore passing the word to millions of children that honor can be more expensive, if always more profitable, than shame.

Lonely, Old, or Fat

❧ ☙

I no longer collect my mail
Each day,
Because it is unkind to me.
The box contains rejections,
The dudgeon notices of my social inabilities,
And hopeless commercial tracts.
As well,
Advertisements for health products,
Let us say,
Which speak for the prolongation of my lonely life,
So that,
I suppose,
I may extend the number of times,
I will no longer go to the post office.

Loneliness should be the most preventable of society's illnesses. The odds in this world are against it. As people we normally dwell in congregated rather than secluded homes, we have ever burgeoning methods of interaction and communication, and, statistically, there are six billion potential companions from which to choose a satisfying circle of pals. Yet who in all this has not been lonely at least occasionally? One in four American adults is single, 20 percent of the households in the nation have but one occupant, and we are constantly reminded that when we are alone, we are not alone, if in the negative sense:

Which of us has known his brother? Which of us has looked into his father's heart? . . . Which of us is not forever a stranger and alone? . . . The whole conviction of my life now rests upon the belief that loneliness, far from being a rare and curious phenomenon, peculiar to myself and to a few other solitary men, is the central and inevitable fact of human existence.

—Thomas Clayton Wolfe

I can vouch for Wolfe's contention. I've had the "hideous doubt, despair, and dark confusion" of which he also speaks in this context. I've traveled widely, I've known tens of thousands of human beings and a parrot from Bengal, I've participated in the most public of endeavors; yet I have at the same time been alone for extended periods of time, periods, as often as not, when I didn't choose the condition, periods that I've felt were thrust upon me by a world so inattentive as to not care if I objected or was able to hold out.

I remember once, separated from a wife, alienated from the writing profession, and living inside the four walls of a home that had become merely a house on the real estate market, I set out one night to walk to Washington, D.C., forty miles to the north, just to belong once again to the family of man. When I got there, I turned around to walk back, this time along the escape route taken by John Wilkes Booth, after he murdered Abe Lincoln, down to the Potomac River, where he crossed into Virginia, and where, alone in a barn, he was shot dead himself.

I was gone for two days.

Didn't help at all.

You cannot talk yourself out of being lonely. You either are or you are not, there is no middle position, and patching does not help. I learned that half a lifetime ago from a hermit in Montana. I've talked with several hermits over the years, and this one was the most introspective. He said even people who choose to live alone, those who have

their faculties, may do so only after other choices have failed and ushered in the ocean of solitude.

I am going way back now. So long ago that I did not yet know everything.

The hermit lived in the wilds northwest of Kalispell, Montana, where I was employed on a small daily newspaper. I'd heard about several men who lived by themselves in the forests, managed to get a map of sorts, and set out with a Winchester rifle in hand to do a story. The Winchester was not just Mountain Man eyewash. There were black, brown, and grizzly bears in that part of Montana. I couldn't hit the blowing wind with a bullet, but I weren't a complete fool.

I drove my 1960 Corvair (stuff it, Ralph Nader) to the edge of a set-aside wilderness, where I continued on foot. I did not see a bear, but (will someone please believe me?) I grabbed a glimpse of Sasquatch, the Abominable Snowman. The creature was lumbering through the trees, upright, dammit, not on four legs. I thought about shooting. I thought about missing and making it mad. I thought about getting beaten to death and thus forgoing sex forever unless it was an option in the afterlife. Since then, I've thought more about shooting. If I had dragged it back to the disbelieving world, I would now be interviewed on the 912 shows that are aired each week on the cable channels devoted insatiably to the world's amazing mysteries.

When I reached the hermit's shack, I told him of the near encounter.

"Coffee?" he said.

"Have you ever seen it?" I asked.

"Sugar? I got all the fixings. My relatives visit."

The hermit lived in three rooms. There was another building out by a stream. He was in his forties or fifties, short, clean shaven, reasonably schooled. He'd built much of his furniture, polishing the wood in a way that he explained but I've misplaced in memory. Theodore Kaczynski, he was not. He had been in Korea. He loved

the United States. He paid taxes (on furniture he sold?), was registered to vote, and each day raised and lowered an American flag.

He said he'd lost a job and a child at about the same time in Spokane, Washington, and moved then with the mother into the forest. He said they did not so much drop out, at first; they wanted merely to test the waters of what, in the early 1960s, was still a romantic option in the nation: living off the land. They stayed in a teepee initially, then raised the shack, along with garden vegetables, and trapped (with a permit) their meat and skins. They kept semiannual appointments with their parents, wrote poetry, gave thanks to "the Spirit," and stayed well.

Then his mate left, and the hermit said he was unable to follow.

"You get scared," he explained.

"Of what?"

"Everything. I'm safe here."

He said the woman came back a couple of times. But then stopped coming. And he said it was haunting. He said they used to put out crafts for Christmas, but he stopped doing it; he said they would argue about events they heard on the radio, but now he had only his own opinion; he said they kept a small hut on a distant pond, for vacations, but now he would not camp there.

Loneliness is easily fixed; you need only one person. But he no longer had her.

"I keep busy . . . ," he said.

"Good," I said, too quickly.

". . . thinking about her."

We walked about. He said he had eight-track tapes and memorized the tunes. He said he had access to books, but it hurt to read about real life. He said he shaved in the hope that someone would be lost in the woods, come to him for help, fall in love with his community of birds and small animals, and stay. And he said he went to town, periodically, for supplies, medical attention, and other business. "I like to see people. I like to talk. I like the supermarket."

I asked him why he didn't move back.

"I told you."

"What?"

"You get scared."

I can vouch for that contention too. It's my experience that when you are alone, really alone, you get scared that the loneliness will be permanent, and if you search for a way out, and fail, you will be assured of the permanence, and be damned. Yet this assertion gets no credence in the self-help industry. It is in the business of repairing emotions such as fear with rhetoric.

In this application, please say hello to the rhetorical Lynn Shahan, a commercial self-help babe. She is the author of a book entitled *Living Alone and Liking It,* a work of blab that the cover says is a "National Bestseller Guide to Living on Your Own." She suggests that those of us who are divorced, those of us who have arrested social skills, those of us trapped on isolated glaciers should look at "the joys of living alone" as an "adventure."

No, she admits, it's not so easy as she's just made it sound. There are "tears and despair and idleness" to endure, not to mention frigid winter nights with only the cat for comfort. But she insists it can be done, if only because she did it herself. "I too have been there [tears and despair and idleness]," she writes, "and beyond." She doesn't get much more personal than that, though. We are not able to find references as to why she's lived alone, which, we think, is important; if she says she's triumphed over a loneliness heaped on her by the death of a spouse, one thing; if she says the triumph came after a reasoned decision to go it by herself, that's another fish head.

It's easier to be without anyone if you choose to be without anyone. It's still no fun, but easier.

So, blind to a clue of her circumstances, we read with suspicion the Shahan credo, which is that: "Living alone is like climbing a mountain. Once you reach the top the view is great."

The author's purpose, therefore, is to help the reader up the slope. And she starts with a set of five alpine principles: *One,* "Don't let

yourself be overcome by the enormity of the situation. Remember others have coped and you can too." *Two,* "Recognize that aloneness is only one part of your life. Don't regard it as all-consuming." *Three,* "Be aware that a plan you make in a positive frame of mind is more likely to be followed than one you conceive in desperation." *Four,* "Recognize that while you can expect some help from others, you must be ready to do most of the work yourself." *Five,* "Remember that the process of learning to live alone can take a long time."

This is reduced-fat counsel, to be sure, stuff that would not constitute a bright exchange between mice. But, insistently, Shahan forges forward. She says courageously that people who live alone do not have to look on themselves as "weird, strange . . . even deviant," that they are, by Grapeseed, just the same as everyone else, if not willing or able to share the bath towels; indeed, she claims, singlehood has acquired a new image in changing times and is "almost fashionable."

At any rate, according to the writer, non-deviants who are single should: "Enjoy your freedom. . . . You can come and go as you please." "Become your own person. . . . You have time for a self-identity search." "Explore your options. . . . You have the privilege of designing your own life on the basis of who you are." "Bolster your self-reliance. . . . There is nothing like knowing for a fact that you can take care of yourself." "Find pleasure in solitude. . . . A major advantage attending the privacy of solitary living is that no one can invade it unless permitted. . . . You are in control."

As to how to proceed, she says:

Understand and adjust. Don't just live numb from one day to the next. "Accept your aloneness . . . learn to work through your feelings . . . challenge yourself to survive. . . . Remind yourself that you are your own first and last resource [for taking responsibility] for your own happiness."

Face your demons. Confront the questions of whether you can go it alone, whether you can support yourself, what will happen if you be-

come ill, and "What if I have to spend the rest of my life this way?" "Identify each fear as precisely as possible," and do not try to hide from them.

And so on.

The foregoing covers, in brief, half of Lynn Shahan's book. Quiz yourself: Did she write anything new, anything thought-provoking, anything *helpful*? If your answer is yes, it's scant surprise no one will have anything to do with you. Shahan's best-selling book is a guide to advice that exists on every stoop in every community where familiarity breeds the commonplace.

But what else can she say? If she wrote something honest—such as, *the remedy for loneliness is people*—who would pay to read it? When self-repair authors know there is nothing of meaning to write, they write anyway, knowing that their readers will complacently believe what they are and *what they are not* told.

So she recites sprinkles that were first distributed when Adam lost Eve (or did Adam go first?). Because the self-help process often goes back to Genesis. It is: *Discover* a dysfunction in something, even if the something is an unavoidable fact of life; *List* the comments that have been made about the problem, particularly those that have been made again and again; *Organize* the results, commend them to print, slap something on the cover about "best-selling," and do not worry that it's pretense if it's not illegal—there's no record of a self-help author ever going to the gallows.

There is one more step in the process: know that the public will play along. It can't help itself. American civilization has converged at a mass gathering where the rule is that since we can put a man on the moon we can do anything. This means that the application of intelligence is more important than the application of thought; it means there have to be those among us who can show us how to do away with all of our problems, how to be rich, how to be beautiful, how to be popular, how to be happy, how to be good parents, and how to live alone and like it.

A last thought on *Living Alone and Liking It,* before I get on with other unhelpful books of this nature. Lynn Shahan is at least right in her premise: people *can* live alone and be happy. People *can* also live in Georgia and be happy. Anything is possible, so say the alchemists.

But can we learn to be happy, in anything, anywhere, from a book? Self-improvement advice always stalls on the beaches of heterogeneity. People are not all reprints, Lynn. Circumstances and personalities differ even as do constitutions and abilities. One man's meat is another's *poisson.* It may be well and good for one million lonely people to get to know their neighbors, but there are another million folks who live next to neighbors better left unknown. So adjustments in this social struggle, as in all social struggles, have to do with the varieties of sex, age, philosophies, economics, and whether the victims have opposable thumbs; self-help publications merely address people of certain peculiarities, such as white women from Queens who refuse to wear panty hose that have not been put on the sale table at Bambergers.

For those of you who are lonely, I know what it is to soak in a tub by oneself. But don't expect a better future in words. Find a companion and treat him or her right. The odds are with you.

That said about that (giving advice is a variation of trespassing), here is a listing of other unhelpful books written for people, like the lonely, who, all said, probably don't need help anyway.

Parents

While writing this literary chef d'oeuvre, fittingly with a quill pen plucked from a Tien Shan goose by a virgin, using ink brought by runners from the Great Heights, I am sitting aside a row of black Venetian window blinds, each affixed with bright orange warning stickers

that read: "Young children can become entangled and strangle in [the] cord or bead loops [which are employed to open and close the blinds]. Use safety devices to reduce access or eliminate loops."

Now, the blinds are in windows that are mandated by the building codes to be three feet from the floor; thus, any young children becoming entangled in the cord or bead loops would have to be at least five feet tall (allowing for enough length to fit around the neck). Moreover, neither the cords nor the bead loops actually loop—they are single, opened-ended strands; thus, even young children five feet tall would have to take a class in strangulation to be very seriously menaced.

The stickers are a sign of the times.

The times are kiddiecentric.

The idea of protecting children in matters of this interest is a relatively modern one. The laws defining kids as helpless did not exist until the second two-thirds of the twentieth century. Before that, in the legal sense, there were no children. Everybody of every age had the same standing (except blacks, Indians, and women). There were rules against, well, beating someone up, but the statutes did not draw differences between the beating of adults and the beating of children. Age was an incidental. Kids did not receive much more official attention than the older rowdies.

I remember that as recently as the 1950s, when I was an All-American boy, there was a lack of codified consideration for my tender years. To illustrate: Each spring, when school ended, I hired out for preteen stoop labor. I would hitchhike daily at dawn to Everett, Washington, where I would hop a flatbed truck that hauled everybody, including braceros, to the strawberry farms. Then I would work eight or more hours in the fields, where if all went well, if the bigger kids did not steal my berry flats, I would earn two or three dollars, plus drinking water.

Today, correctly, society is more circumspect. The states recognize that kids are charges, that they are entrusted for a while to adults; the

states also recognize that the tads are dim-witted as dandelions and are prone to foozles like hopping flatbed trucks. So big people have taken little people by the hands to direct them, temporarily, through the heavy traffic of a tough planet. No one is working tots for $2.00 a day anymore, except fathers too lazy to cut the grass themselves.

Fair enough.

But.

Warning stickers on mini-blinds? The present posture of child protection has become an undoing of reason. And the effect is everywhere to be felt. Cigarette lighters have been childproofed. The government will not permit any loose item in a toy that can be accessed by a first grader with a jackhammer. Woe to a merchant who sells a pack of butts to a helpless seventeen-year-old. And every kid in the union knows that if kids want to get their way with adults, they have merely to suggest that they are thinking of going to the cops with this or that dread tale of abuse.

Who let this rhinoceros loose in the streets? It has been the Baby Boom Generation, a group that inhabits a bluestocking wasteland. The Booms resent their own parents for largely imagined slights and have forced the nation to provide excessive restitution. Their philosophy is that children must be protected from everything, including their consanguinity, and they've spent their adult lives conspiring to nail a single rule to the national door: be a good parent, and you will have good children. It is crap, but it's the law.

And what is a good parent? The Booms have set it down in self-help books. Thousands of them. There are books of rules regarding kids who wet their beds, kids who fertilize their pants, kids who won't get interested in sports, kids who are too interested in sports, kids who can't sleep, kids who have nightmares, kids who do poorly in school, kids who take long walks in the forest, kids who insert their souls into their computers, and kids who lock themselves in the bathroom and turn up the radio volume.

Of course, all of this gumdrop rumination demands a wise-guy question. After we have shared with our adolescent victims our personal values and taught them everything Al Gore knows about the absence of controlling authority, what, yet, do we do with the kid who is advised by the ghost in the closet to push the schoolyard bully off the slide, then puts sugar in the gas tank of the teacher with the hot hand, then takes a sixth grader with a training bra to the Stink Fingers Concert, and then sneaks in for an all-night stay watching the dolphins at Marine Land?

Huh?

No reinforcement for you, bucko.

How to say this, firmly: raising kids is an impossibility that usually works out anyway. The Booms have added little of interest to the contrivances. The lesson of history (there have been times before ours) is that, one, it is futile to confuse kids with psychology; two, it is unruly in a just world to dictate character; three, it is a conceit for parents to believe they make much of a claim in child development; and, four, kids grow best, one way or the other, without bindings.

Certainly, big people should be kind, generous, merciful, and available to little people, the same as they should to other big people. Other than this, formulas do not impress. You can break your back for a son who turns out to be a jackboot, you can hardly ever know a daughter who is elected to the statehouse. Involvement is commendable but chiefly for your sake; most children get their strengths and weaknesses from circumstances outside the home, and this includes the sex, and the concerts, and the encounters with the bully on the playground.

If this were not true, if the formulas and the psychology were paramount, then we should have at this stage the finest body of youthfuls in history. We do not. They are about average. Less than that if the baseball caps are a factor. The SAT records, actually, suggest they are not as smart as were kids in school when teachers used switches and strawberry work paid $2–$3 a day.

The Booms want to control (two parents in New York State with a child who has an allergy to peanuts have demanded that their elementary school ban all legume products for all children). The Booms want to meddle (a mother from hell hired a hit man to bump off her daughter's principal cheerleading competition). The Booms want to force all parents into thinking they are responsible for everything, including the future of their charges. All for nothing, for sure; kids today, as kids always, will write their own scripts, with quill pens plucked from Tien Shan geese by virgins, and ink brought in by runners from the Great Heights.

Oldies

Aging reluctantly is one of humankind's most ancient dysfunctions. People have been bothered about growing old since, oh, since just before the deluge when Methuselah said to Noah: "Don't worry about me in the deluge, Grandson. I'm too old and worthless to be of concern. Sure, I did think I could at least have lived to be 1,000. I still have plans, you know. But go ahead; if you don't have room for me on the ark, fine; I'm 969 and I'm wrinkled, go ahead."

The thing is, the condition is relatively common as well. Almost everybody who survives his youth keeps having birthdays. So in addition to being a dated dilemma it is also one that is considerably chronicled. We have therefore learned a thing or two about aging reluctantly. For example, we have learned that it's not a bad idea, at all, and that no one has ever gone down in flames from accepting the multiplication of his years, only because of the multiplication itself.

Nevertheless, the whole damn thing does not seem fair to the self-betterment industry. In its search for the faultless world, where everyone is happy, where everyone is loved, where everyone is satisfied, the thought of having to shrivel into one of those gray-heads who drive so slow on Interstate 10 is a cloud across the sun. So the indus-

try has also searched for a reasonable alternative, and found it in the noumenon that growing old can and should be an ice-cream soda. In that respect, hear this:

> I would like you to join me on a journey of discovery. We will explore a place where the rules of everyday existence do not apply. These rules explicitly state that to grow old, become frail, and die is the ultimate destiny of all. . . . However, I want you to suspend your assumptions about what we call reality so that we can become pioneers in a land where youthful vigor, renewal, creativity, joy, fulfillment, and timelessness are the common experience of everyday life, where old age, senility, and death do not exist . . .

Wowzah. The paragraph initiates a 1993 book entitled *Ageless Body, Timeless Mind*. It was written by Dr. Deepak Chopra, who, in the years passing, seems from his photographs to have yielded physically to the ultimate destiny—but perhaps only to those of us who have not yet suspended our assumptions of reality. Certainly he has yielded to the rewards of self-help celebrity. He is a god in affairs of human-renewal. His fellow traveler, Dr. Wayne Dyer (*Your Erroneous Zones,* etc.), says the New Delhi–born alternative-medicine advocate is "a genius," which can be translated to mean that we cannot expect to absorb anything he writes.

Like, page 10:

> The new world ushered in by quantum physics made it possible for the first time to manipulate the invisible intelligence that underlies the visible world. Einstein taught us that the physical body, like all material objects, is an illusion, and trying to manipulate it can be like grasping the shadow and missing the substance. The unseen world is the real world, and when we are willing to explore the unseen levels of our bodies, we can tap into the immense creative power that lies at our source.

So, Chopra the genius takes liberties with Einstein's instructions. He also serves himself by dropping into his text the names of John Eccles, Ellen Langer, and Albert Rosenfield, which lends nothing of clarity to the process. He wants readers to believe that they do not have to despise or fear old age, because there isn't such a thing, not in terms of quantum physics. He does not go so far as to say that none of us need term life insurance; instead, he tangos around an abstract dance floor that is littered with platitudes ("You are only as old as the information that swirls through you"), and that provides no platform for, let's say, the destitute, the backward, and the terminally ill, because Chopra works with perceptions that are divorced from experience.

Dr. Chopra says human beings can avoid aging by learning to direct the way they *metabolize time.* Dr. Chopra says we can live in "the land where no one grows old" by intervening at the level where *belief becomes biology.* Dr. Chopra says his readers can experience "how the brain resists aging," they can discover that "the field of human life is open and unbounded," and they can "break the spell of longevity" by "seeing through the mask of matter," by understanding that "time is not absolute," and by ending the "tyranny of the senses."

And you thought all there was to it was shuffleboard. Old age is not for retired people.

Genius indeed, Deepak Chopra! And where may I ask is the Nobel Prize Committee? Caged in the tyranny of the senses, I wager.

Then again, the committee may have merely decided to concentrate on another book about the exhilaration of turning eighty-five. *Miles to Go, The Spiritual Quest of Aging.* This work is written by Richard Peterson, who is a latter-day disciple of Edgar Cayce. *The* Edgar Cayce, who proved that we don't have to die, even if we are dead. The late Edgar lives on in the thoughts of tens of thousands of people who believe in his ideas, ideas so oily they could be on a hot lunch.

Cayce was a mid-century houngan who packaged what he called "readings." Sometimes he talked with spirits during the readings.

Other times he was the spirit. He once found out in a trance that the second coming would be in 1985. In 1986 he learned that he'd been misinformed.

The trances were, of course, spine-tingling with authenticity. Talking for God, he'd often say something like "Ye, my brethren."

And Peterson continues to carry the bucket in *Miles to Go,* a book that supposes, in fact, that the odometer of life rewinds. He says rightly that old age is a time for new thoughts, but he fastens the thoughts to pesky spirituality, and to other puppy dog tales.

At one point he suggests that elderly folks should forgive their enemies. Okay? Then he blows a fatal hole in his argument with a shell from the canon of new- and old-age owlishness:

> The heart of the process is two short, almost identical prayers— one directed to the other person [the enemy] and one to yourself. The process is the same whether the other person is living or dead. [*First prayer:*] William, I am praying to you. Thank you, William, for doing to me all that you have done. Forgive me, William, for doing all that I have done to you. [*Second prayer:*] Oscar, I am praying to you. Thank you, Oscar, for doing to me all that you have done. Forgive me, Oscar, for doing all that I have done to you.

God is incidental in all this, understand. If William has killed Oscar's wife, and Oscar is now in a nursing home, he can resolve by himself the fault for the assault and dismemberment of Irene, and his eyewitness testimony used to send William to the felon farm at Angola.

Hi-de-ho, Miles to go? Despite Chopra and Peterson, it is still not a journey to make the heart sing. The eyes water, the legs look like road maps, the hunks at the gas station no longer smile. And the big hope is that, if Cayce was right, we have to go through it all *again.*

Better to die hard, people, once and for all. Grow old creatively, keep trying to show the world that it erred when it failed to elect you

emperor, don't let anybody beat you down, never admit to the "O" word, never give anyone the opportunity to make you feel less than you are, and keep in mind that people of your own age can be just as prurient, and far more interesting, than the ox at Texaco whose reach does not extend past the six-pack counter at 7-Eleven.

Also, here's the best part. Break the rules. When you were twenty, you learned the ways necessary for survival in a finicky, ordered, and competitive society. At sixty you no longer need them. Don't kill Oscar's wife, even if she deserves it, and don't rob banks, even if that's what the old guys do in the movies; otherwise, lift your index finger and do things your way for a change.

Butterballs

The psychological libraries of fat people contain both cooking and diet books. It is the inapprehensible dynamic behind one of the largest, and the most unnecessary, fix-it spoliations. People who eat too much are almost always on diets, and the self-improvement writers take advantage of, which is to say they plunder, the glutton's reluctance simply to buy fewer groceries.

Gad, it's a walkover. And yet millions don't get it. Americans are looking more and more like Germans, even as the dietitian-authors are working overtime. The titles are ever promising—*Fatness to Fitness, Maggie's Food Strategies, The Honest Truth About Losing Weight, The 30-Day Diet, The 2-Day Diet, The 5-Day Miracle Diet, Thin at Last*—but all of the information is lost to the weakness of the flesh hanging in billows on the fatties.

It reminds me of a story I've written about the Framingham Heart Study in Framingham, Massachusetts. The study, the oldest of its kind in the world, has tracked the health of ten thousand people over forty years and provided science with much of what it knows about the

relationship of poor diets and cardiovascular disease. Thus, the citizens of Framingham are fully aware that an excessive reliance on fatty foods is a form of self-abuse, yet that awareness does not much affect their behavior in culinary considerations. The residents eat just as many Big Macs and Tater Tots as we do in the rest of the republic, and suffer the same in the medical and mortality statistics.

And here too is the conundrum for the overweight. They know the truth but hide from it. That's why diet books have become incrementally more outlandish. One cannot anymore write simply about calories and resolution and expect success in the market; one must write about "magic" methods of dieting that rely on technology or secrets that make everything easy.

Case in point: Several books have been published in recent years that suggest that dieting is not difficult if people learn the rules of quickly losing the desire to gorge. *The Zone* is one of the books. *Sugar Busters* is another. Also there is *The 5-Day Miracle Diet* by Adele Puhn, a nutritionist who writes that she was "born in a cookie box," that she grew up "bonded to diet pills and Weight Watchers" before encountering the thesis of her book, to wit, "losing weight is largely dependent on . . . preventing low blood sugar and creating a state of good blood sugar."

Long life to Adele. She doesn't want to punish us. She doesn't want us to log time walking. She doesn't want us to go to bed hungry. She wants only to regulate our chemicals.

Author Puhn believes, among other things, that even healthy foods can break down into sugar in the body. Cantaloupes, bananas, carrots. She says they can foul the blood sugar balance, which leads to a sore cycle: more sugar, more craving for sugar, more eating, and more weight.

And even with this, the writer does not say we have to give up cantaloupes, or for that matter Ring Dings. We just have to learn a few painless rules for maintaining blood sugar:

One. *Eat breakfast within a half hour of waking up.*
Two. *Eat a breakfast of protein and bread, or cereal and [well, almost painless] skim milk.*
Three. *Eat a hard chew snack [apples, celery] within two hours of breakfast.*
Four. *Eat another hard chew in another two hours if it's not time for lunch.*
Five. *Eat lunch by one P.M., especially early risers.*
Six. *Eat afternoon snacks three hours apart.*
Seven. *Eat a dinner of vegetables and proteins, or [well, almost painless] a vegetarian meal. Men can eat starches every day, women only every other day [well, almost painless].*

The list continues. I won't give the rest of it away. Neither will I promote yet one more attempt to suggest that dieting is not trying; that maintaining proper body weight is anything other than making universally known choices; that being thin can be properly achieved by trickery, herbs, surgery, or that which pretends that fat people can lose their desire to eat, in a few days, from a book by a woman born in a cookie box who feels comfortable telling her readers:

Put aside every notion you ever had about diets. Toss out your food pyramids, your low-fat cookies, your bananas, and your carbo-packed breakfasts, lunches and dinners. And while you're at it throw away words such as *willpower, nutrition, cravings* and *urges*. You are about to begin a new way of life. You will feel fabulous on a day-to-day basis—and lose weight, too. Within the pages of this book you will learn about a food program so innovative, so exciting, and so effective that you will never have to diet again.

And this: "There is one more thing I offer: love. A lifelong romance with your good health, your vitality, your strength. Quite simply, as . . . thousands of my clients have discovered, the 5-Day Miracle Diet

gives you the ability to love yourself. And that more than anything else is the reason why this diet plan is a miracle. To your new life. To miracles. To love."

That's it. No more. Who has the Tums? Of course, if you are so fat you can't tell if you are wearing your slippers, if you are not on speaking terms with your blood sugar, if you think Little Rock is a fishing village, and you know that frogs have dandruff, you need more than these tempting excerpts from *The 5-Day Miracle Diet;* you must buy the book to read yourself, and to afterward shelve between your copies of *Easy French Desserts* and *Chocolate Cookin'*.

If on the other hand you are ready at last for religious class, if you are fed up (so to speak) with the boys at the night ballgames saying you are blocking the sun, if you have any hope left of dating that chick in accounting, don't read Adele Puhn, read Jim Fixx. The world is full of violated people who can't help their condition—you can. Be grateful, be wise, and, if you want diet advice, are in good health, and do not engage in a physical vocation, try eating a late breakfast, an early dinner, and skipping lunch. Lions eat only once a day; twice is enough for most modern humans.

Afterword: Readers who may be worried to death about dying, and concerned also that reincarnation may be nothing more than a rumor with an attitude, take heart. In the 1970s, self-help slicker Raymond Moody wrote a magnifying book, *Life After Life,* in which he detailed the "true experiences of people declared clinically 'dead' [who have lived to tell about it with] descriptions so similar, so vivid, so over-whelmingly positive that they may change mankind's view of life, death and spiritual survival forever."

Moody, a philosopher, went to lengths to remind readers that he was not concluding positively that there really is life after life (the book title and the book text notwithstanding), but he claimed to have stud-ied more than one hundred cases of after-death experiences that at

least suggested there may be—possibly, hint-hint—hope rather than finality in our untimely ends.

More, he said he discovered remarkable parallels in the cases he researched, and from them was able to construct "a theoretically ideal" after-death model from which we may gain insight:

A man is dying and, as he reaches the point of greatest physical distress, he hears himself pronounced dead by his doctor. He begins to hear an uncomfortable noise, a loud ringing or buzzing, and at the same time feels himself moving very rapidly through a long dark tunnel. After this he suddenly finds himself outside of his own physical body, but still in the immediate physical environment, and he sees his own body from a distance, as though he is a spectator.

After a while, he collects himself and becomes more accustomed to his odd condition. He notices that he still has a body but one of a very different nature and with very different powers from the physical body he has left behind. Some other things begin to happen. Others come to meet and to help him. He glimpses the spirits of relatives and friends who have already died, and a loving, warm spirit of a kind he has never encountered before, a being of light, appears before him. This being asks him a question, nonverbally, to make him evaluate his life and helps him along by showing him a panoramic, instantaneous playback of the major events of his life. At some point he finds himself approaching some sort of barrier or border, apparently representing the limit between earthly life and the next life. Yet he finds that he must go back to the earth, that the time for his death has not yet come. At this point he resists, for by now he is taken up with his experiences in the afterlife and does not want to return. He is overwhelmed by intense feelings of joy, love and peace. Despite his attitude, though, he somehow reunites with his physical body and lives.

Since Moody, scores of other published works have recounted this heavenly tale of the human egress system. We've seen the paragraphs of a man who said he'd had an after-death sexual encounter with a famed historic beauty; we've seen the frank recollection of a woman who brought back poems written by the white light, and, ah, tried to have them published; we've mucked through a testimony in which a husband and wife team, "dead" from a car wreck, said they were met at the Gate to the Beyond by the apologetic driver of the other vehicle.

Funny, the books do not speak of any but swell experiences. Where are the clinically dead who don't like what they see on the other side? Where are the life-after-lifers who do not see friends at the end of the long dark tunnel, but only another tunnel, and another, each smaller and smaller until there is nothing at all? I'll tell you where these people are. They are stuck in the smallest of the tunnels, unable to advance or come back, hoping that someone will write a self-improvement book that tells them what to do. And, be it known, someone will.

Afterword number two: For fat folks who require dieting assistance from both natural and supernatural sources, there is Overeaters Anonymous. It is a group cut from the same security blanket as Alcoholics Anonymous, Drug Addiction Anonymous, Sex Addiction Anonymous, Road Rage Anonymous, Upper Lip Hair Anonymous, Public Urination Anonymous, and White House Interns Anonymous. The good part is that OA does not necessarily blame you for your infatuation with Moon Pies, because the organization believes eating too much is essentially a "disease."[1] The bad part is that if you

1. Overeating is a disease. Satyriasis is a disease. Anti-Semitism is a disease. Even hard-drug addiction, according to those who operate junkie centers, is a disease. Shooting heroin has nothing to do with morality or will, we've been advised, it's merely an illness, like pinkeye.

are going to be a member in good standing—that is, if you are ever going to do something about your unsightly corpulence—you must accept Jesus as your savior, confess all, and read the group's pocket-sized book, *Meditations for Overeaters,* a volume of writing that raises the temptations of taste buds to the level of Christian-Inspired Philosophy. The book sets down 365 meditations, one for each day of the year. People with balloon butts are to reach for it as an alternative to a Whitman's Sampler. For example, June 3:

> There is nothing snobbish about our disease. It attracts individuals of every social and economic group. In OA, we meet the young and the old, male and female, rich and poor. One of the amazing things about an OA meeting is that it brings together in meaningful communications people from very disparate backgrounds. Even the generation gap closes when a common problem is the focus of genuine concern.
>
> Thanks to OA, we experience warm fellowship. Perhaps for the first time, we come together in a situation where game-playing and ego-building are at a minimum.
>
> To be accepted for what we are and as we are is a healing experience. We may take off our masks and let down our defenses since we do not need to try to impress anyone in OA. As children of God, who happen to be compulsive overeaters, we are all equals.
>
> We give thanks for OA.

Does game-playing and ego-building lead to five hours a night of television and potato chips? I didn't know that. But I will say this, the meditation book works. I've lost my appetite.

* * *

Afterword number three: An alternative newspaper called *The Onion* is published in Wisconsin. Part of its content involves parody. In one issue, under the headline "Concerned Parents Demand Removal of Arsenic from Periodic Table of the Elements," the story read in part: "Our schoolchildren, some as young as the fourth grade, are being exposed to this deadly element in their science classes.".

CHAPTER TEN

Why Are We This Way?

❧ ❧

The insects have spoiled the outside.
There are many of them,
And they are aggressive,
And callous,
And adverse.
As are their victims,
You and I,
Who have spoiled the inside.

There is no place left.

A man named William Hillcourt taught me the important difference between the terms *relevance* and *reason*. The first word is less permanent, and so more perfidious, than the second.

I met William Hillcourt when he was eighty-six years old. I was researching a book about America's twentieth century, as experienced by some of its artisans. Hillcourt had been born in Denmark but immigrated in the 1920s to New York, where he was to be employed by the Boy Scouts of America, and, as it happened, where he was to become the nation's best-known Boy Scout.

Hillcourt was asked by the organization to write several scouting manuals. He also became editor of *Scouting Magazine* and a columnist for *Boys' Life*. He achieved celebrity status as Green Bar Bill, a nom de plume associated with the (then) insignia of a scout patrol

leader. In that capacity, Bill originated *The Boy Scout Handbook,* among the most popularly read publications in United States history. This was the manual that several generations of kids consulted to become mentally awake and morally straight. The book detailed everything from Tenderfoots to tourniquets, leadership to locomotion, merit badges, first aid, and self assurance.

The Boy Scouts sold more than 600,000 copies of the handbook annually. Then, in the 1970s, the organization decided to revise the work. Bill said the scouting nibs felt it was no longer relevant to the needs of modern kids. He said they wanted the book in tune with the trend toward micromanagement: "The Boy Scouts of America hired a polling firm to survey public attitudes on the Boy Scouts. In other words, we went outside the group to find out about the group. It was the 'Days of Management,' as I call it. Everybody had to be trained to be a manager, the BSA had to be the manager of learning. I argued that this had nothing to do with scouting, because the truth is the boys themselves should decide what their learning is to be."

William Hillcourt was retired, and a new, more relevant, handbook was published.

It was a dead ember.

Sales were cut in half; BSA membership also got lost on the trail.

You might predict what's next. Green Bar Bill and scouting tradition were exonerated. Hillcourt was brought back from exile. He was asked to return *The Boy Scout Handbook* to its roots. The book became a big buy once again. So much for relevance in relationship to reason.

I love this story. Because apart from the happy ending, I know it on a larger screen. In the second act of my life (F. Scott Fitzgerald was as wrong as can be), the American enterprise has become more relevant than reasonable, and it has in the process lost the membership of those, like myself, who no longer consider it worth the purchase.

There are numerous reasons for this castration of the national manhood. The Baby Boomers, a flagitious collection, are not the only

ones at fault. Societal progression at the end of the twentieth century has been in large measure mere propulsion; it can be compared to a vehicle filled with humanity that is proceeding without lights on a dark night faster and faster down a twisted mountain road, with no one at the wheel.

That journey is the subject of this final (one cheer) chapter.

It's a perilous plunge toward what the passengers hope is but gratification.

We have become a population highballing into amusement, diversion, and positive karma. We will not accept deceleration in the name of pain, or failure, or restraints, and we are pushed on by anyone who insists we can have it our way. Therefore, we believe in: angels, TV wrestling, radio prayer cloths, inner children, inner sanctums, celebrities, advertising slogans, musical lyrics, New Age spiritualism, homeopathy, herbal healing, aromatherapy, Eastern mystics, cult love, virtual reality, UFOs, crystal healing, copper healing, uranium mine healing, astrology, ecopsychology, witchery, warlockery, bumper sticker doctrine, ESP, QM, feng shui, higher consciousness, lower consciousness, middle consciousness, magic, clairvoyants, parapsychology, aphrodisiacs, miracles, dianetics, spas, sensual massage, athletes as gods, children as gods, everyone else as assholes, theosophy, typology, iconology, telekinesis psychic surgery, the third eye, the superstring theory, out-of-body experiences, saying "plus-size" instead of elephantine, and Shirley Maclaine, who was a babe before she became batsy.[1]

1. We also believe to the depths of our beings in Us and Ours. And we go to homely extremes to protect this big deuce. Some affluent dads and moms are so determined to impress their children with the benefits of family sanctuary (plus sportsmanship and free-market politics) that they bond together to hire professional coaches for their community soccer teams. This gives junior's club the advantage over teams not so flush, or debased, that they can do the same—"That's my boy. Look how he runs over those pumpkins from across the tracks."

In all, we deal with life as children with soap bubbles, not with patience or with regard to history. When our muscles ache, literally or metaphorically, we do not merely rest until the pain goes away, because we are assured that we can make it go away proactively, immediately. We apply Zen or Absorbine Jr. for "deep heat" relief. These ointments do not heat anything, not particularly aching muscles, they only create the feeling of warmth on shallow nerve endings. They do not fix, they mask, yet we believe anyway because that's what we've been told to do.

And who is doing the telling in this merry moment in time? For blame, I'll open with the Mass Information Media, a star shall we say that has collapsed upon itself, becoming hugely dense if very small.

I was a newsman from age nine to age fifty-nine. I gave it up because it gave up on me and because I no longer cared that it did. Disillusionment does that. Sour regret makes it worse.

I entered the business with warm passion. I was never too bright, but I knew even as a child that journalism was a profession for alarmists, and alarmists were the conscience of the republic. I used to scribble imaginary stories in notebooks ("The president said today that an army of ants was marching up from Mexico to take over the sugarcane fields in the Deep South"), to which I would attach headlines ("It's Not Going to Be a Picnic, Insects Warn").

I was well positioned for alarm. I was then as now of modest means. The privileged do not easily ring the warning sirens of societies, but the disadvantaged do, and I joined the news industry at exactly the right time for it. The media business was in the spring of flowering. The town criers came to speak of a thousand points of light. The public prints were claiming a soul.

It was some mighty change from press tradition. Journalism had not often before aligned itself so fast to the considerations of compassion. The nation's first newspapers were political organs that were slanderously partisan and wildly inaccurate. Then, in turn, they were to become sandwich boards for (among other things) blind patriotism,

community entrenchment, social repression, gender injustice, and the strangling special interests of trade. But when I started writing commercially in the 1960s, the journals were entering a tender age of Aquarius; they had discovered that racism, and want, and injustice were loose in the soil, and they declared war on government and economic elitism in the name of the Plain Potato Americans who are kicked around by the rules, the arrangements, and the leadership.

I was a believer. It was a moment to write about unemployed coal miners in Appalachia, migrant field workers in New Jersey, powerless Chicanos in Texas, put-upon Negroes in Alabama, pissed-off students in California, and the hungry and neglected throughout the world. It was a time to know that news is never about issues or events, it is always about human beings.

Yet, unpleasantly, the good times for the bad times were brief. They lasted less than two decades. When the 1980s took place, and the Boomers grabbed control of the water supply, the media pulled out of the battle against establishment indifference, declared victory, and set off on a corporately updated course. The new view was that nobody wanted any longer to see AP photographs of hungry children, that in fact the future of AP photographs of any sort was at risk. Print publishers were alarmed at dwindling circulation; editors said it was because young people had different expectations of news; and the pollsters concluded that newspapers had to become more relevant to those expectations if they, the papers, were to survive.

So, journalism changed. It fell out of love with the reasoning of its obligations, choosing instead to rumba with relevancy. How to bossa nova with the thirty somethings? How to appeal to the afflicted children of Degeneration X? Dumb down. Necessary news would still be reported, the editorials would still have bite, but the thrust would change to appeal to the emerging fussy constituency (advertising patrons, who understand that focusing on the fortunate allows us to miss the sights of the slums). Some papers tried short relationships with offerings such as "good news"; others imported NBC peacock colors,

not because they have any kinship with content, but because they're what appeal to soccer moms; the rest redefined the term *people* to mean "popular people," as in *People* magazine—where a people is somebody like Bruce Willis, a people who performs in films like a man reading a comic book at the toilet.

The *Washington Post* has an entire people section. It's called "Style," a word the newspaper defines carelessly. Bimbos are in Style. Head-dead politicos are in Style. Flap-mouthed filmsters, conniving lobbyists, and date-raping athletes are in Style. The people section has not in a dozen years featured a story about a real people, unless he or she has been caught in a redaction with a congressman, or has otherwise lassoed the attention of the butt-kissing newspaper staff.

I'm looking at a "Style" section as I write. Something about the overexposed Oprah Winfrey and the overrated Toni Morrison; something about the uptown standby Tom Wolfe; something about the late Vincent van Gogh, a painter, apparently; something about designer Stella McCartney, a household name at the unemployment office; something about a Playboy Playmate whose boobs are enrolled at the University of Maryland; something about United States Representative Mary Bono (widow of predecessor-husband Sony Bono) newly dating a band drummer ("It's pretty overwhelming," the dowager is quoted, cheeks faintly aglow, "I feel like I'm in high school").[2]

And the following (in its entirety) about Harrison Ford, who has not dated either Mary or Cher: "Star-Studded Tequila Blast. One Caipirina, two Caipirina, three Caipirina . . . floor. Actually there

2. In another "Style" story, weeks later, Mary Bono was quoted as saying the dead Sony Bono was a pill popper, moody, and made their twelve years of marriage "very difficult." I didn't know Mr. Bono, but I read where he was a decent fellow with good instincts. I don't know Mrs. Bono, either, but it's apparent that if it weren't for her marriage she probably would have been a table wait rather than seated in the House of Representatives and appearing in "Style." Shakespeare once wrote of this: "Freeze, freeze, thou bitter sky, thou does not bite so nigh, as benefits forgot."

were 49 shots of the expensive Brazilian firewater ordered at Coco Loco Thursday night as Harrison Ford and the rest of the 'Random Hearts' cast [then filming in Washington] got together to celebrate their time off for Columbus Day weekend. The 52 cast and crew members, including director Sidney Pollack, ran up a $4,200 food and drink tab, which they paid in cash."

No journalist with balls would write this willow sap. But there it is. People? If Helen Housefrau wants her name in the dailies, she has to stalk Harrison Ford. The *Post* has lost it. It's still a better read than Robert James Waller, but, other than that, the best thing to be said about it is that it has not gotten as craven as *Time* magazine. With exceptions, *Time* has become as remote from reason as the Waddell Sea (when ten thousand Central Americans lost their lives to 1998's Hurricane Mitch, the magazine carried a 450-word report); *Time* is the Fox network on paper; *Time* is written by people in Pampers; *Time* introduces itself each week with a half dozen pages of cute-people stuff that makes "Style" look like *The Economist; Time* is Yo-man-cute, savage cute, unfair cute, and nerd cute; *Time* is relevant.

Finger aside the nose here. The summer of reason has departed from the newsprints. Levity is no longer available. Greed, garbage, and hip get the bylines. I left newspapers about the time the word *cool* was no longer confined to the weather report, when reporters started buying fashion eyewear for television talk show appearances (often to speak with prejudice on issues and personalities about which they write in news articles), and when the *Miami Herald* became more like the *National Enquirer* than the *National Enquirer* became like the *Miami Herald*.

Today, journalism is a craft for people who would rather be dining with Bernardo Bertolucci, who would rather be sailing on Loon Lake with technology investors, who would rather be standing for public office, preferably above the chair of governor. There are some who demur. But such are increasingly found far from the national beat. For example, newspeople who publish weekly newspapers are

among the last of the media's dedicated knights, and they joust in chancy obscurity. When a $90,000-per-year reporter at the *New York Times* stands up for the First Amendment, he is protected by the full weight of one of the most influential corporations on earth; when a small-town weekly publisher takes on, oh, local government corruption, he does so in the jaws of consequences that can range from the loss of friends and allies to financial ruination.

As to the last-mentioned soldier, I speak from praetorian experience. The final newspaper for which I worked, I owned. I tried to do it right. I tried, like Bill Hillcourt, to be a good scout. I stacked my publication in favor of reason and right, and I rode against the forces of exclusionary government and habits gained from the Us-Versus-Them school of human direction. Thus I upset the balance of power in the neighborhood. And for it, I was thoroughly discredited by those in charge of The-Way-Things-Are. I was abandoned by nervous friends and degraded by the usual nidderlings who, when it comes to right and wrong, characteristically fall in safely with the bullies and the bandits. When I finally surrendered this pursuit of publishing integrity, no one cared, least of all the news profession to which I had dedicated—and for which I had frequently risked, and several times nearly lost—my life.[3]

So, anyway, I'm gone from a business that has just become a business. And what has it to do with the self-help folly in the country? It has much to do with it if we consider that the newspapers have

3. It's not just obscure publishers. Everyone is subject to penalty for doing the right thing in an America that has misplaced true direction. The country was formed in part from the idea that each person's opinion is an important contribution to the benefit of all. Yet practice it with a forewarning. If your opinion is arm in arm with established belief (tulips are pretty), welcome. If your judgment contradicts the norm, you will feel a popular chill. It's not that we have come to be against fresh thinking in theory. People still admire those people who raise storms from afar. But we have a word for the townspeople who stand up to wave their arms; it is—*troublemakers.*

changed because the culture in America has changed; and because the zany search for fixing ourselves—renovating our selfish, relevant walk through life—is part of the new culture.

It was Nehru who observed that he could not define good culture, other than to suppose it must include individual restraint and consideration for others. Likewise, I can't identify bad culture, except I know it when I see it, and I see it from Dan to Beersheeba in the nation.

I might easily have said the same thing when the nation was freshly claimed by the non-aboriginals. The first Europeans to reach the shores were brave but monosyllabic people. They grouped tightly together for protection against the ravages of the wilderness, and they paid a price for the companionship: the forfeit of individual thought. Far from being the free sons of the soil presented in the Thanksgiving readings, the Pilgrims were enslaved by the dictates of their betters regarding government, politics, religion, economics, and personal conduct. Deviants were cruelly punished, sometimes executed. *Liberty* then was a fancy term for surviving on the road gang.

Soon, though, within a generation, the Pilgrims started to become pioneers. And the seeds of a bid-fair America were thereafter planted. People with their own ideas broke away from group diplegia and rather quickly formed new towns, new ways, and new rules. Each successive settlement was to incorporate vestiges of the old order— that is a limiting but unavoidable requirement of civilization—yet the pioneers found that it took individual initiative to penetrate and tame the great land, because settlements themselves lose the zeal for exploration.

In this way the enduring confidence of the nation took hold. We have ever since been a routinely conformist people who rely on uncommon individualism for progress. The combination has served us fine. Stability undermined by adventure has worked. Yet there have been consequences with the rewards, among which is that individu-

alists have regularly persuaded us to conform to foolish activity. Relevancy is always on watch in this respect. The group knows better, but it can't help itself, sucker as it is for getting in line with what everyone is talking about.

In such wise, black Americans between the ages of fifteen and twenty-five have formed one of the most ill-thought and damaging cultures on earth. Their grandparents fought for human liberty, their parents fought for economic justice, and they—far more fortunate than their forebears; by world standards a privileged class—they fight for the vulgarity of the mind and body. Their clothes are the garments that discredited Stepin Fetchit, their music suggests that they enjoy necklacing one another, they wear their hair so it makes them look like daisies, and their language is such they do not know how to say hello in earnest. They claim: just because da boys knock up da girls don't make them bad people. They believe: the only way to succeed is to get everyone to avoid you.

My. As well, the young blacks are the cultural relatives of old rednecks. And the latter may be an even more disgusting American manifestation. Rednecks are the po white bro's idea of class. They drink beer from cans and urinate on their legs. They hunt deer with pack dogs and eat Cheez Whiz. They grow beards in the winter so they can decorate the hairs with frozen spittle, they smoke Winstons because by God there ain't nobody going to tell them what to do, they eye women with a leer that they are convinced is as sexy as the stomach that rolls over their denims, and they listen to music that speaks to the ambition of eating biscuits at a truck stop.

Pals, what did we do to deserve either subset?

Or the hundred other circus acts that contribute to and dirty American culture.

By themselves, they are incidental. Together, they drag everything below the line that floors dignity. They are servile, manipulable, ungifted, reckless, infantile, intolerant, and sweaty; and, with regard

to what the world is all about, they are guided by the imprecise conviction, as someone has spoken of it, that defeat is worse than death because one has to live with defeat. They have in this respect made Americans blind to the light of reason. They have killed our better instincts. They have turned us away from the search for dreams and toward the demand for personal indemnification. We want more rap, better sneakers, all the sandwich crackers in Alabama, and Coors to wash them down; by extension, we don't want anything to interfere with our appetites—no sorrow, no loneliness, no hard times, no difficult diets, and no baseball strikes. We want to have everything, except pain; we want to live goddamned forever, even though at this stage of development we don't know what to do with ourselves when the electricity goes off.

And we don't want the electricity to go off.

Feed me, feed mine. It's the relevant demand of unreasonable times. And it has provided the philosophic and commercial rationale of the personal-development industry. If people want to live forever, as Deepak Chopra and the other Milky Way quasars have written, they will show you how to do it. How to be happy as well; how to have a great lay; how to organize your closet; how to get God at your table; how to dress for success; how to forgive your mother for making you eat the rice before the custard; how to achieve nirvana in your duties as an Orkin man.

Of course, none of it works. If you are simple enough to buy a self-help book, you may be congenitally programmed to fail. But what of it? Reason does not much define our culture anymore. The defining insistence now is threefold: one, America is still a better place to live than England if you don't think for yourself; two, if you do think for yourself, you should join a group where people won't know it; three, whether you do or don't, not to worry, everything is relevant.

I've mentioned the media. Other things responsible for our present condition follow.

The Cinema

When D. W. Griffith depicted members of the Ku Klux Klan as Christian warriors in *The Birth of a Nation,* he introduced the surgical procedure of separating fact from films. It has since then become a comfortable tradition in the business. Directors maintain that lying is necessary to the interests of the story, actors say misrepresentation is a key to audience involvement, and bottom-line producers know what T. S. Eliot knew: "Human kind cannot bear very much reality."

Even the ticket-buying patrons are in on the scrimmage. We understand that if Jimmy Stewart had really gone to the icy bridge because he was upset with events (in *It's a Wonderful Life*), there would be no pudgy Clarence to save him; but we must accept the highly unlikely intercession of the angel, else Jimmy would have dropped to his death, stomping hell out of the story line and aborting his chance to later win an academy award for *The Philadelphia Story.*

The KKK as heroes?

A Christmas miracle in Bedford Falls?

We say knowingly, tut-tut, they are *only* movies.

Still, we can be manipulated. There are nearly a billion U.S. movie tickets purchased every year. There is no telling how many films we see in total, in theaters, from videos, and over television channels, but it's reasonable to say that we spend some wee time in the activity, and that means some wee time absorbing what amounts to fantasy. Many of cinema's great romantics have never been in love with anyone save themselves; any good YMCA heavyweight could floor Sylvester Stallone in a round or two; I'm thinking of the movie *Boys,* in which a young man is drowned in his automobile, and when the vehicle is pulled from the water, the kid's face is against the window, looking quite swell for being dead, no bulging eyes, not a hair on end.

As for dramatic misrepresentation, recall the caped Clint Eastwood, walking slowly into Mexican gunfire in *For a Few Dollars More.*

The Mexican was Italian, for one. For two, he was traveling on a bald tire. He kept shooting at Eastwood's chest, which was protected by a piece of iron under the cape. In all honesty, even an Italian playing a Mexican would have gotten the light bulb into the socket by aiming for another part of Clint's bod; between the eyes would have worked.

Or *Snow White and the Seven Dwarfs*. Not one of them put the moves on her. And dwarfs? It's "little people," Walt. But even that is not so bad as *Pinocchio;* Jiminy Cricket did not represent his fellow bugs, who, in actuality, spend their time waiting for one another to die so that they can cannibalize the meaty parts; true; look at the separated legs and antennae lying on your garage floor; the bodies have not gone to heaven, because wishing on stars has limitations.

So where are we? Taken each by itself, these are, right, only movies. Totaled, the exaggerations influence our perceptions by creating lasting images in the storage bays of our imaginations. We establish Michelle Pfeiffer as the standard for what we should look like. We think that Bonnie and Clyde were misunderstood citizens. We place Oliver Stone in company with Stephen Ambrose. We are sure that parents do not understand their children; that convicts are superior to jailers, just as enlisted men know more than their officers; that policemen must be scuz in order to be sexy; that Doc Holliday was a misunderstood citizen; that southern people before 1970 were Burl Ives, but Geraldine Page after that; that somewhere in the darkest night a candle burns; that Joe Valachi was a misunderstood citizen; that if we have faith in the cultural lessons we have been given by the likes of Tommy Lee Jones, we may have to suffer some discomfort for the first two hours of our lives, but things are going to turn out all right by the time the popcorn is finished.

Malcolm Muggeridge, the critic, observed: "Hollywood continues to furnish the heroes and heroines of our time. . . . They are the American Dream . . . a dream in terms of material satisfactions and

sensual love, whose requisite happy ending is always a drawn-out embrace."

The consequence is that life is no longer nine to five at the filling station. It is wearing jowl bristle like Sam Elliott; it is talking street like Eddie Murphy; it is wishing to God we would hurry up and be Jodie Foster; and it is knowing that if we lose our job, if our husband runs off with someone else's husband, if we get AIDS, or grow out of our size 44 trousers, there is a movie we can see that will animate perjury and make us feel better about ourselves.

The use of propaganda teaches that a lie told repeatedly becomes a truth. That is the curse of the population that has been watching films since infancy and has come to rely almost entirely on theater drama for evidence regarding the ways of civilization. It is a lie that Jack Nicholson is substantially different from you and me; it is a lie that the Old West was overrun with punks who would challenge fast-gun legends in order to make a reputation; it is a lie that police chase many vehicles through the streets of San Francisco;[4] it is a lie that any one person or small group has saved, will save, or can save the earth from destruction by applying actual violence to potential violence; it is a lie that any woman would willingly go to bed with the decrepit Lee Marvin of his last half dozen films; it is a lie that our own lives are like movies in which we can fashion whatever part we wish for ourselves, and, as well, make everything we want, or don't want, come true.

4. It's not a lie, however, that cops are brutal, swinish, brain warped, and have the class of Peterbilt drivers on Interstate 29. In the 1960s a presidential commission urged the nation to staff its police agencies with educated, trained people and dress them in blazers instead of militaristic livery. Today the law enforcement IQ remains at 75, many policemen do not know how to aim their weapons safely, and their Falangistic uniforms suggest brute-force bellicosity. Talk with one of them. Hear him grunt. Would you like to have him and his Glock over for dinner?

Television

One distressing thing that television isn't is radio. Radio is a landfill of noise. Radio is a structure where the nails have come loose. Take away the valuable efforts of public broadcasting, and a deputy sheriff would be assigned to arrest everyone employed in the business. They would then be taken in Ryder trucks to La Grange, Georgia, where there would be a reeducation camp operated by people who would be conditioned in this sort of thing through hours of tapes of the Art Bell show, and who, at commencement, would hand out diplomas or heads.

I listen to an all-news station while in my car. It is all news except for the space given to NASCAR contests, which is exciting if you know who Alan Kulwicki is and care that he has friends who know how to quickly change a tire; it is all news except for the sixty-second feature presentations, which is okay if you know who Rosalie Fox is and care about four-alarm information from the entertainment industry; it is all news except for hours of worn public service announcements, which is okay if you know who Randy Travis is and care to have him repeatedly advise you, on behalf of the Humane Society of the United States, to have your dogs and cats neutered or spayed, or risk having their children picked up and incinerated.

Then there are the football games. "It was a gain of about a foot on the play. Make that a little more than half a foot. Yes, about eight inches. Right around there. Biff, that puts Kowalski's total rushing on the day at twenty-two yards, eight inches, with 42:30 remaining in the game."

Then there is basketball. "He drives in, jumps, and stuuuuuuuuuuffffffs it! Wow. Can't he jump? Can he jump? Can he jump? Biff, I gotta say that little monkey can j-u-m-p. Call out the maintenance man. They are going to break some overhead lights before this night is over."

Television, then, is only second worse. This is of skinny comfort, because television is a train wreck. I remember it from its early days,

when Japan was only good at making flat noodles, and Americans manufactured the sets. Firestone sold a line that had eight-inch screens and vacuum tubes. The light programming was news; the serious stuff was old movies.

Today, Americans make the noodles, and Japan the television sets. The latter have screens the size of bedsheets, and transistors. The light programming is news; old movies are serious.

Anything too stupid to print, television gets it.

David Letterman, since you asked. He should be doing radio. Unless the cigars kill him, he will, years from now, give the 10 Most Important Things to Know about the Colonialization of Mars. Number 10, John Glenn and other workers have a footlocker full of Viagra; Number 9, Monica Lewinsky is a crew member.

Not funny? Exactly.

In the primeval period, television consisted of three networks, stations on the edges of towns, and four or five channels. There was an early expansion experiment with something called UHF, which no one understood, and so it died with Ed Sullivan. Then cable viewing was invented. Proliferation happens. We can once again see Ed Sullivan. If the old programs were bad, the new programs are worse, and put together it's a sign the world is coming to a close.

When cable was fighting for footing, the technology guys promised customized television. Something for everyone. And it's come to pass, if everyone means those with dementia. I have an eighteen-inch reception dish. Most of the channels I receive would gag Marilyn Chambers. So help me, there are programs for human beings who are activated by the sight of large tractors wheeling through dirt.

Those readers who know about the tractors, and Letterman's cigars, should examine themselves without delay. And I'm sorry to have reminded you of your disorder. But the foregoing is wed to a great truth: No American subjected to television, day after day, year after year, is any longer responsible for himself. That is why we believe in

angels, advertising slogans, and herbal healing. That is why Monday Nitro Wrestling is relevant, that is the reason there are a half dozen Disney cartoon channels, and that is the explanation behind the appearance of Howard Stern in the human race.

Newborn children in these parts are faced with a horrible choice: free thinking, or television. Very often, Biff, they pass on fourth down with a yard to go, because that's the way they are coached. We fail them thus. We fail ourselves. It would be worse if radio had pictures.

Being Somebody

In uninspired times while a journalist, I would track presidential candidates on the rounds of their campaigns, state to state, town to town, where crowds of the eager would be gathered to take in the carnivals. One day, in Pascagoula, Mississippi, as I got off the press bus, I was quickly occupied by a Faulknerian woman who pushed a pen and a piece of paper against my arm.

"Are you somebody?" she asked.

I said I was Tom Brokaw.

"You don't look like him," she said.

I said something about makeup.

"Sign anyway," she decided.

And I did.

Today, years later, I draw two conclusions about this. One, the little lady has grown up to operate a Magic Maid service. Two, just as likely, she has the signatures of a good many personalities framed on her wall (including that of Tom Brokaw), she adds to it whenever somebody comes to Pascagoula, and she lives for the day one of them says he is Garth Brooks.

Wait. I draw *three* conclusions. The third is that she is now the secretary general of the United States of America Society of the 'Umble, Manipulable, and Easily Awestricken.

It used to be, as it was said, that celebrity was the perfume of noble or heroic deeds. It was Titian painting the Venus of Urbino. It was Cromwell forcing democracy on the monarchy. It was Edison toiling in a world with little sound in which he nonetheless heard more than most, and it was Marian Anderson showing that there is nothing to hear for those who will not listen.

Now it's a reporter in a campaign caravan. It's a country-western picker. It's a football player booked for a lewd act in a rest room. It's Donald Trump. It's Bryant Gumbel. It's Robert Downey. It's Rudolph Giuliani. It's Grace Slick. It's Paula Jones. It's Ice Cube. It's Judge Wapner. It's creepy, cookie-soft exercise nerd Richard Simmons. It's Tom Brokaw, or someone who doesn't look like him. It's anybody who may be somebody in the minds of somebody who is not anybody, and in this way it's the stench of a decomposing culture.

I put it to you that in the self-help world, where dysfunctions proliferate, there is no more dysfunctional activity than celebrity worship. We are a gang that would, and sometimes does, run over the fallen bodies of the slow to rub up to Natalie Portman's driver. Women throw their panties at gangsta rap wooden spoons who believe putting girls on the rack is poetry; people turn over their fortunes and lives to Marshall Applewhite; someone as narrowly talented as Gianni Versace can fill the airwaves even in death; and people become household names for cross-dressing (Marv Albert), masturbation (Pee-wee Herman), and cold-blooded murder (you know phew).

America has muffed it again. The nation of proud commonality has become a large rolling Bigstuff Idolatry Movement. The celebs have been installed as the United States royalty. We happily wash the feet of Brad Pitt. People who never heard of Oliver Cromwell think of history in terms of Wolf Blitzer. Larry Flynt must be great because they have made a movie about him. When she rises again, Diana Spencer will teach everyone how to mutilate themselves when

things go wrong at their palaces (she can't be God, though, because Elvis is).

I remember Morris Udall saying of the sublime recognition that accompanies political publicity, "I feel like Caesar must have felt, when I have to take time out to merely relieve myself." It's a time when Michael Douglas becomes a United Nations envoy, when an intellectually dyslectic wrestler becomes governor of a whole state, when a one-letter hack like Dean Koontz is turned into an object of acclaim; and when there is scarcely a domicile that would not hide Mike Tyson, with his millions, and his press clippings, if he came banging at the door ahead of a police dragnet.

And why? What possesses the most fortunate and singular people on earth to give up their heritage of better instincts for the sake of Regis Philbin? Writing in *American Heritage* magazine, in 1998, historian Richard Brookhiser constructed the case that we have a need for "imaginary companions"; and though he did not explain the opinion in detail, I took it to mean that he felt we think of Martha Stewart and Kelsey Grammer as our make-believe pals, holding our hands, even if they are not really holding our hands, in a life where we are better off having someone bigger than us, which is to believe that they are better than us, walking with us on the footpath.

There's truth in that. When John Glenn reentered space when he was seventy-seven years old, he was doing it, if not really doing it, for millions of emboldened oldies who imagined that the flight might reinvigorate their image and their place in the minds of the young (two cheers). And yet there were limitations in those expectations, just as there are limitations to the theory that we celebrate anyone, young or old, because we feel a security in it.

The larger reason we worship personalities is because we are ordered to do it. Celebrity is chiefly a process of marketing and advertisement. For the same reason, it's democratic. Glenn became a celebrity twice in his life—not just for being brave and accomplished but for being em-

braced by the overpowering publicity that shapes culture.[5] The same can be said, from different perspectives, about Paul Reiser, Rosie O'Donnell, Sinbad, Seal, Marky Mark, and Ted Bundy.

So it can also be concluded that doing right has little in common with celebrity. More, the right stuff can act against public acclaim. Paul Reiser would have been another face in the crowd had he been a crew member of the space shuttle *Discovery*. There would be no books about Bundy if he'd hung out a shingle in Seattle to service the psychotic. If George Washington was the nation's first celebrity, in the 1700s, he might very well be only a farmer today, without a revolution to fight and the resulting promotion from which to profit.

Jesse Jackson exemplifies this line of thought. Celebrities go steady with news and entertainment considerations. Where would Jackson be without the cameras? He has not in his life done anything past being Jesse Jackson. He's a minister without a church, he's eensy history, he's a politician who does not win elections; still, he's well-to-do, notorious, and draws attention; he's a personality by reason of being a personality, famous for merely being who he is. And who is he? He is a limited human being who has carried himself into the national consciousness by tireless self-promotion, struggling to put his face on the television screens. Modern Americans can appreciate a man who has brass nuts, even when he hasn't much else.

That is, we can appreciate anyone who elbows his way to the front of the crowd, so we can see them. That's all, just *see* them. In this, we have parked our brains, because the athletes and the actors and the singers, the least productive people we have, are doing our thinking for us.

This thinking includes the proposal that we are heads of lettuce. Vanity license plates ("IMAWWSUM") and shirt-pocket telephones won't fool anyone. We need help—we need glittering companions—

5. People rarely anymore become celebrated for accomplishments. Quick, name the man who originally set up the Internet. Hint, I don't know either.

who beat up the bar bullies that worry us, who kiss around with the pinups who ignore us, and who get the recognition that eludes us. In some ways, it's almost better than being there ourselves. As arms-length worshipers, we don't have to become a has-been like Marie Osmond, we don't have to turn out to be a pedophile in public like Woody Allen, and we do not as Margot Kidder have to read the head-lines when our traffic lights go red.

And we don't have to be blindly idolatrous. When the celebrities announce they are gay, when they are arrested for beating their room-mates, when they are hit by the spinning propellers for other infrac-tions (getting old), we can sit in stern judgment, delight in their trouble because they deserve it, and go on to worshiping somebody else, somebody new, somebody not so human.

When I throw pennies into the outlet mall fountains to make a wish, I wish people would admire more of themselves and less of others. When we forfeit our individuality to the Celebration of Swells, when we are satisfied with dreaming rather than doing, when we must safely have somebody else do the worthy living, we are flowers picked before we open, and we are disabled. Humankind is not meant to live on the weak soup provided by strangers. It leads to intellec-tual anemia, thence to a sense of inadequacy, thence to questions re-volving around dissatisfactions and helplessness, and from there to the bookshelves where the self-help writers are ready to put even more water in our bowls.

It has been recorded that when everything without tells us we are nothing, everything within should contradict it. We must know we are all kings or queens in our different ways, as opposed to being vassals who bow, scrape, and drool. We must know that Madonna and Rambo just have different jobs than you and I; otherwise, ask your doctor, read the headlines, watch the obituaries. The leading lights are of exactly the same ingredients—no fooling—as you and I.

Athletes are but hirelings. Actors are just players. And singers are nowhere so exciting as they seem on the video takes. In my thoughts,

the only deserving celebrity in the world of this minute is Mikhail Gorbachev, who helped lift every human being on earth from the fallout shelters, and when he strolls down the street in his own land, people spit on the ground as he passes.

Venerating the Unripe

It began in the late 1960s. The children of the flowers (the Baby Boom generation that redefined youth) decided that they knew best. They said there were Ottomans in government, Philistines in the boardrooms, and that everyone over thirty was lost. They said people should tie-dye their clothing, wear hair over their ears, and oppose all war except that against the fetus. They took their dictates to the streets, they stapled them to the foreheads of university presidents, and they otherwise distributed the directives through media that decided, with the deliberate speed that rallies the most derisory of cultural change, that Black Panthers and Peter Max were relevant.

The rest of the population was not at first so certain. Curtis LeMay wondered about a nuclear attack on Greenwich Village. There were jokes about wrist beads in Luckenbach, Texas. And a view was held in the church that Janis Joplin had poor skin because she used benwah balls. Still, everyone came around, as everyone always comes around in the United States, and in Berlin. Madison Avenue began selling dhotis; the editorialists turned an extrinsic (though wretched) shooting at Kent State into a moral indictment of everybody in public office since George Mason; and moms and dads began requiring their daughters to grow up naked and dusty in Tennessee communes.

Oh, yeah, the hippies were right. At least for the fling. Then the Boomers grew up, leaving the shambles to history. The bell-bottoms. The wooden shoes. The geezer glasses. The head lice, the Doors, the drop-out rhetoric, and the shirts from the Trini Lopez collection.

Except, not everything. The Boom kids who gave the nation so much that was temporary and light-minded also sentenced it to something that has become permanent and saturnine. The extolment of the young. The kneeling to the culture of the kids. If celebrating the publicized is the largest religion in America today, and television constitutes the altar, the theology is provided by residents under the age of maturescence, residents whose bandwidth is thin if overweening.

The kids still know best, it's well known.

So they still dictate the styles, mores, and everyday wisdom.

And the adults want to be just like them for it.

It's true there's always been a little of this in the union. Each generation has provided new directions and things to admire. But until the Boomers altered the healthy rules, the successive generations merely contributed new ideas to complement the old ideas, and the grin was that the children were born handsome and anxious only to make them bearable until they grew up. Today, the boys and girls have gotten control of the country's compass, which means the minds of the country's men and women, and they succeed in setting the cultural agenda, no matter how cheesy, because the men and women want to be young too.

We want to say young things like fuggeddabowdit. We want to wear young clothes such as long gymnasium trunks. We want to have young pierced navels. We want to watch young films where the actors grow melanoma at Malibu; we want to roller along on young in-line skates, to nod in agreement as Ritalin-deficient children get the best of their elders on television, to worship fifteen-year-old country warblers, to idolize twelve-year-old Olympic athletes, to be enthralled with nine-year-olds in beauty pageants, and to lay out bunting when an adolescent popster says something orderly enough to be clipped and placed for reference in our wallets.

We want to have a place in the rookery, so we chirp the right tune.

In this way we think we stay young ourselves—by encouraging kids to mature way before they are mature and thus erasing the lines between tots and adults. When we watch little girls fix their faces with

eyeshadow, when we see teenagers get credit cards, when we sew their sexy fashions and provide them with birth control pills and excuse throw-up drinking, we make the concept of "children" disappear. If there are no puppies, if everyone is in the same room, then we are all part of the community of the unripe and so not actually advancing in age.

It doesn't wash, to be sure. We can make kids older by magnifying their culture, but we can't make ourselves younger by aping it. In fact, just the opposite has happened since the 1970s. The concentration on and capitulation to youth has made the rest of us that much older and more vulnerable. The Boom-hippie philosophy of murdering those over thirty has come to pass, culturally if not physically, which may be as bad. (Why would a forty-year-old mother want an ankle tattoo? Kids think it's quaint but dopesy. Do the offspring in this example want to grow up to be just like Mom? No. More likely, fuggeddabowdit No. Mom was almost intolerable before; now, with "a flower on her foot" she is someone not to be taken to the swimming pool.)

Kid's stuff is kid's stuff. When it sets the standards, it drives adult stuff from the earth. Thus do Boomers feel old at fifty. It's because they set the clock. I applied for a newspaper job when I was fifty-five years old. I did not list my age, but the résumé was suggestive. The publisher called to say that he'd never before received an application from a journalist who had reported from one hundred countries, and wanted verbally to meet me but offered no employment. "The cutoff here is about thirty-five," he said. Fuck knowledge and experience; show me your baggy gym shorts.

Even thirty-five can push it. In 1998 a television writer was fired from a television series when it was discovered that she was thirty-two rather than the nineteen she claimed. The producer said she was wasted because she'd lied; the rest of the industry knew it was because she had suddenly developed chronological crinkles. Nineteen-year-old network television writers! That's someone born *after* 1980. So picture it, TV fans, the scribe and a series producer at session:

"Okay, wow. The episode will have Derick dating an older babe who has already graduated."

"Cool."

"Derick is, like, down and needs a conquest, so he takes her to a 'plex movie. Then they go to the Burger King, where she has a chicken salad, God, and where the show opens."

"Cool."

"Brewster comes in, does a double take at the table, and makes a crack about menopause."

"Cool."

"But Derick doesn't care. The old babe's father owns a Meineke, and Derick has to have a new muffler. He's falling all over himself and gives her a suggestive french fry."

"Cool."

"Did I say she's wearing shoulder pads? Like, 1980s."

"Cool."

"Then when everything looks good, it goes like, retro, when Derick blows a fart."

"Cool."

"He looks around and blames it on Brewster."

"Cool."

"She doesn't buy it and leaves with a guy who isn't wearing a basketball jersey."

"Cool."

"Brewster sits down. 'What's this?' he says. 'It's chicken salad,' Derick says. They flap their arms, like they're laying eggs. Did I say Derick had grown a little mustache?"

"Cool."[6]

So, thirty-two is too old. Grown-ups of all ages must move aside. We do it voluntarily, or we are pushed. We don't fight back because

6. Even more objectionable than "cool" is "uncool." Unhot? Uncold? Unsmart. No wonder we have not been able to eradicate failing grades.

we are not only in awe of our children, we are afraid of them. They lift weights, they study computers, they live on the edge, and we feel they are stronger and more organized than we are, plus they are not prevented by convention from running us off the sidewalk. The older we are, the more we look at the young with FUD, an acronym of their clan that refers to Fear, Uncertainty, and Doubt. We fear their unpredictability, we are uncertain about their motivations, and we doubt they know peach pits from pronghorns, but it's too late; they have taken over everything from politics to showbiz to the schools. The adults still have the Vatican and the Supreme Court, but most of us are neither Catholics nor lawyers.

Someone in a news magazine has referred to this experience as the "expiration-date culture." And the oldies are doing everything they can not to think of it. We have all become Alan Alda, showing up in *Same Time Next Year* in a headband. We look ridiculous trying to keep up, but we can't help it under the present cultural administration, and we've gained in dysfunctional behavior what we've lost in self-respect. Ma has gained thirty-five pounds after receiving a membership from AARP. Pa has punched out an AA host who made a crack about comb-overs. Grams is in therapy because she can't stay on the skateboard during a loop. Why can't we have the hair, the sex, and the oily smirks that we used to, now that they are more than ever in demand?

Getting on used to be depressing. Now it's uncool.

"Dear Dr. Laura Schlessinger: I have read your self-improvement book *Ten Stupid Things Women Do to Mess Up Their Lives* and enjoyed it very much. But I am sorry to say that I am still a wreck. Do you have any more advice? Please write. By the way, how old are you?"

Fallacies

In 1998 an Illinois man who was having problems with his affairs and had asked a fortune-teller for help received in the mail what was pur-

ported to be a personal psychic reading. The psychic wrote, "Someone who had just passed over to the other side just poked me hard in the ribs and told me to contact you." The reading went on to say: "As I consider you my new friend, I want you to discover your true self. You were sent to this earth to explore and attract money and wonderful things to you. We know that you are a vital center of creativeness and not insignificant as so many people might lead you to believe. So let's start . . . your own self-exploration with the premise that you are a very smart person, walking tall among all men and women alike. This is not an overestimation of what you really were created to be and you must realize it here and now and accept it as the truth. (You can and will draw riches to yourself.) . . ."

The reading cost $20.

It was deceit from the first word to the last.

The letter was from a company called Creative Publications of Herndon, Virginia. The Illinois man asked authorities to investigate. The firm was subsequently found guilty of sending the same personalized reading to thousands of Americans, grossing $5.8 million in the scheme. A court imposed a $40,000 fine and told the firm to publish notice that it had been convicted of fraud.

One of the aberrations here is that it's not an aberration. Everyone over the age of Montessori enrollment has a memory box full of this broken glass. The law has been exposing psychic deception since Esau came out red from the womb. As well, we know of the anciently fallacious nature of clairvoyants, poltergeists, psychic surgery, E-meters, Marian sightings, the Hollow Earth, lost Mormon tablets, Oahspe science, perpetual motion, levitation, numbers such as 666, stone faces on Mars, Kermit the Frog on Mars, people who study sky saucers, people who breakfast with ghosts, evangelists who cure cancer with their hands, the idea that spacemen carved statues on Easter Island, and anything that Uri Geller said or did for a relevant audience.

The biggest aberration?

We still believe in all of it.

Bent spoons don't lie.

Some time ago, as Martin Gardner writes in his book *The New Age*, a Tibetan monk named T. Lobsang Rampa had a best-selling work called *The Third Eye,* in which he insisted that he'd gone through a ritualistic surgical procedure on his forehead that opened "a blinding flash" enabling him thereafter to diagnose diseases from the shapes and colors of the auras that surround the sick; he said the new opening likewise enabled him to levitate, to advise the Dalai Lama, to take part in out-of-body jaunts, and to see others "as they are rather than they pretend to be."

Writer Gardner says the venerable monk was pretending. His name was not Lobsang Rampa, it was Cyril Hoskins. He was not a monk, he was the son of an English plumber. Before he succeeded with *The Third Eye,* he'd failed as a writer on women's corsets.

Still, by God, his teaching lives on. His taradiddle book continued to be published long after its lie was exposed, even after the liar's death (1981), and can even now be found in many shops.

So too presses still publish books about channeling. Books about psychic astronomy. Books about magicians who walk through walls. Books about Satan. Books about spirit rappers. Books about reincarnation. Books about astrology. Books about sorcery. Books about palmists. Books about automatists. Books about mediumism. Books about cabalism. Books about the Inner Government of the World. And books about the bone-rotten Pat Robertson.[7]

7. We are indebted to author Dick Dabney for reminding us that Robertson, now as wealthy as God, used to be a "shotgun healer." The laying on of hands can be slow; the shotgun technique is a faster method of withdrawing devotion and money from the rubes. "There's a woman in Kansas City who has sinus," Robertson would report. "The Lord is drying that up right now. There's a man with a financial need—I think a hundred thousand dollars. That need is being met right now. . . . Thank you, Jesus. There's a woman in Cincinnati with cancer of the lymph nodes . . . and the Lord is dissolving that cancer right now." After which, an aide might run in from the wings

Books about Easter Island, too. The imaginative volumes by Erich Von Däniken insist that the ancients who cut the fabulous statues on that remote patch had to "possess ultra modern tools," therefore could not be of the indigenous population, and so must have been beings from other worlds, stranded on the island because of a "technical hitch" and moved to fashion the statuary as they were waiting for (or as a means of signaling) fly-in help from their own world.

In fact, there is no question as to whether the Polynesian natives done it, Erich. With primitive implements like picks and chisels. The statues were roughed up from volcanic basalt, dragged into pits for the finishing touches, and then dragged again to the platforms on which, ever since, they've rested.

Who was it who said, "A man is a small thing and the night is large and full of wonders"? It's a pleasant way of explaining why Von Däniken's version continues to resonate, why people still read *The Third Eye,* why perhaps everyone in the nation worries about walking among tombstones at night, swears there's a God who practices damage control, thinks moving shadows are mountain yetis, or pays a fee for long-distance, no-see-em, obscurant psychic consultation.[8]

We need our fallacies. We must believe in the unbelievable, because it's a diversion from the humdrum cut and dry. We do not get wonder enough from, say, waking each A.M. to the light of a day that must necessarily be different from any day before (there is no repetition in life); so we assign it an extended significance by thinking, for luck, that we must get out of bed on one side rather than the other and touch the floor first with the same foot every morning.

to shout that the lady with the cured cancer has decided to "go all the way" and give the Robertson program the money she'd been spending for cancer treatment, $120 a month. (We'll tell you you're fixed; you send us your savings; and yet another hospital bed is open.)

8. Yes, I did say a chapter back that I'd seen a sasquatch. I can be as much of a sweatwipe as anyone. Worse, I know better.

Similarly, we care little when it doesn't help. The process is important because the process is hope. There is a book entitled *Paranormal,* written by Arthur Ellison, who thinks that the human mind is like an iceberg, of which the knowable part is "the conscious" and the unknowable is "the unconscious." He says the purpose of hocus-pocus is to implant cracks in the berg through which the hopeful information at the bottom (for instance, the ability to communicate with the dead) flows up to the wan data at the top (for instance, the ready knowledge that the dead no longer speak to the living and that those who say so are wiener filling).

Naturally, we are more interested in the bottom, because it has more range than the top. And if we learn how to facilitate the cracks of connection, we will learn how to use our third eye, float in space, chat with late Uncle Eustice, find great mates, attract money, avoid depression, forgo pain, play for the Minnesota Vikings, be happy, live in peace, and understand that we are "not insignificant" and that we walk "tall among all men and women alike."

No, there's no proof. Yes, there are scams in the mix. But a hint, a possibility, that's enough. The least we can do is keep an open mind. The night is large and full of wonders.

Self-help writer Susan Hayward has issued a book called *A Guide for the Advanced Soul.* In it she devotes a page each to the wise readings of other self-improvement personalities (like country-western singers, these people have ballads about one another). On one page, then, this by Eileen Caddy: "Expect your every need to be met, expect the answer to every problem, expect abundance on every level." And on the next page, Caddy's source, Matthew 7:7–8: "Ask and it shall be given you; seek, and ye shall find; knock, and it shall be opened unto you. For every one that asketh receiveth; and he that seeketh findeth; and to him that knocketh it shall be opened."

How much better these poetic beliefs than adherence to the fact that they are vapors. Too, how much nicer to think Pat Robertson can bandage us (for a fee); that our pineal gland may be the third eye

to a thoroughgoing human revitalization; that if we have surrounding auras, we might stop hostile buckshot; and that if spirits *do* exist, it follows that we *do not* perish.

There was a time on earth when many men, many scientists, thought man could fly with wings of paper attached to his arms. That belief has disappeared with the knowledge that we are too heavy to do anything but glide. The change is called maturity. We practice it selectively.

There was a time on earth when many men, many scientists, thought man could predict the future by observing the disposition of the stars. That belief has grown with the knowledge that it has commercial applications. The change is called pragmatism (relevance?). We practice it blindly.

There has not in all of time been the slightest evidence of ghosts. No one has ever been able to specifically tell the future. Pat Robertson meets with bankers, not with Yahweh. The night is indeed large and filled with wonders, none of them paranormal. Normal is enough. Embrace normal. We have brains, drive, and each other—that's plenty even absent the occult diversions. Engage in the fallacies if you will, but keep them a goodly length from your main stream; believe not in what others see for you—including preachers, clairvoyants, car salesmen, and self-help authors—but in what you can see for yourself. I promise you it's the way to true happiness and prosperity on this twisting rock; only, I have to add, sometimes, oftentimes, it's not.

Gracious. I have run out of space. I could continue down the list of how we are incited to be the way we are, the way the self-betterment industry wants us to be. For instance, I could make light of our comfort with distorting special interests; I could note the humid gays who say Jesus did not engage in sex because he did not want to endorse one way over another, or the PETA persons who believe there should be laws to protect gallinippers, or those who insist that the rest

of us have a duty to accommodate foreign residents who do not want to speak English. But fuggeddabowdit. I've carried on for too long as it is, and it is time to end this composition (three cheers).

Almost.

First, I must deliver on a pledge made in the first chapter. There, mentioning the slyboots advice goddess Laura Schlessinger, I reworded her book title *Ten Stupid Things Women Do to Mess Up Their Lives,* and said that I would relieve myself eventually of a similar list about men.

Does anyone remember men? They are the people with the smaller selection at the stores.

One. *Men are born with more obligations than women, and so have more confrontations with priorities.*

Two. *They take an easy measure of others but seldom of themselves, soliciting injury on both ends from the slings and arrows of false impressions.*

Three. *They believe they are the curators of the planet, everyone else the staff.*

Four. *Awkward, they have trouble growing stones in rock gardens, and lean in this way on bluff.*

Five. *Dogmatic, they are more contentious in peace than war, if as conquering.*

Six. *Lonely, they wish women and children would hold them by the hand instead of the pocket.*

Seven. *When they can't do something, they are confused when it works.*

Eight. *They reach too far for stars instead of flowers.*

Nine. *They work the whole of their lives, then die.*

Ten. *If they don't die, they drive trucks, the same thing in ways that matter.*

Here is a story about men: In the Midwest, they pay landowners to shoot prairie dogs. They sit in chairs on the plains, they drink

whiskey from the bottle, and they kill as many of the small things as they can find through telescopic instruments. The prairie dogs sit on top of their burrows. They are stationary targets. When the animals are hit, they fly into the air, often in multiple parts. The shooters get drunk, kill all the day long, and then go home to be with their families.

Here is a story about women: They can be just as infernal.

I recall a poem, whose author I do not recall. "Roses are red, violets are blue, I am a schizophrenic, and so am I." It reminds me that Americans sing with more than one voice. They are both on key, and off. This is the schizophrenic characteristic that has taken us to the top of the material world, and to what so far is one of the lowest moments of our incorporeal weakness.

The fix-everything authors are right about one thing: we do need help.

Yet not from them, for they are part of the reason we need help.

I urge you to go to the forest for succor instead of the bookshop. Stand next to a tall tree. If that doesn't make you feel better, then: kiss someone like you mean it; turn in a crooked cop; join a movement to eliminate first class on air flights; learn to play the guitar; read about the lives of Jefferson, Gandhi, and Paul of Tarsus; give $10 to a street bum; do well by your parents; reach down to lift someone from their knees; exercise; take vitamins; ask the divinity to get religion.

If none of this helps, you were born soon after World War II or are otherwise deformed; if it does help, go forth under your own splendid power and sin against yourself no more.

Either way, be suspicious of the advice I've provided in this publication. The purpose of the writing is to advocate inside (personal) rather than outside (public) counsel. I have a frontier philosophy; I might have used it for profit in the Dakota Territory; today it is in large part obsolete. In this particular, I would be just as wrong, if less huggable, than Leo Buscaglia, were I pretending to know what is best for you. I do not. He did not. You must think, and mess up, for yourself.

Self-reliance.